W9-BPL-546

THE ACCIDENTAL MASTERPIECE

THE ACCIDENTAL MASTERPIECE

*On the Art of Life
and Vice Versa*

MICHAEL KIMMELMAN

THE PENGUIN PRESS

New York

2005

THE PENGUIN PRESS
Published by the Penguin Group
Penguin Group (USA) Inc., 375 Hudson Street, New York, New York 10014, U.S.A. •
Penguin Group (Canada), 90 Eglinton Avenue East, Suite 700, Toronto, Ontario, Canada
M4P 2Y3 (a division of Pearson Penguin Canada Inc.) • Penguin Books Ltd, 80 Strand,
London WC2R 0RL, England • Penguin Ireland, 25 St. Stephen's Green, Dublin 2,
Ireland (a division of Penguin Books Ltd) • Penguin Books Australia Ltd, 250
Camberwell Road, Camberwell, Victoria 3124, Australia (a division of Pearson Australia
Group Pty Ltd) • Penguin Books India Pvt Ltd, 11 Community Centre, Panchsheel
Park, New Delhi–110 017, India • Penguin Group (NZ), Cnr Airborne and Rosedale
Roads, Albany, Auckland 1310, New Zealand (a division of Pearson New Zealand
Ltd) • Penguin Books (South Africa) (Pty) Ltd, 24 Sturdee Avenue, Rosebank,
Johannesburg 2196, South Africa • Penguin Books Ltd, Registered Offices:
80 Strand, London WC2R 0RL, England

First published in 2005 by The Penguin Press, a member of Penguin Group (USA) Inc.

1 3 5 7 9 10 8 6 4 2

Grateful acknowledgment is made for permission to reprint an excerpt from "Entrance"
from *The Book of Images* by Rainer Maria Rilke, translated by Edward Snow. Translation
copyright © 1991 by Edward Snow. Reprinted by permission of North Point Press,
a division of Farrar, Straus and Giroux, LLC.

Image credits appear on pages 244–245.

LIBRARY OF CONGRESS CATALOGING IN PUBLICATION DATA
Kimmelman, Michael
The accidental masterpiece : on the art of life and vice versa / Michael Kimmelman.
p. cm.
Includes index.
ISBN 1-59420-055-6
1. Art—Psychology. 2. Creation (Literary, artistic, etc.) I. Title.
N71.K557 2005
700—dc22 2004060059

Printed in the United States of America

DESIGNED BY AMANDA DEWEY

To my mother, to Maria, and to Harry

CONTENTS

THE ACCIDENTAL MASTERPIECE

INTRODUCTION

B Y ONE OF THOSE ACCIDENTS of fate, in 1893 the painter
Pierre Bonnard was walking down a street in Paris (or so
the story goes) and he spied a young, elfin woman alighting
from a tram. She was maybe five feet tall, thin and fragile,
with the manner of a nervous, fluttery bird. She would later
tell Bonnard that her age was sixteen and that her name was
Marthe de Méligny. He followed her to work (it turned out
that she sewed artificial pearls onto funeral wreaths). It was
many years before he learned her real name, Maria Boursin,
and her real age, which had not been sixteen at the time but
almost a decade older.

For the next half century, as Bonnard's biographer,
Timothy Hyman, has put it, Marthe became "the defining

figure of his life and work." Her increasing nervousness, her misanthropy, her jealousy and hypochondria conspired to determine what became their solitary and circumscribed life together. And that life, in turn, shaped Bonnard's path as an artist of ecstatic and inward-looking vision. Not that any art, particularly any great art, like Bonnard's, can be attributed to, or defined by, just one thing—as the art historian Kenneth Clark put it, masterpieces are many layers thick. In Bonnard's case those layers included the influences of Edgar Degas and Antoine Watteau and ancient Greek statues. But Marthe, or rather the relationship Bonnard undertook with Marthe, was a catalyst. It's unlikely that Bonnard set out that morning to find a partner, a muse, whom he would then endlessly draw and paint. But probably no artist before him had so completely and obsessively centered his art on a single person. Who knows? Maybe without realizing it, Bonnard intuited something about Marthe at first sight, something he sensed he might need as a painter, although it is hard to imagine that he would have dreamt about spending his later life more or less sequestered with such a brittle person. In any case, although he was already a significant artist by the time they laid eyes on each other, he dated the birth of his painterly identity to shortly after they met. Had he walked down another street that day, or had he looked the other way when she stepped off the tram, or had he not pursued her but rather headed off for a café or to find a friend, or just stopped to tie his shoelaces, he might have met another woman and pursued a different life.

The consequence of his meeting Marthe was, you might say, an accidental masterpiece. Or to put it another way, Bonnard made his novel, deep, and beautiful art out of what seemed to many friends and observers a claustrophobic and sometimes unfortunate relationship. To live intensely is one

of the basic human desires and an artistic necessity. Bonnard, in his elective reclusiveness with Marthe, lived all the more intensely through his work. His force of will in so doing was a creative and illustrative act. "What attracted me was less art itself than the artist's life and all that it meant for me," Bonnard once said. "I had been attracted to painting and drawing for a long time, but it was not an irresistible passion; what I wanted, at all costs, was to escape the monotony of life." What seemed monotonous from the outside was the reverse to Bonnard. In fact, in painting such rhapsodic scenes of his domesticity with Marthe—their house, their garden, their breakfast room, a bowl of ripe fruit on their dining room table, the view from the window, Marthe in her bath—he transformed his own fairly withdrawn life into an art of irresistible passion.

Unfortunately, we are not all gifted artists like Bonnard, who clearly had a leg up in making art out of life, but we can, I think, still learn something from him about how art transforms lives. We can learn, among other things, that a life lived with art in mind might itself be a kind of art. If few of us are like Bonnard, more of us are like a Baltimore dentist named Hugh Francis Hicks, who in his spare time had a hobby. He amassed some 75,000 lightbulbs and objects related to lightbulbs. For many years, until he died in 2002 and two of his daughters arranged for his enormous collection to go to the Baltimore Museum of Industry, he kept his lightbulbs on view in a private museum in his basement. He called it the Museum of Incandescent Lighting, and invited visitors, admission free, to enjoy his lamp from the original torch of the Statue of Liberty, a microscopic bulb from a missile warhead, and other oddments and novelties he compiled from the history of electric lighting over the course of roughly seven decades.

Lightbulbs were his abiding love. When a stranger showed up unexpectedly to see his museum, Dr. Hicks would gladly quit his dental office on the ground floor of his house to give a tour in his doctor's gown. One of his daughters recalled patients abandoned in the dental chair with peroxide still bubbling in their mouths. On average, around six thousand people a year stopped by the museum. "They all come here to gasp in wonderment," Dr. Hicks said. He may have been right. He certainly created something wondrous out of his improbable hobby. His achievement was not simply to put together a collection of lightbulbs; it was to convey through his collection the obvious contentment and meaning that this obsession gave him. The collection, crowded into old wood cases with yellowing labels, arranged by type, era, and size, with sections set aside for subcategories like sconces, streetlights and chandeliers, became his masterpiece by accident— by which I mean not a traditional work of art like a painting or a sculpture but derived, like art, from a creative impulse, a deep compulsion pursued to the nth degree. His museum became a shrine to his peculiar ardor, which (again, like art) entailed the value of looking at something very closely, in this case at a humble lightbulb.

I like the serendipity of the fact that lightbulbs happen to be our familiar, comic metaphor for invention, the image that pops into the thought balloons of cartoon figures whenever they get an idea. The idea behind *The Accidental Masterpiece,* the one that popped into my head at some point, is pretty simple. It is not that I should write a book of art history or criticism, exactly, or solely dwell on the accomplishments of the greatest or of my favorite painters, sculptors, and photographers. Nor is it that all art is salutory. A day of looking at bad art can be long and dark. Instead, it is that—whether the example is the life of an artist

as lofty as Bonnard or the passion of a lightbulb enthusiast like Dr. Hicks—art provides us with clues about how to live our own lives more fully. Put differently, this book is, in part, about how creating, collecting, and even just appreciating art can make living a daily masterpiece. I don't mean that every day becomes perfect if we enjoy art. But having spent much of my own life looking at it, I have come to feel that everything, even the most ordinary daily affair, is enriched by the lessons that can be gleaned from art: that beauty is often where you don't expect to find it; that it is something we may discover and also invent, then reinvent, for ourselves; that the most important things in the world are never as simple as they seem but that the world is also richer when it declines to abide by comforting formulas.

And that it is always good to keep your eyes wide open, because you never know what you will discover. The drive to live life more alertly being an instinctive need, whether you are an artist by trade or by desire, the art of seeing well is a necessary skill, which fortunately can be learned.

I hope to approach the art of seeing here in the spirit of an amateur. I mean amateur in the original sense of the word, as a lover, someone who does something for the love of it, wholeheartedly. The best amateur has the skills of a professional but true professionals stay amateurs at heart, keeping a lid on the cynicism and irony that can pass for sophistication in some circles. Skepticism is useful, and for critics, necessary. But in *The Dehumanization of Art,* in a section aptly titled "Doomed to Irony," the Spanish philosopher José Ortega y Gasset laments how our aversion to pathos and dependence on irony "imparts to modern art a monotony that must exasperate patience itself." A few years ago I wrote a magazine article about my experience of entering an amateur piano competition, having returned after many years to playing the piano. At the

competition I was struck by the sight of ninety-one other contestants from around the world—scientists, mechanics, doctors, flight attendants, television announcers, interior decorators, mothers, court reporters, diplomats, computer consultants, office managers, a former Miss Minnesota— who had taken time out of their daily lives to get themselves to Fort Worth, Texas, for the chance to play for just ten minutes or so in the first round before a bunch of strangers.

There was a French judge, a hairstylist from Denver, and a man who installed glass in Oklahoma who had once sold his piano to buy crack. He had gone to jail for burglary. Taking up music again helped him recover. There was Len Horovitz, a doctor, who had an extra thumb at birth and had to have it removed. He learned the piano, overcoming his disability, then turned to medicine, which had given him the chance to play. At one point he asked another contestant, a Cambridge philosophy professor named Dominic Scott, why the Greeks connected music with medicine. Scott told him that the Greeks thought music healed the soul the way medicine healed the body.

The same might be said about visual art. I was moved by how many readers responded to my magazine article with stories of their own about creative pursuits abandoned, paths not taken, loves lost—about hopes of bringing out the art inside themselves, but also about their fears that this was irrational, a dream. Nobody wants to suffer the fate of the old bureaucrat of Toulouse, whom Antoine de Saint-Exupéry described as rolled up into a ball of "genteel security," raising "a modest rampart against the winds and the tides and the stars." Over time, Saint-Exupéry said, "the clay of which you were shaped has dried and hardened, and naught in you will ever awaken the sleeping musician, the poet, the astronomer that possibly inhabited you in the beginning."

Honoré de Balzac once wrote a story called "The Unknown Masterpiece" about a painter who becomes so obsessed with a painting he is doing, which to other artists looks merely inchoate, that he calls it his wife, his lover. Just thinking about it makes him feel young again. Pablo Picasso found the story so wonderful that he moved into the studio on the rue des Grands-Augustins in Paris where he believed Balzac's story had been set.

Dr. Hicks's choice of the word *wonderment* was apt. This book is meant as a kind of *Wunderkammer,* a cabinet of wonders about art, which, like the heart, can sometimes defy logic and which can also be instructive even (and often especially) when it is difficult or unfathomable. It is said that in 1911 Edgar Degas paid the most extraordinary tribute to his nineteenth-century hero Jean-Auguste-Dominique Ingres when as an old man he went every day to visit an Ingres exhibition at the Galerie Georges Petit in Paris. Degas was blind. He went simply to run his hands over the pictures. I imagine Degas hoped to touch Ingres's works in the way that adults caress their children, not just out of affection but to make some physical contact through which to transcend the moment. Time briefly dissolves in these gestures of love and devotion—through these points of contact with what we cherish and deem longer-lasting than ourselves.

What follows are some of my own points of contact with things greater than myself.

THE ART OF
MAKING A WORLD

T HE BEAUTIFUL is a promise of happiness," wrote Sten-
dhal. A logical extension of this thought might be that,
with the proper perspective, an interior life may be happier
and more beautiful than it appears on the outside. Perspective
is the key. A case in point is the painter Pierre Bonnard's
marriage to Marthe de Méligny. Some years ago, I was walk-
ing around the Pompidou museum in Paris with Henri
Cartier-Bresson. We came to a self-portrait by Bonnard,
whom Cartier-Bresson photographed not long before the
painter's death, in 1947, at seventy-nine. In Cartier-Bresson's
photographs, Bonnard is a bespectacled sparrow wrapped
in scarf and jacket and wearing a canvas hat—a tall, stooped,
shortsighted, and endearing figure. In Bonnard's painted self-

portrait, finished near the end of his life, he is more pathetic: an old man before the mirror, shadowy against a brilliantly colored backdrop, his head a pulpy, sunburned blob on a skinny naked torso, the face slightly out of focus, the eyes recessed in the skull. It is one of the humblest, most unsentimental self-portraits in modern art. Cartier-Bresson looked at it for a moment, turned to me, and said, "You know, Picasso didn't like Bonnard and I can imagine why, because Picasso had no tenderness. It is only a very flat explanation to say that Bonnard is looking in a mirror in this painting. He's looking far, far beyond. To me he is the greatest painter of the century. Picasso was a genius, but that is something quite different."

I knew what he meant. When Bonnard died, *Cahiers d'Art,* the powerful French art magazine of that day, published an editorial by Christian Zervos, one of Pablo Picasso's mouthpieces, parroting Picasso's views of Bonnard. "How can we explain the reputation of Bonnard's work?" Zervos asked. "It is evident that this reverence is shared only by people who know nothing about the great difficulties of art and cling above all to what is facile and agreeable." I find this remark rather appalling. Picasso had also called Bonnard a piddler: "Don't talk to me about Bonnard. That's not painting, what he does. . . . Painting isn't a question of sensibility: it's a question of seizing the power, taking over from nature, not expecting her to supply you with information and good advice." And worse, to Picasso, Bonnard "is not really a modern painter." In the years since, Bonnard's reputation has recovered, fortunately, though he still tends to be regarded as an art-historical anachronism: an impressionist after impressionism was dead. Bonnard was thought to be too soft; modern art has accustomed us to abrasiveness. We're wary of an art of such paradisiacal beauty, whose

complexity and peculiar sadness aren't immediately apparent. Having earned a niche in history as one of the Nabis, the group of painters who emulated Paul Gauguin at the end of the nineteenth century, he went on to paint for many years in a manner of extravagant opulence while the art world embraced cubism and other stern -isms of the modern era. So the idea arose that Bonnard was a démodé painter of bonbons living on the Riviera.

But in fact, no one who has looked seriously at his later work can have thought of him as a lightweight hedonist, much less a piddler. He did paint many poor pictures, because he painted a lot. But his best work, as Cartier-Bresson said, deserves to be ranked with Matisse's and Picasso's, above all the paintings of his wife, Marthe, which are mysterious elegies of love.

Bonnard is the great example of an artist who made the most of a relationship that, to outsiders, seemed tragic, but which proves that all relationships are finally unknowable except to those inside them. We can only know that Marthe allowed Bonnard to lead the productive artistic life that he did. And that he was not simply a passive partner or a victim: he adapted to her fragilities, which worsened with time, while he also got what he wanted from her. There must have been an element of the ruthlessness of the artist at play.

In Bonnard's pictures of Marthe, time stands still. Bonnard met her in 1893 and they became lifelong companions; he painted her nearly four hundred times. Her real name was Maria Boursin. She was born in 1869 at Saint-Amand-Montrond, south of Bourges, into a family of five children; she left home, broke off all contact with her parents for reasons unknown, moved to Paris, and changed her name. Bonnard didn't learn that she had been called Maria Boursin until they were married in 1925, when she declared, falsely,

THE ACCIDENTAL MASTERPIECE

that her mother was dead. As Sarah Whitfield, a writer on Bonnard, has observed, "It is not hard to understand how someone who claimed to have no family, no ties of any sort, and whose past was a blank would have appealed to Bonnard's love of solitude and privacy." But, coming from a middle-class family to which he remained very attached, Bonnard was aware of the impropriety of his relationship with Marthe, with whom he lived out of wedlock for decades. The sole witnesses at the eventual wedding were their concierge and her husband, Louisa Poilard and Joseph Tanson. Bonnard's family only learned of the marriage after he died, many years later.

Who was this strange woman? Thadée Natanson, who knew Bonnard and Marthe for as long as they knew each other, recalled that in the 1890s Marthe "already had the resemblance to a bird which she never lost; the startled look, the liking for water and for taking baths, the weightless walk that comes from wings, her slender high heels as spindly as a bird's feet, and even something of a bird's gaudy plumage. But her voice croaked rather than sang, and was often hoarse and breathless. Slight and delicate, her health had always given cause for alarm both to herself and to other people; nevertheless she still had fifty years to live, which gave the lie to the doctors who had condemned her from the start."

Increasingly, over those years, she became reclusive, fragile, and suspicious. Tuberculosis may have afflicted her mind. Its effect crept up on her by middle age. She became paranoid. One observer called her a "tormenting sprite." Another said she had a persecution complex, that she didn't want other artists to visit Bonnard because they would "steal his tricks." If she accompanied Bonnard on his walks, she carried an umbrella, not to shade her from the sun but to prevent others from spying her. She would wear bright clothes and then complain when people stared. She and Bonnard frequented

French spa towns so that Marthe could have hydropathic treatments for her cough and could tend to her nerves. There were periodic dietary regimes of sardines mashed in cod-liver oil, for her anemia, and raw steak to improve her energy. For years she and he lived a kind of vagabond life in remote villas and cheap hotels, Bonnard painting Marthe in her bath, as if it were a fortress and refuge, a "glittering jewel chamber," as Julian Bell described the pictures. A relative of Bonnard's said that Bonnard loved and cared for Marthe but also "feared her, put up with her." Only once, during the winter of 1930–31, did Bonnard seem to complain openly, writing to his friend George Besson, "For quite some time now I have been living a very secluded life as Marthe has become completely antisocial and I am obliged to avoid all contact with other people. I have hopes though that this state of affairs will change for the better but it is rather painful."

And yet.

What profound art came out of all this, born of an interior radiance on Bonnard's part. It's true, as Cartier-Bresson said, that Bonnard's work is tender, and it requires patience from the viewer to grasp its precise emotional pitch. You can appreciate the pictures superficially, because they're ecstatically colored. But unless you look long and hard, you don't really get Bonnard's vulnerability and also his rigorous geometry, the way his compositions are locked in place yet everything seems fluid and shimmering, as with his compatriot, Paul Cézanne. And on one level, that's the art's optical point: it's about looking hard enough to recognize, say, that things appear different when seen out of the corner of your eye or squinting into the sun or staring from light into shadow. In a work like *The Breakfast Table*, which is set in the small sitting room on the second floor of Bonnard and Marthe's house at Le Cannet, with its pretty view through

big windows overlooking Cannes, the parts of the scene dis-
entangle themselves only after we stare at it a while. Like
other Bonnards, the picture looks flat at first, as if the forms
were flowers pressed between pages in a book. The art histo-
rian Robert Rosenblum has compared Bonnard's textured
paint to tweed. The woven surfaces yield slowly to depth.
Then we gradually make out the landscape through the win-
dow, a teapot on the table, the edge of a chair, the open door
beside a radiator—and Marthe, ghostly, in profile, gingerly
inspecting a teacup with the same curiosity that we have
about the whole image. Marcel Proust wrote about "optical
illusions, which prove to us that we should never succeed in
identifying objects if we did not bring some process of rea-
soning to bear on them." And that's what's happening here:
Marthe struggling to put a name to what she sees.

Only after a moment do we notice that there's another
figure in the picture: the mirrored reflection of the slender,
reticent artist behind her, as always linked to her inextricably,
looking at us looking at her looking at the cup.

A source of Bonnard's particular intimacy is his invari-
able presence in pictures like these: he inhabited his scenes in
one way or another. He once told a model that he wanted her
not to sit still but to move around the room while he painted.
"He wanted both presence and absence," she concluded. Put
differently, he wanted to convey the feeling of living human
beings occupying a room, so that his work would not be sim-
ply a static image of an inanimate place recorded by a de-
tached observer but a remnant, like lingering perfume, of the
interaction between himself and his model in that space, a
memory of their being together, which meant, frequently, a
memory of him and Marthe, his principal model. Like Edgar
Degas's famous bathing nudes, Bonnard's views of Marthe
can seem frank and unposed, Marthe looking away, as if un-

aware of being watched, or ignoring Bonnard and by exten-
sion us; she is absorbed in her privacy. But Degas maintained
a clinical distance from his subjects, while Bonnard some-
times projects himself right into these images of Marthe.
There she is reclining in her sepulchral tub, meditating and
passive, her privacy in fact one shared with Bonnard, the two
together in their isolated world. To make explicit that he's
present, sometimes he paints his knee or thumb in a corner
of the picture—like a fumbling photographer who gets in the
way of his snapshot, except that Bonnard was cunning and
purposeful; he took just such a photograph, in 1908, of
Marthe kneeling in a zinc tub, sponge-bathing herself, her
body a blurry silhouette against the light, with his hands jut-
ting into the picture, looming in the foreground.

Sometimes he's just implicitly there in a painting's tacky
surface, which looks caressed and nervously fussed over, as
he fussed over Marthe. Cartier-Bresson, who as a young man
hunted boar and antelope in Africa before picking up a cam-
era, intuitively noted the invasive aspect inherent in the rela-
tionship between any artist and his model when he said,
"There is something appalling about photographing peo-
ple. It is certainly some sort of violation; so if sensitivity is
lacking, there can be something barbaric about it." With
Bonnard there is no aggression, no voyeurism even, only an
impression of him graciously losing himself in Marthe's
predicament, surrendering to their mutual separation and
dreaming up something joyful out of this claustrophobia: a
sensuous fantasy realm for them to occupy together, outside
time. Again and again, his paintings of Marthe suggest, as
the critic David Sylvester once put it, "the promise and the
memory of the delights of handling her flesh, of bringing his
body into contact with her body. He conveys that it is too
precious, too fragile for him to dare to take hold of it: he

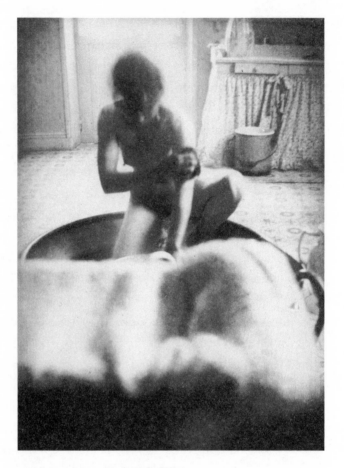

PIERRE BONNARD, *Nude in the Tub*

holds back, leaving the flesh to be caressed by the light that plays over it, invades it, infuses it as it infuses and floods the surrounding space."

But we are now ahead of ourselves. How did Bonnard find himself in that bathroom with Marthe?

Despite being shy, he was a man of quiet energy and charm, and during the 1910s he had at least two affairs with his models: one with a woman named Lucienne Dupuy de Frenelle, who is in several of his pictures from around

1915–16, and another, starting around 1918, when Bonnard was already in his fifties, with a statuesque woman in her twenties, an aspiring artist with a distinctive round face named Renée Monchaty, who was sometimes called Chaty. She was living with Harry Lachman, an American painter who became a film director, and at first she was friendly with both Bonnard and Marthe. She addressed postcards to the two of them. By 1920, she and Bonnard had become lovers. In 1921, we hear of them passing several weeks together in Rome, where they met her parents and evidently obtained permission to marry. It isn't clear when Marthe learned of their affair. By 1923 Bonnard had begun a painting of Renée smiling in a sun-drenched garden; she is a robust flapper with emerald eyes, the antithesis of the withdrawn Marthe. Renée casually leans her head on one hand, seated before a table that is draped in a brightly striped cloth on which rest two plates of ripe fruit.

Their affair soon became a tragedy. In the end, Bonnard could not bring himself to leave Marthe. He told Renée, and finally married Marthe. One version of Renée's suicide, a month after the marriage, has it that she used a revolver. Another has it that she was found on a bed of roses. Yet another, that Bonnard found her drowned body in a bathtub. Marthe insisted that he throw away all his paintings of Renée. Bonnard put aside the unfinished one in the garden. He and Marthe bought a pink stucco house with gray-green shutters at Le Cannet, above Cannes, a modest and remote hillside villa, a fixer-upper that afforded excellent views. It was perched in a garden of orange and palm trees with stepped terraces. He named it Le Bosquet (The Grove) after the district of town where it was located. Around this time, having flirted with the theme of the solitary bather, he also began the series of bathtub paintings of Marthe that preoc-

cupied him for the remainder of his life. The connection with Renée's drowning, if that is what it was, seems unmistakable.

There is a picture from around this same moment that Timothy Hyman has cleverly called a coded message "from prison." It shows a sunny view of the Midi through tall windows from inside a room. A desk is at the window. A woman is on an apple-green balcony gazing across the landscape. We barely glimpse her profile. It is Marthe. On the desk is *Marie,* a Danish novel by Peter Nansen that Bonnard had illustrated in 1897, among the earliest drawings for which Marthe ever posed. In those illustrations, she looks like a child. Back then, Bonnard also painted her in black stockings, sexually spent on unmade beds, the receptacle of his young erotic reveries. On the balcony, she is sexless and plain, a domestic fact, staring vacantly into space. We note that the plot of *Marie* entailed an upper-class man who seduced a lower-class woman, abandoned her, and then returned only when she fell ill.

As Hyman observes, after Renée's suicide "Bonnard's involvement with Marthe seems to have been rekindled in a new way—as a kind of convergence, almost an infection, by which the artist entered into her experience, centered especially on her life in the bathroom." His art about Marthe, their life filtered through his cleansing imagination, became Bonnard's obsession and, evidently, consolation, while Le Cannet became his Eden. He turned it into a little private paradise. The bathroom of the villa needed repair, so Bonnard outfitted it with gray-blue glazed tiles and running water. He installed electricity and central heating and added French doors to the dining room, the only room on the ground floor, which opened onto the garden. He painted the dining room walls a cheery yellow, and painted the inside of a glass-fronted dining room cupboard red. On the dining

room table, which he covered in red felt, he placed tall-handled baskets of plaited osier for peonies and mimosa, and for oranges, lemons, figs, and persimmons picked from his garden. He acquired the adjoining property, which had an almond tree on it, and added a little pond in the garden for goldfish. He painted pale blue the two small second-floor bedrooms, one for him, the other for Marthe—plain and spare like monastic cells.

And he built himself a curious two-level studio on the second floor: a cramped, jerry-built space with a high wall and big window. He used a rickety bamboo table for his paints and a chipped plate for a palette. He would tack his canvases to the wall with tiny pins, several canvases on the wall at a time, close together, like postcards on a bulletin board. If he wanted to see them from any distance, he had to climb to the studio's mezzanine and peer over a flimsy wood railing. There's a wonderful photograph by Brassaï, from 1946, showing several of these pinned-up canvases, and Bonnard, in a hat and furry slippers, bending over to touch up one picture of his almond tree. It's like the pose of a man feeding pigeons, a stooped figure of sweet humility, the Saint Francis of modern art.

Clearly, whatever his domestic relationship entailed, he thrived in this cloistered environment, notwithstanding that as a successful painter he could afford to live less modestly. He was the least bourgeois of men, as André Fermigier once put it, an ascetic indifferent to money or ordinary comfort except when it came to Marthe and her bathroom. With wartime rationing and winter approaching, Henri Matisse, who famously preferred luxury, suggested in 1941 that his friend Bonnard move from Le Cannet into "a nice deluxe hotel in Cannes." Bonnard politely responded: "I assure you I'm much better off here in my corner. . . . If need be, I'll

wrap myself up like an Eskimo, hardly the look for a hotel. . . . Not to mention the horrible clientele in the deluxe hotels that you can't help rubbing elbows with—I prefer my grocer and tobacconist." Until then, he traveled by car—in succession, he owned a Renault, a Ford, a Lorraine-Dietrich, and a front-wheel-drive Citroën—and he would sometimes absentmindedly lash to the roof his painted canvases, rolled one inside another, exposed to the elements and prone to flying away and scattering on the road, possible masterpieces lost to the winds. But when the war began, with gasoline hard to come by, he pretty much was obliged to stay put at Le Cannet, and that seems to have been just as well as far as he was concerned.

As BONNARD PROVES, a circumscribed world can be made to seem enormous through a rich enough imagination. The antithesis of Bonnard in personality, the American abstract painter Joan Mitchell, infamous for her thorniness, in her later decades settled in Vétheuil, a town near Paris, where Claude Monet had lived for a while in a gardener's cottage on what became her property. There, in her own little world, she was inspired, as Bonnard had been, to ecstatic flights of fantasy in paint. She pushed Monet's style into the late twentieth century in paintings like *After April, Bernie* that are so full of sun and sky that they seem to redouble the light that shines on them. They are abstract Bonnards. Her dancing lines suggest bursting streamers; in a classic late Mitchell work, *Faded Air I,* a diptych, hectic squiggles of black and green against pastel colors of peach and lemon bind the two panels together by an intricate knot. The work is about sunflowers, Mitchell volunteered, which "look so wonderful when young, and they are so very moving when they are dying." Hence, as with Bonnard, there

is a trace of wistfulness in the ecstasy. Mitchell's abstracted landscapes suggest, like Bonnard's views of Le Cannet, a lost Arcadia. Silence and warmth pervade the pictures of both, the warmth and silence of a partially dreamed-up past, which seems sweeter and more precious because it is gone or never was. Nathan Kernan, a poet who collaborated with Mitchell on a portfolio of prints she made at the end of her

JOAN MITCHELL, *After April, Bernie*

life, has recounted an episode, shortly before she died, when she asked him to select poems to read at a friend's funeral. When he read Rainer Maria Rilke's "Entrance" to her, she said, "Save that one for me." So he did, for her memorial. And it also speaks to Marthe's effect on Bonnard.

> With your eyes, which in their weariness
> barely free themselves from the worn-out threshold,

you lift very slowly one black tree
and place it against the sky: slender, alone.
And you have made the world. And it is huge
and like a word which grows ripe in silence.
And as your will seizes on its meaning,
tenderly your eyes let it go.

Bonnard, who made a world out of his little villa and gar-
den, led a life that, it must be said, would have been impossi-
ble without Marthe and her enforced misanthropy. He
evolved a satisfying routine: it consisted of a walk by himself
first thing in the morning, followed by a breakfast of bread
and marmalade, followed by work in the studio (his habit
was to paint several pictures at the same time), followed by
a trip to the bottom of the garden to check on Agenor, his
goldfish. He dressed like a retired government clerk, a petit
bourgeois. Into his rumpled jacket he would stuff the draw-
ings he incessantly did on any odd scrap of paper at hand.
He carried a pocket diary. Most days, with typical discretion,
he tersely noted the weather or jotted down a shopping
list or telephone number on pages where he also made
little sketches of faces or landscapes or nudes. "Shirts, pol-
ish, gum, honey, cheese, soft soap." "Cloudy." "Fine."
"Showers." On September 3, 1939, the day France and En-
gland declared war on Germany, he wrote simply "Rainy."
Only three times in twenty years did he put down a thought:
"The moment one says one is happy one no longer is"
(February 12, 1939); "It is better to be bored on one's own
than with others" (September 4, 1940); and, "He who sings is
not always happy" (January 17, 1944). Nothing about the
war, or about the occupation, or about Marthe's health or
his own. "The artist who paints emotions creates an enclosed
world—the picture—which, like a book, has the same inter-

est no matter where it happens to be," he once allowed in an article in a French journal. "Such an artist, we may imagine, spends a great deal of time doing nothing but look, both around him and inside him."

Astolphe de Custine, the French chronicler of czarist Russia, wrote that "to see is to know." Custine anticipated Bonnard's condition at Le Cannet when he added, "We are all vaguely tormented with a desire to know a world which appears to us a dungeon. . . . I should feel as if I could not depart in peace out of this narrow sphere unless I endeavored to explore my prison. The more I examine it, the more beautiful and extensive it becomes in my eyes."

And that was precisely Bonnard's gift to posterity. He explored his world every day, and as he did so, it became more and more fantastical. Behind Le Bosquet a steep path ran down the rocky hillside through olive groves and fields where herdsmen tended goats. Each morning, on his walk, Bonnard would don his canvas hat, slip away from Marthe with his little dachshund, Poucette, trailing behind him, and head down the path. "I have all my subjects to hand," he boasted. "I go and look at them. I take notes. Then I go home. And before I start painting I reflect, I dream." He often spoke about dreaming while painting, and this may have meant partly that he escaped from everyday life into his art but also that he allowed his images to assume their own lives: letting the shapes shift and the forms take on new guises. "People always speak of submission to nature," he said. "There is also submission to the picture."

Was he suffocated by marriage? Who can ever really know? A self-portrait from 1931 shows him as a scrawny shadowboxer, fighting unidentified demons. But mostly he seems to have spent his time contentedly painting what was immediately around him, especially Marthe, who is always

unmistakable with her dome of hair and boyish body with skinny legs—unmistakable even though her face is frequently blurred, as if to suggest she were fading away from this world. It makes sense that her bathtub, as he paints it, has been compared to a coffin or a womb. It may be either. Or it may simply be a warm place to rest. A master of indirection, Bonnard was a lifelong disciple of Stéphane Mallarmé. You see that in his exchange of letters with Matisse, who, enraged after Bonnard's death by Zervos's dismissive editorial in *Cahiers d'Art,* scrawled across his copy of the magazine, "I certify that Pierre Bonnard is a great painter today and assuredly in the future." Their letters are understated, modest, and stupendously heartbreaking, just two codgers moaning about the weather and their health because everything that's really important to them in the world goes without saying. That's essentially how it also is in Bonnard's art: things don't happen, they're implied.

Bonnard's unflinching only when it comes to his own aging, in self-portraits like that one as a boxer or the one at Pompidou before the mirror; but Marthe remains even in the pictures of the 1940s uncannily as she was in the ones from 1900. She is forever young, a gauzy dream of unspoiled hope. Just the quality of light in the late paintings changes. Increasingly Bonnard paints gaily patterned rooms where big bowls of fruit sit on the table and the open windows let beaming summer sunlight pour in on perfumed breezes of orange and lavender. He painted the mix of jasmine, mimosa, honeysuckle, and wisteria in the garden behind the house as nirvana.

And there is Marthe, in her bath or sitting at the table or standing before a mirror, eternally twenty-five, embalmed in Bonnard's memory. She often appears at the edge of these pictures, in a corner, against the pink latticed wall of the

breakfast room, or barely glimpsed slipping through the bathroom door into the sitting room carrying a tiny cup, as if in our peripheral vision. "These works crystallize what has always been Bonnard's primary mood, that of elegy," Sarah Whitfield has astutely observed. "He has often been described as a painter of pleasure, but he is not a painter of pleasure. He is a painter of the effervescence of pleasure and the disappearance of pleasure." The remark reminds me of a favorite passage from Vladimir Nabokov's *Speak, Memory*: Uncle Ruka finds some French children's books from his own childhood in Nabokov's schoolroom. Decades later, Nabokov comes across the same books, and they trigger the recollection of Ruka recollecting his past. "I see again my schoolroom in Vyra, the blue roses of the wallpaper, the open window," Nabokov writes. "Its reflection fills the oval mirror above the leathern couch where my uncle sits, gloating over a tattered book. A sense of security, of well-being, of summer warmth pervades my memory. That robust reality makes a ghost of the present. The mirror brims with brightness; a bumblebee has entered the room and bumps against the ceiling.

"Everything is as it should be, nothing will ever change, nobody will ever die."

Marthe died on January 26, 1942. In his diary, Bonnard simply recorded the weather, "beau," below which he placed, in a slightly shaky hand, a small cross. He stopped recording the weather in his diary not long after that. He locked the door to Marthe's bedroom and never went into it again. He told only a few close friends that Marthe was gone. To Matisse, he wrote, "You can imagine my grief and my solitude, filled with bitterness and worry about the life I may be leading from now on." But in fact he immersed himself in work that, being steeped in memory, did not really falter af-

ter her death. His last years were productive, as usual. The works combine happiness with decay. Landscapes become humming, busy vistas, gorged with light—tremulous, quivering mosaics of color, bursting like overripe fruit. His housekeeper, Antoinette Isnard, recalled how he would wait to paint the flowers that she picked for him, to "let the flowers wilt," because "he said, that way they would have more presence." Everything surrendered to time, except Marthe.

Admirers arrived at Le Bosquet after she died. Painters came to the door begging to do Bonnard's portrait. Ever courteous, he complained to Matisse that "portraits cannot be done in a day, or even in two, but how to refuse a painter whom one has already refused several times and who finally comes ringing your doorbell, all sweaty with his kit and caboodle?" He worked on a few pictures that provisionally tied up the strands of his life. Many years before Marthe died, he had painted her, as usual, in her tub in a painting where we see only her lower half, her purple legs underwater, extended upward from the bottom of the picture, so that it is as if we were standing above her, looking down. Entering, stage left, Bonnard paints himself in dressing gown and slippers, also cut off above the chest. He is holding what looks like a palette. The room is filled with blue light.

After Marthe died Bonnard completed the self-portrait that Cartier-Bresson admired, the spectral head hypothetically filling in the headless figure in the bathing scene with Marthe. He also painted Marthe in her bath again, the room now a phantasmagoric space in which she seems almost to dissolve or disappear in the melee of refracted color. John Berger has remarked, "by the strength of his devotion to her or by his cunning as an artist or perhaps by both, [he] was able to transform the literal into a far deeper and more general truth: the woman who was only half present into the im-

age of the ardently beloved. It is a classic example of how art is born of conflict." Or else, how art is born of love, which can seem from the outside to be conflict. With Bonnard and Marthe, we cannot be sure.

And at the end, he returned to the painting of Renée, *Young Women in the Garden*. She is, we may recall, seated at the table, turned around in her wicker chair, facing toward us, smiling. Bonnard now added a cornflower backdrop, a brilliant curving golden swath, like a halo behind the blond Renée. After a second, we notice another, shadowy figure in the picture, back toward us, dark-haired, moody, and mysterious, just barely visible in the lower right corner, whom Renée is in fact looking past.

It is Marthe.

PIERRE BONNARD, *Young Women in the Garden*

THE ART OF
BEING ARTLESS

NOT LONG AGO I fished two old photographs from a shoebox. They were shot during the late 1960s when I was a little boy on a family trip to the Soviet Union, where my father traveled often. In one you see just the back of my head, one ear and a birdlike shoulder bearing the thin leather strap of a carrying bag across my maroon sweater. I barely make it into the lower left corner of the picture, staring up at Pablo Picasso's *Absinthe Drinker* in the Hermitage, where I was no doubt planted by my parents for the purpose of the photograph. The worldly woman in Picasso's painting, arms tangled, leans across a table, glowering down at me. Whoever took this snapshot—my mother, I suspect—failed to center it, and the result, which is mostly the bare white

museum wall, is more striking for being off-kilter and odd. The other photograph, black and white, is fading. I beam from behind a collection of crystal and glass bottles in a large, musty Moscow hotel room. My father must have been hold-

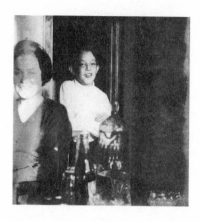

Tamara and the author

ing the camera, his old Brownie. So I am smiling at him. I realize now that when he took this picture, he was then just a little older than I am today. Beside me in this picture is Tamara, our Soviet guide, on whom I developed a childish crush. I have no idea whether she, like my father, is dead. In the snapshot, her image has partly evaporated, like my memory of her. Her side of the photograph is also badly overexposed, so she is a ghost. Another mishap with a camera, another curious picture. To me they are recovered memories. After the shock of coming upon them in the shoebox, I stared as if across a gulf of time at my father, although he is not there in the picture, just as he is no longer here. The French critic Roland Barthes once wrote about a photograph of his mother: "I observe with horror an anterior future of which death is the stake. . . . In front of the photograph of my mother as a child, I tell my-

self she is going to die. . . . Whether or not the subject is already dead, every photograph is this catastrophe." To a stranger, of course, my parents have nothing to do with these pictures, which are just a couple of amateur photographs whose minor visual interest, such as it is, depends on their physical miscues. They are formal curiosities. On the back of the black-and-white shot, I note, is an exposure number with a date. On the back of the color photograph is the red logo of the film manufacturer in script, "Made by Kodak."

During the summer of 1888, a thirty-four-year-old one-time junior bank clerk from Rochester, New York, George Eastman, introduced to the public a simple box camera already loaded with a roll of film. People pulled a string to cock the shutter, pressed a button to shoot the picture, then turned a key to advance the film. "You press the button, we do the rest," was the advertising slogan for what Eastman called the Kodak, a made-up name that he thought easy to pronounce and to remember. K was his favorite letter (his mother's maiden name was Kilbourn).

When the roll in the Kodak was finished, people sent the camera back to the Eastman Dry Plate and Film Company in Rochester, where the film would be developed and printed and the camera reloaded with another roll. Roll film and small box cameras weren't actually new then, but they didn't become popular until Eastman found a way to market them through the convenience of point-and-shoot technology and easy film processing. With Kodaks, the public could forget having to learn about messy photographic chemicals and camera mechanics. By the turn of the century more than 1.5 million of these roll-film cameras were in circulation. The carefree Kodak Girl soon began appearing on posters, stylish and windswept in a striped frock, holding a camera aloft like a trophy. Editorialists started fretting about the impropriety

of shutterbugs, set loose upon the public, snapping pictures of unsuspecting strangers, including women in their bathing suits on the beach (horrors!). Professional photographers weren't too happy, either: they attacked the new Kodak culture as a threat to their ambition that photography be taken seriously as an art. "The placing in the hands of the general public a means of making pictures with but little labor and requiring less knowledge has of necessity been followed by the production of millions of photographs," wrote Alfred Stieglitz in 1899. "It is due to this fatal facility that photography as a picture-making medium has fallen into disrepute."

Stieglitz was right. Amateurs flooded the world with pictures. A special new class of amateurs—camera-club enthusiasts—fetishized camera equipment, read the latest photo magazines, and made "artful" nudes and flower studies. Bad snapshots diluted the overall quality of photography. That said, aside from the money, amateurs and professionals were motivated to take pictures for pretty much the same two basic reasons: to save a part of the world for themselves, and to save a part of themselves for the world. The inherent poignancy in any photograph, whether a Stieglitz or a family memento, entails both the private memory it tries to preserve, by stopping time, and also the hope, however tiny or even unconscious on an amateur's part, that something interesting might result in the expression on the face of a beloved relative or in some other serendipitous gem captured when the camera's shutter is released. Memory and hope, past and future: snapping a picture with a Kodak, like painting a picture with a brush and canvas, is a way to leave a mark for posterity, a trace of oneself. It is a bottle tossed in the ocean of time. "Everything is constantly lapsing into obliv-

ion with every extinguished life," wrote W. G. Sebald. "The world is, as it were, draining itself, in that the history of countless places and objects which themselves have no power of memory is never heard, never described or passed on." So people make pictures, no matter how modestly, to give these places and objects and also the people they love a better, albeit still slim, chance at survival. And Kodak cameras democratized this effort.

Before cameras, educated, well-to-do travelers had learned to sketch so that they could draw what they saw on their trips, in the same way that, before phonograph recordings, bourgeois families listened to music by making it themselves at home, playing the piano and singing in the parlor. Cameras made the task of keeping a record of people and things simpler and more widely available, and in the process reduced the care and intensity with which people needed to look at the things they wanted to remember well, because pressing a button required less concentration and effort than composing a precise and comely drawing. During the last century, the history of amateurism in America, whether it entailed snapping photographs or painting pictures or tickling the ivories, like so many other aspects of life, increasingly centered on labor-saving strategies to placate our inherent laziness and to guarantee our satisfaction, a promise, if you think about it, that should be antithetical to the premise of making art, which presumes effort and risk.

The modern exemplar of the art-made-easy school of amateurism was a bearded, bushy-haired air force sergeant from Daytona Beach, Florida, turned televangelist painter. Even now, years after his death in 1995 at the age of fifty-two (on, appropriately, the Fourth of July), Bob Ross may still be the most famous artist on the face of the earth. For 403

episodes, he was the humane host of *The Joy of Painting,* the public television series on which he gently guided couch potatoes through the intricacies of painting a landscape in twenty-six minutes. In his lullaby voice, Ross encouraged viewers to paint "happy little clouds" and insisted that anyone who followed his simple recipe could succeed.

His purpose was as much to massage souls as it was to teach painting. He sold hope. "This is your world on this piece of canvas," he whispered to viewers. "You can do anything that your heart desires here. You have absolute and total power. This is the only place in the world I have any power. Here, here I am a dictator—boy, I can do anything here, anything, and you can, too." Ross thereby touched on a basic reason for making art—to have a place to indulge your id and comfort your ego, an area of authority, where perhaps, secondarily, with luck and a little effort, you might make something good enough to hang on the wall or show to strangers. Ross's message was: You may feel hemmed in by work or by family, but before an easel (or, by implication, at a piano keyboard, or in a dance studio, or typing your novel) you are your own master. Ross did not get bogged down in the issue of whether his cheesy paintings were actually good. Nor did he really care whether anybody even painted along with him. Evidently only about 3 percent of his audience would. His shows were art's *A Better Body in Thirty Days,* painterly equivalents of televised aerobics; most viewers watched just for the sake of watching. But whether they painted along or not, devotees were given a recipe for deliverance from life's travails, at least for the duration of the program.

Painting was its own high, Ross promised. Do you dream of pink mountains and chartreuse clouds? Go for it, he coun-

seled. His psychedelic palette dovetailed with his famously narcotic voice—a voice that, according to Ross's mysterious calculation, was the reason that the other 97 percent of viewers, from Akron to Ankara, from Harrisburg to Hong Kong, tuned in. The "Bob Ross coma" became a phrase to denote a desired state of being while viewing him, and it was meant affectionately. In death, he still reportedly reaches 500 million households in twenty countries around the globe, including Iran, and his products—paints, brushes, videos, and books—sell better than ever, satisfying what Walt Kowalski, who now owns Ross's company, calls "this craving to be creative," and providing comforting escape from worldly woes.

Ross was the heir to a noble heritage reaching back to Charles Cooke, whose 1941 *Playing the Piano for Pleasure* is now long-forgotten but in its day was a minor classic of musical amateurism. Cooke anticipated Ross's dictum of empowerment through art, but he expressed an earlier generation's greater willingness to sacrifice for accomplishment. A writer for *The New Yorker*, under the pseudonym Mr. Stanley, Cooke occasionally composed short pieces in the magazine about obscure sites in the city with odd names like Fteley Avenue and Yznaga Place and about people with weird hobbies. One of these people was a gentleman who memorized the placement and gist of every advertisement in *Collier's*. Another was a psychiatrist who wrote more than 50,000 sonnets in his spare time. Yet another was an obsessive who filled seven of the eight rooms of his New York apartment with pulp magazines, none of which he read.

About his own hobby, piano playing, Cooke wrote in the upbeat style of Dale Carnegie's self-help manual, which, probably not coincidentally, had just been published a few years earlier. "By systematically working one hour a day at

the piano, you can, in a few years, revolutionize your playing," Cooke promised. "The better you play, the more your circle of friends will expand." From the pianist Ignacy Paderewski, Cooke extracted the related observation that "far too many students study music with the view to becoming great virtuosi. Music should be studied for itself. The intellectual drill which the study of music gives is of great value—there is nothing that will take its place."

Cooke then provided the equivalent of a twelve-step program, starting with "one piano, tuned," "one keyboard, clean," "one pair of hands; fingernails trimmed." Bear in mind, he wrote, "that 30 minutes of Repertoire a day become 10,950 minutes, or 182 hours, in a year; 910 hours in five years; and 1,820 hours in ten years." Time and discipline, in other words, were his prerequisites for artistic pleasure. He differed in this respect from the later salesmen of mass culture, for whom strenuous effort was to be minimized, if not entirely avoided. Cooke told his readers, "We will worm our way, expending considerable effort, into the small end of the cornucopia, in order that we may later emerge, expending less effort and having the time of our life, out of the large end." The artist Chris Burden once showed me some illustrated instructions for early Erector sets. The pictures were sometimes vague. Hobbyists and model engineers were expected to figure out how to build a bridge that wouldn't sag or a house that wouldn't tip over. The fun was partly in not relying too passively on the manual, a slow, inconvenient, and therefore more rewarding process of self-improvement.

Years later Bob Ross peddled a philosophy of convenience and speed for a society more accustomed to them. Ross marketed the "wet-on-wet" technique, cultivated under the tutelage of William Alexander, who, in a Shakespearian twist, became his main competitor as a TV painter. By gently wig-

gling one of his two-inch brushes slathered in a mixture of his blue, green, brown, black, and crimson paints, Ross confected an evergreen tree in less than a minute for viewers. He used wide, house-painting-type brushes with a slick liquid base coat, and also showed how to make "clouds, mountains, trees and water appear in seconds. . . . No previous experience of any kind is required," although Ross's own line of specially designed paints and brushes evidently were obligatory. "Without them," his advertisements warned, "the quick and easy results cannot be achieved." Ross didn't paint people—whether because they might spoil his vistas or because they were too complex for a thirty-minute program, he didn't say.

In any event, his landscapes were resolutely American, chock-full of fruited plains and purple mountain majesties. "If I paint something, I don't want to have to explain what it is," Ross said, an odd remark coming from someone who made his fortune explaining to millions of viewers precisely what he was painting, although you knew what he meant. His technique was fast, but his delivery remained slow, which was also a savvy approach for a modern audience. His show consisted, basically, of a static camera lazily trained on him or his canvas. The approach was calculatedly homespun, like his voice, tapping into a nostalgia for the cozy can-doism of America in the 1950s, the heyday of Grandma Moses and the paint-by-numbers craze. Ross updated both with his treacly pictures of a mythical frontier and his self-help technique. Give him half an hour, and he could teach you to paint a picture. He was said to have completed 30,000 of them himself, an average of almost two a day for every day of his life. "Painting will change your life," was his line, and he was right. "It allows you to associate creativity with every aspect of your life, not just on the canvas. Many have been led to

find pleasure in music, reading, writing, sewing, gardening and much, much more as a result of painting"—which was also a source of "personal relaxation and even physical therapy."

Ross capitalized spectacularly on the widespread popular notion of therapeutic recreation, as clever American businessmen before him had done in promoting similar forms of casual art-making since the 1940s. After World War II, the standardized forty-hour, five-day workweek spawned a vast middle class with leisure and money on its hands, and many people who felt uneasy about not doing something useful with their newfound free time hunted for a hobby. Stamp collecting was an old and noble pastime, but it was a little passive. Mild labor could justify the time being whiled away on a self-indulgent endeavor, even if it was labor that, under other circumstances, might seem ridiculous. As the historian Karal Ann Marling has recounted, in a splendid survey of postwar hobbyists, the president of a small toy company in Venice, California, named Revell, hit upon the ingeniously counterintuitive idea of making a replica of Jack Benny's antique Maxwell car and then, instead of simply selling the toy car intact, broke it up into parts that required the buyer to assemble them. Revell kits reached stores in 1951 and became an overnight smash. By the end of the 1950s, companies were manufacturing kits for everything from models of the battleship *Missouri* to "design-it-yourself" neckties. There was even a kit for a do-it-yourself mink coat.

Painting became an especially popular postwar hobby. The painting craze cut across social classes. Painting by numbers was a natural fit for a society looking for a bit of self-expression but reluctant to stray outside the bounds. Women had always done handicrafts as work and in their spare time—sewing, knitting, embroidery. But now the new white-collar middle-class consumers, both men and women, more

and more of them employed in offices instead of on farms and production lines, could exercise their desire to be creative by consuming kits of painting by numbers. A decade that American art historians reverently define as the heyday of Jackson Pollock, Willem de Kooning, and their fellow abstract expressionists, an era of supposedly high moral conflict between advanced modernism and a reactionary public, was dominated, commercially speaking, by a national mania for filling in checkerboard canvas panels with ready-mixed oil paints, and by other self-generating forms of amateur daubing. The first Bob Ross, Jon Gnagy, produced at that time a fifteen-minute weekly television program teaching people to paint. Ike, leading by presidential example, let it be known that he was in the White House, twice a week, no matter what crisis the nation faced, painting copies of greeting cards (up to seven in ten days), sometimes while watching television, and occasionally indulging in paint-by-numbers. Hollywood stars promoted themselves as painters: Frank Sinatra was painting clowns; Henry Fonda, plums; Claudette Colbert, portraits. Ozzie and Harriet hawked paint-by-numbers on their show. Even mobsters from Mulberry Street, it was said, idled away hours in jail painting by numbers (a line of kits called Venus Paradise was supposedly their favorite). A paint-by-numbers entrepreneur bragged to *Business Week,* "We pray a little, keep our fingers crossed, and hope that when the herd finally turns to glass blowing, enough will stay behind to keep us in business. In the meantime, we're cleaning up."

A paint-by-numbers ad for a company called Picture Craft read, "Decorate Your Home . . . or Sell Your Paintings for Profit." Choose whichever you like; it was entirely up to the consumer. As Marling noted, do-it-yourselfism "was the last refuge for the exercise of control and competence in a

world run by the bosses and the bureaucrats." Even Winston Churchill, who ran a good part of the world for a while, felt the need to find some refuge before an easel. It was his physical relief and a perfect distraction—"a friend," he wrote in an article in 1925 in *Nash's Pall Mall Magazine* titled "Hobbies," "who makes no undue demands, excites to no exhausting pursuits, keeps faithful pace even with feeble steps, and holds her canvas as a screen between us and the envious eyes of Time or the surly advance of Decrepitude." He wasn't bad at art, either, although he never claimed to have any grand ambition for it except to let off steam. In his 1948 book *Painting as a Pastime,* he extolled the therapeutic value of putting down "large fierce strokes and slashes." Taking this aspect of painting nearly as seriously as he took war and politics, he recalled the first time he tried to paint a landscape out of doors. The great man of action felt paralyzed by indecision until a friend grabbed his brushes and started splashing and walloping paint "on the absolutely cowering canvas. Anyone could see that it could not hit back. No evil fate avenged the jaunty violence. The canvas grinned in helplessness before me. The spell was broken. The sickly inhibitions rolled away. I seized the largest brush and fell upon my victim with Berserk fury. I have never felt any awe of a canvas since." Churchill therefore found painting "complete as a distraction. I know of nothing which, without exhausting the body, more entirely absorbs the mind. Whatever the worries of the hour or the threats of the future, once the picture has begun to flow along, there is no room for them in the mental screen. They pass out into shadow and darkness. All one's mental light, such as it is, becomes concentrated on the task. Time stands respectfully aside, and it is only after many hesitations that luncheon knocks gruffly at the door.

When I have had to stand up on parade, or even, I regret to say, in church, for half an hour at a time, I have always felt that the erect position is not natural to man, has only been painfully acquired, and is only with fatigue and difficulty maintained. But no one who is fond of painting finds the slightest inconvenience, as long as the interest holds, in standing to paint for three or four hours at a stretch."

Marling notes: "Churchill's insistence that art was cheap psychotherapy or a way of releasing pent-up feelings found some resonance in the 'splash and wallop' technique of the Abstract Expressionists." So the gulf in quality aside, maybe paint-by-numbers enthusiasts and abstract expressionists were not so far apart after all: both were affected, to a degree, by that same tension between social strictures and personal freedom. Both trafficked in the prospect of emotional liberation. That said, after Eisenhower got his fellow art hobbyist and world savior to agree to a traveling show of paintings (sponsored by Joyce C. Hall, of Hallmark, who had reproduced several of Churchill's pictures on his greeting cards), the exhibition toured the United States in 1958, even stopping at the Metropolitan Museum of Art, and it prompted Harry Truman to unburden himself of the view that Churchill's works were "damn good" because "at least you can tell what they are and that is more than you can say for a lot of these modern painters."

At the end of the day, like Truman, most Americans still had a taste for only so much freedom in art. Abstraction was acceptable when it took the form of asteroid shapes and squiggly blobs on the new Formica kitchen countertops; it was another matter with, say, Adolph Gottlieb, the abstract expressionist whose mysterious paintings of floating disks the masses found ugly or dismissed as too highfalutin or just

ignored. Churchill's and Grandma Moses' paintings were more broadly suited to popular taste. "Anyone can paint if they want to," said Moses. "All they have to do is to get a brush and start right in, same as I did." A generation later, Ross stole that line, more or less, and delivered the same sort of Americana, conforming in his pictures to age-old clichés about balanced compositions: trees on one side, mountain on the other, moonlit lake in the middle.

Eventually, Ross achieved cultlike status among an ironically inclined segment of Generation X by starring in a series of promotional spots for MTV. Soon thereafter he died, but he inspired an all-girl band in Germany to name themselves after him (Hello Bob Ross Superstar), while the Dutch christened a Bob Ross amaryllis. The Mr. Rogers of oil painting, as he has been called, has lived on, and even grown in popularity, not only via reruns but also through the preaching of more than fifteen hundred certified Bob Ross instructors, who have passed a three-week training course in Ross's wet-on-wet technique and spread his comforting, trouble-free gospel of oil painting. I heard one of the Bob Ross instructors on the radio not long ago, explaining how, after he had suffered an aneurysm, catching Ross's show changed his life. He trained to become an instructor. Ross, he felt, became "like a second father" to him. "He gave me this recovery," he said. The instructor taught a class in a rented room in the back of a pet store in Brooklyn that was lined with Ross-inspired pictures of dogs and cats. The shop's owner had enrolled his twelve-year-old daughter in the class, snippets of which were captured on the radio. The instructor lacked Ross's pacific voice but conveyed Ross's cunningly humble message of hope. Two hours later, her first painting done, the girl, beside her father, burbled with pride, announcing that

her picture was worthy of taking to her mother in the hospital. Sometimes, as Ross knew, the artistic value of a painting, as with a family photograph or any personal memento, is its least important quality.

Then again, to get back to where we started, sometimes it's not. I came across a snapshot that some anonymous amateur shutterbug took during the 1930s of a woman smiling at a camera, one foot propped on the running board of a car. In the picture, a man (with an uncanny resemblance to Marcel Duchamp, by the way) is looking toward the camera, too, his head sticking out the car window. I glimpsed this black-and-white gem in an exhibition of anonymous snapshots collected by Thomas Walther, at the Metropolitan Museum of Art, of all places. Who were these people in the picture? Source unknown, the snapshot becomes a talisman of evaporated memory that over the years probably made its way from the corner drugstore, where it was developed by a chemist, to a family album, where it was briefly cherished. Then, in the extraordinary way things happen, it may well have traveled from attic to Dumpster to flea market into the hands of some scavenging dealer-collector, whereupon it became an item on the art market until finally wending its way into the greatest art museum in the country.

It is a fair guess that this man, this woman, and their photographer would be surprised to learn, if they are still alive, that their memento made it to the Met, sharing wall space with Rembrandts and Monets. Whenever the picture was snapped, wherever that was, the man and woman peering into the sun, the photographer maybe fumbling with the shutter before asking them to say "Cheese!"—none of them were presumably motivated by the desire to create timeless beauty. They were like my family in the Soviet Union, just

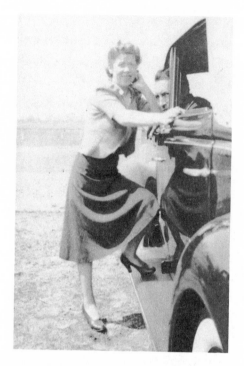

Anonymous

trying to save a moment. But the art in the photograph of those strangers and the car is there, plain as day. It is in the reflection of the woman's body on the car door. By some act of divine comic grace, the reflection happens to match up precisely with the head of the man so that he looks like the woman's ghostly, dwarflike double, a funny-surreal coincidence that, by adding a layer of unanticipated meaning to the picture, suddenly elevates it from ordinary snapshot to art.

Sometimes art works that way. It appears unexpectedly. It doesn't arrive through the front door. It sneaks in the back, the more startling for being the result of dumb luck. This picture would be less likable, I suspect, if we learned that a professional had planned it, because the amateur's fluke reminds us of a basic fact in life, which is always heartening:

that art is out there waiting to be captured, the only question being whether we are prepared to recognize it.

We have had the impassivity of Eastman's popular invention to help us locate it, fortunately. During the early days of his Kodak, which had no viewfinder, amateurs went around pointing the lens more or less in the direction of what they wanted to shoot and hoping for the best, which resulted in innumerable headless portraits and what Mia Fineman, a photo historian writing in the catalog for that Met show, neatly called "successful failures, pictures that sail past their intended targets and into the foggy ether of a different kind of truth." With luck, the amateur photographers captured what they intended; but often plenty of other things crept into the pictures, too. The amateur who pointed at a building behind a wrought-iron fence in another snapshot at the Met found a giant apple blocking the view. This accidental Atget could thank serendipity and the camera's wide lens for what turned out to be a far more intriguing photograph than just a view of a building, and presumably he (or was it she?) recognized good fortune because the picture was preserved, a minor act of artistic connoisseurship that has allowed it to come down to us. Since digital technology now permits people to delete mistakes before they are printed and to preserve images in computers rather than deal with deteriorating prints, like the one of me and Tamara in a Moscow hotel room, posterity is being deprived of who knows how many similar examples of creative artlessness.

The decades when black-and-white amateur photography dominated, from the Kodak No. 1 through the 1950s, were clearly the peak years for these sorts of accidental masterpieces, which overlapped, perhaps not coincidentally, with the heyday of surrealism, whose roots were in happenstance and error. It was also the era that included the so-called New

Vision photographers, professional camera artists whose unconventional viewpoints, weird croppings, and tendency toward mysterious imagery came from looking at all sorts of photo images—at scientific and journalistic pictures, at trick photographs and joke postcards, and especially at radical Soviet films. The results were often in psychic sync with amateur snapshots. One amateur bird's-eye view of a man tipping his hat that I have seen is serendipitously in tune with a famous work by the great Russian radical artist Aleksandr Rodchenko, which shares its extreme angle of vision of the same subject. An amateur photo shot straight down from atop the Eiffel Tower, the sort of tourist view millions of shutterbugs have taken without thinking much about it, except more vertiginous, duplicates almost exactly a classic picture by the Hungarian modernist André Kertész. A photo-booth joke shot of a woman with her back turned to the camera mimics the often-reproduced nineteenth-century photograph of a woman seen from behind by the otherwise little-known Onesipe Aguado, a modernist precursor. Coincidence? Not really. Consciously or by osmosis, amateur photographers have clearly absorbed the language of professionals, just as modern professionals (Walker Evans, Robert Frank, Harry Callahan, William Eggleston, Garry Winogrand, Lee Friedlander; the list goes on) have, more or less deliberately, tried to emulate the amateur's blithe innocence, immediacy, surrealism, and comedic charm. The difference between amateur and professional is not strictly between luck and intention. Professionals can get lucky, and amateurs may be very savvy. The point is that these categories can be constructively fluid.

That said, amateur snapshots are often appealing when we perceive their distance from, not connection to, professional art: mostly unpretentious, the amateur photographer expects little or nothing of the public, assuming at most an

audience of family and friends, thus leaving vast room for our ignorant conjecture about the pictures' messages, which is the beauty part. Strangers to these happenstance images, we are blissfully free to fill the space between what we see and what we know, an anarchic, unbridgeable gap. What is the meaning of the gesture of a woman in a tight-fitting dress on a suburban lawn bent over a panting spaniel? One hand out, index finger of the other hand pointed up, she is like a crooked John the Baptist directing us heavenward, a divine puzzle, decipherable only perhaps by dogs and the woman's descendants. Or what about the man seen from behind in hat, vest, garters, and boxers, earnestly ironing his pants? Or what to make of the photograph of a house being dragged on tethers through the water? It floats as if in the middle of an ocean, an apparition, inscrutable.

And then there is the snapshot of a man dangling from a zeppelin. The photograph is not a bad composition, formally speaking, two dark bands sandwiching one white, of the zeppelin, with the tiny figure of the man in the center. He is in

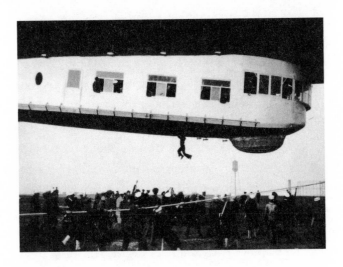

Anonymous

uniform, a German policeman: we can decipher that much from the silhouette of his bell-bottom pants and from the crowd of similarly dressed policemen below him. But is he on the way up or down? And how did he get there in the first place?

It turns out that this picture was taken at Hamburg airport, circa 1927. Because there were no moorings at the airport for zeppelins, the local police tried to secure this one by grabbing its ropes, but on a windy day it lifted up into the air anyway, taking the man with it. We know this because John Bing was there that day, as an eight- or nine-year-old boy, and he also saw a reproduction in the newspaper of the photograph at the Met almost three-quarters of a century later. It rekindled his memory and restored the picture to its original purpose as a private record of a particular moment. Absent Bing's memory, the image remains untethered.

The art critic John Berger distinguished photographs shot by strangers, including professionals—what he called public photographs—from private photographs, which we take for ourselves, and which stay with us and remain continuous with our memory. Public photographs "carry no certain meaning in themselves," Berger decided. They are "like images in the memory of a total stranger," lending themselves "to any use." The pleasure of displaying the anonymous snapshot, you might say, is that it makes a private picture public. I came across another amateur blunder, an extraordinary double exposure of a bedroom and a street. In this dreamlike overlap of scenes, bed lamp becomes streetlamp and streetlamps become bedposts and a streetcar chugs past the foot of the bed, where a tiny woman stands alone in the slanting sunlight. Where did this incredible picture come from? Who knows? It exemplifies a bigger truth about all

Anonymous

photographs, that by their nature they never tell us as much as we expect they will. Private pictures made public, like the zeppelin or the double exposure in the bedroom, disclose especially little except what they reveal to us about ourselves: what used to have the narrowest meaning to the person who snapped it (that's Uncle Burt as a boy catching a baseball; that's Edythe sitting cross-legged next to the burbling sprinkler on the lawn; that's me and Tamara smiling at my long-gone, beloved dad, who I'm sure was smiling back at us) becomes a Rorschach of our own imagination, which is how so much art operates. Trying to decipher these tiny mysteries, we progress from being voyeurs, which we always are when we look at other people's pictures, to excavators, combing our memories for what we may recognize from our own family albums, from our own lives. We look for us.

"No matter how artful the photographer," the critic Walter Benjamin once wrote, "no matter how carefully posed his subject, the beholder feels an irresistible urge to search such a picture for the tiny spark of contingency, of the here and now, with which reality has (so to speak) seared the subject,

to find the inconspicuous spot where in the immediacy of that long-forgotten moment the future nests so eloquently that we, looking back, may rediscover it."

So, it turns out, there is such a thing as artless art. It is waiting to be released by our Kodaks and our private memories—or at least we may hope so. The redolent snapshot is one in a million. You might bear this in mind before devoting a weekend to fishing through your own shoeboxes, in wallets, behind the sun visor of the car, wherever you keep your keepsakes, in the hope that one of those innumerable fading pictures you preserved over the years with your own Tamara in it might be worth shipping off to the museum or auctioneer.

Then again, who knows? The world is full of amazing surprises.

THE ART OF HAVING
A LOFTY PERSPECTIVE

PANTING AND EXHAUSTED on the top of the second mountain I had climbed in two days in France, waiting for an epiphany that didn't come, I realized recently how frustrating it can be to fail to see what others find beautiful. If, like most people, you have ever walked into a museum or gallery or looked at a picture in a magazine or newspaper and wondered how anything so ugly and lacking in taste had come to be considered art, you might recall the moment in 1917 when Marcel Duchamp acquired a porcelain urinal from a plumbing equipment manufacturer on lower Fifth Avenue in Manhattan, signed it "R. Mutt," and submitted the now infamous *Fountain* to the Society of Independent Artists exhibition, in which any artist who paid a small fee

could participate. The society, as he no doubt expected, found the urinal beyond the pale.

"You mean to say, if a man sent in horse manure glued to a canvas that we would have to accept it?" asked the artist George Bellows.

"I'm afraid we would," replied Walter Arensberg, Duchamp's patron and champion, who had shopped with him for *Fountain*.

Arensberg, perhaps with tongue in cheek, went on to defend the work aesthetically as "a lovely form," which was going too far even for Duchamp, who later said he was horrified that his readymades—machine-made, store-bought urinals, bottle racks, metal combs, bicycle wheels, snow shovels, and so forth—had come to be admired for their beauty. "I thought to discourage aesthetics," he said. "I threw the bottle rack and the urinal in their faces as a challenge, and now they admire them for their aesthetic beauty."

It was a challenge to the very idea of sculpture, which had until then been a representation of an object, a man-made transformation of material into an illusion, a spiritual adventure. The readymade was, well, just what it looked like. A urinal was a urinal. It didn't stand for anything else. And to grasp its meaning involved no special discrimination of taste, as traditional sculptures did. Duchamp had replaced the art of discrimination with art by designation. "I declare this snow shovel to be a work of art," he said, and so it was. Who was to say it wasn't? But for that matter, if someone were to say the shovel was beautiful, who was he to deny it?

Such became the world of modern art. By the early 1960s, Robert Morris was issuing a "Statement of Aesthetic Withdrawal," a typed document declaring his art independent from all considerations of "aesthetic quality and con-

tent," and Piero Manzoni, upping the ante of Duchamp's urinal, canned his own excrement and called it art. Beauty and taste were bourgeois and tepid. They dwelt in shallow pleasure. Good taste was about delectation, while real art had a higher intellectual purpose than just satisfying the senses.

Modern artists were in fact echoing a sentiment expressed in the early nineteenth century by Georg Wilhelm Friedrich Hegel, who wrote that the true depths of art "remained a sealed book to taste, since these depths required not only sensing and abstract reflections but also the entirety of reason and the solidity of spirit, while taste was directed only to the external surface on which feelings play. . . . So-called 'good taste' takes fright at all the deeper effects of art."

When the painter Barnett Newman added in 1948 that "the impulse of modern art is the desire to destroy beauty," he was going so far as to contrast beauty with the sublime. This impulse didn't entirely originate among modern Western artists with Duchamp, I might add. From Courbet and Manet to van Gogh and Gauguin, it was already a tradition. Picasso's introduction into his art of non-Western aesthetics—African, Oceanic—during the early 1900s further affronted Western views about what was beautiful and by implication raised the (to some people) alarming question, Is beauty even necessary to art in the first place? Or put differently, Is what Western eyes consider beautiful intrinsic to art? It is probably not coincidental that this affront to received aesthetics came from a clash of cultures. Immanuel Kant, to whom we owe much of our aesthetic philosophy and perception of beauty, saw engravings of tattooed native New Zealanders and announced that the tattoos did not enhance the beauty of the human figure. That was just one man's aesthetic opinion. It seems

never to have occurred to him that the tattoos may not have had an aesthetic purpose but were the consequence of a ritual or religious passage: through the painful process of tattooing, the tattooed New Zealander achieved power. What was a question of beauty to one man was something entirely different to another.

So how to define the beautiful? The ancient Greeks tried to come up with a rational answer. They devised a mathematical scheme for the proportions of the human body that set an abstract ideal of physical beauty, which had little to do with real life. As Kenneth Clark wrote, "It is widely supposed that the naked human body is in itself an object upon which the eye dwells with pleasure and which we are glad to see depicted. But anyone who has frequented art schools and seen the shapeless, pitiful model that the students are industriously drawing will know this is an illusion. . . . A mass of naked figures does not move us to empathy, but to disillusion and dismay." Art's job, at least until the modern era, was therefore to perform a kind of plastic surgery to make bodies look beautiful; as Aristotle put it, "Art completes what nature cannot bring to a finish."

Beauty thereby came to be associated with ideal form based on accepted proportions. But if it were only a matter of following mathematical formulae, beauty would be mundane, while in fact it is characterized precisely by its divergence from the norm and by its exceptional status. What is beautiful in artistic representations of the human body has not stuck to a single formula but varied: Albrecht Dürer's nudes differ from Michelangelo's, which differ from Picasso's, which differ from Lucas Cranach's, each artist having more or less distorted the classic proportions to create something that looks distinctive. The philosopher Francis

Bacon summed this all up by saying, "There is no excellent beauty that hath not some strangeness in its proportion."

So, on second thought, forget formulae. Beauty depends on individual expression. As proof, a few years ago, two ironic Russian artists, Vitaly Komar and Alexander Melamid, produced composite paintings based on surveys of what the public in various countries considered most beautiful. The results were kitsch and predictably awful, proving, in case anyone didn't already know it, that beauty, by definition, is irreducible to a common denominator.

So we're back where we started, with no clear answer to what is beautiful, except that we continue to assume certain things must naturally be beautiful. Nature, for instance—the Alps, Mount Fuji—nature is beautiful. And people have always thought so, right? Wrong.

Which returns us to mountain climbing. Mountains, which have inspired countless writers over the years, once caused the young Thomas Hobbes to try his hand at verse:

Behind a ruin'd mountain does appear
Swelling into two parts, which turgent are
As when we bend our bodies to the ground,
The buttocks amply sticking out are found.

Hobbes fortunately abandoned poetry for philosophy. I mention his minor and forgettable poem to stress that even mountains have not always been a source of reverence and awe. We take it for granted that since the beginning of time people have climbed them for pleasure and written paeans to their beauty, because we assume that our own responses to them are, like nature, eternal and natural. But this is not true. Throughout most of Western history, at least since the an-

cient Greeks, people felt unmoved and even repelled by mountains. The Romans found them desolate, hostile places. John Donne, reflecting the general attitude of his age, called them warts on the planet. Martin Luther believed them to be part of God's retribution for man's fall, an outcome of the Flood, before which the earth had been perfectly round.

In fact, our modern attitude toward mountains—to what we consider their natural beauty—is a matter of conditioned learning, inherited through literature and theology, which has evolved during the last few centuries to encompass a notion of the sublime in nature: we have been trained what to see and how to feel. The evolution of the whole modern worldview, including the notion of beauty, you might even say, is exemplified by the evolution of our feelings toward mountains.

I myself had, until recently, what you might call a second-hand sense of the power and inspirational character of mountains, gleaned mostly through the usual books. I'm neither a skier nor a hiker, and probably the closest I ever came to experiencing what the English writer John Dennis in 1688 called the "delightful Horrour" and "terrible Joy" of mountains was when I got lost, briefly, in the Green Mountains of Vermont as a twelve-year-old at summer camp. Recently, newspapers reported that some 1,600 people had so far reached the peak of Everest, following Sir Edmund Hillary and Tenzing Norgay, who first did it in 1953. You can understand why Hillary and Norgay went. The allure of the indomitable peak is, like all fresh earthly challenges, irresistible to certain intrepid souls, who get to boast that they have been where no one else has gone before them, one of the rarest of human experiences. Today sherpas prepare the ropes, ladders, and camps ahead of time so that their customers, tourist climbers, tag along—mobs of them assaulting Everest each year, enough to cause traffic jams and garbage

heaps on the mountaintop. Reaching the summit is still an astonishing feat, and tremendously dangerous, of course, but it is not what it was, and to a cynic it can now seem almost banal.

My own motivation for climbing Montagne Sainte-Victoire was, as modest climbing is for most ordinary people, mundane. Mild exertion, to which I am, like any healthfully slothful person, reluctantly resigned, was justified by the prospect of a pleasurable dose of cultural enlightenment. I imagined there would be a nice view. Sainte-Victoire is the modern-art exemplar of the mountain as sublime nature in the midst of civilization, thanks to the fact that Paul Cézanne painted it again and again. It overlooks Aix, a Provençal tourist magnet in summer but peaceable in winter, with a panorama at the top toward Marseille and the Mediterranean. I decided, having committed to the trip, to add another peak with an aesthetic pedigree, Mont Ventoux, which is not far away: it is the mountain that Petrarch climbed in the 1330s, when few people would have thought to climb a mountain just because it was there. Ventoux is higher and harder to climb than Cézanne's mountain, enough to have inspired Petrarch to leave behind a description of mountain climbing that has become a premodern classic of what is now fashionably called environmental writing. Something of the history of Western man's shifting perception of mountains is encapsulated in these two legacies, and I wondered what it would be like to see what Cézanne and Petrarch had seen.

So not long ago, just before winter set in, I bought my first pair of hiking boots, at Harry's Shoes on the Upper West Side of Manhattan, packed a bag, and flew to France. Petrarch had gone up Ventoux with his brother, and Cézanne walked with Emile Zola up Sainte-Victoire. I realized I ought

to have a companion, too, and so enlisted my friend Alan, a middle-aged Englishman, raised in Brazil, who lives with his Dutch wife in Paris, and whose greatest exertion in recent years, as far as I knew, had been teaching me the fine points of selecting and lighting good Cuban cigars. Alan is dashing, energetic, and game, but not since the Profumo affair has he been in racing shape, which made him an ideal partner, because I could be fairly sure he wouldn't abandon me on the mountain.

He, in turn, brought Daphne, a gorgeous and capable French colleague and friend of ours who cleverly arranged for local guides, and so late one clear, pleasant, windy morning we met Daniel, our guide for Sainte-Victoire, at a café in the town of Vauvenargues, at the base of the mountain opposite Aix, where we stocked up on coffee and pâté sandwiches. Daniel, a wiry, weathered, sleepy-eyed Frenchman of about forty, was dressed in running shoes, a light sweater, and a windbreaker, as if he had just happened on the café while out for a Sunday stroll, which, at 3,316 feet to the peak, Sainte-Victoire is for any self-respecting hiker.

We, on the other hand, utterly clueless, had planned for polar conditions. Alan wore giant spanking-new orange hiking boots and multiple layers that included a double-breasted, brass-buttoned navy blue blazer beneath his vast overcoat, making him simultaneously prepared to climb the mountain and to enjoy *rougets au fenouil et kumquats* at Troisgros when he came back down. I had on my new boots, new gloves, a heavy sweater, a coat with wool lining, and a wool hat. Only Daphne was sensible, with a sporty scarf and light parka. Puffing on a cigarette, Daniel regarded us with undisguised pity as we set out on our little expedition, following sheepishly behind him.

He led us up what I presume was the path that Cézanne took with his friends Achille Emperaire, the sculptor Philippe Solari and Solari's son Emile in 1897, the last time, it seems, that he climbed Sainte-Victoire. He was fifty-eight. The route rises through thickets of pine and rosemary, and then opens onto a vista of the Bimont and Zola lakes before weaving along a craggy switchback toward an old abandoned monastery beneath the Pic des Mouches, which is the mountain's highest point. The monastery is nestled in a cleft that ends at a ledge overlooking the steeper side of the mountain, the side Cézanne mostly painted. A sign warns you against walking onto the ledge, which is narrow, slippery, and dangerous when the mistral, the strong seasonal wind, kicks up in the afternoon. But from it you get a clear view, beyond the ugly stacks of a huge power station, toward Marseille and the sea.

I sidled onto the ledge, trying to look nonchalant, although Daniel said that the winds were now gusting around sixty miles per hour, which seemed an exaggeration but not a big one. Partly I had ventured there out of humiliation: after having huffed my way up to the monastery, I found myself face to face with a group of elderly Frenchwomen, lightly dressed, unwrapping finger sandwiches, calmly enjoying an outing in the countryside. Half of them, I noticed, were carrying canes. Peering from the ledge down a thousand feet or so toward a jumble of boulders, I remembered at that instant having read what Heinrich Heine said about climbing Ilsenburg, in the Harz region of Germany, where the legendary Princess Ilse supposedly lived: "I advise everyone who may hereafter stand on the summit of Ilsenburg to think neither of emperor and crown, nor of the fair Ilse, but simply of his own feet." Accordingly, I tried to take in the view as best

I could while remaining fixated on my untied shoelaces. Then I essayed some slightly tricky scrambling over rocks— tricky only because of the wind—to get to a lookout post, an open cement booth covered with Russian graffiti, on the very top of the mountain, above the monastery. I sat down on the peak and surveyed the territory below.

I am aware that ecstatic accounts of mountain vistas have become hopelessly clichéd at least since Samuel Butler made fun of poor George Pontifex in *The Way of All Flesh* for gasping in knee-jerk rapture at Mont Blanc. So let me simply say that the panorama was pleasant—not more, not less.

What became a cliché in literature also became a cliché in painting in the nineteenth century. Caspar David Friedrich's spectacularly suave and rapturous views from mountaintops exemplified romanticism's radical elevation of landscape painting to a status previously occupied by religious painting and epic poetry. In America, mid-nineteenth-century painters gave a certain parochial spin to this new equation of landscape, and in particular of mountains, with the sublime. Nature, being abundantly present in the vastness of the American West, was said to express God's infinitude. From there, it was only a short leap of faith for many Americans to conclude that Manifest Destiny was a matter of Christian duty and divine right, a viewpoint self-consciously underscored in the mountain paintings of Frederic Church and Albert Bierstadt.

By Cézanne's time, painting a mountain had already be-come a familiar device. He recognized this, and it's signifi-cant, I think, that he chose to paint views of his mountain but rarely the views from it. He must have realized that the view from it would have seemed too much like every other mountaintop view, which had lost its power to surprise us be-

CASPAR DAVID FRIEDRICH, *Wanderer Above a Sea of Fog*

cause it had become so commonplace in art—but also that the view of the mountain could still be distinctive, like a portrait, and that beauty derived from the particular, not the general. Moreover, the mountain, for Cézanne, was not something to be overcome but something that simply existed; it was always there, hovering like a divine presence in the background: Cézanne, you might say, took it for granted that we would see even his modest mountain as a manifestation of the godly sublime. If his Sainte-Victoire paintings are

on one level religious works, they are modern religious works of the most intensely private, introspective sort.

Descending from the peak, Daniel guided us to a hollow. We reclined on some rocks, letting our ears thaw out where the wind couldn't reach us, until the sun began to fade. On the way down I noticed the same late-afternoon burst of red light, like an erupting flame at the instant before it is suddenly extinguished, that Cézanne had occasionally painted. "Look at Ste.-Victoire," he once told a friend. "What imperious thirst for the sun, and what melancholy in the evening when all that weight sinks back. Those blocks were made of fire. There's still some fire in them." For a second, I saw what he meant. It had taken rather a lot of preparation and exertion, but I had my Cézanne moment. Sometimes a moment is all you get, but it can be enough.

THE NINETEENTH-CENTURY American landscapists saw beauty as intrinsic to mountains, which is to say natural, because they thought God spoke directly through nature. But if beauty is actually in the eye of the beholder, then it is not a matter of nature or science or something that can even be easily named. People have the ability to see that something, like a mountain, is beautiful or they do not, in the same way that you may describe in great detail a piece of music to a deaf person, and that person, despite having rationally absorbed what you have said, will still never quite know what the music sounds like. Meanwhile, real beauty in art cannot only be a quality intuitively recognized, something plain on its surface, because then it might be shallow. The philosopher and art critic Arthur Danto has made the point that beauty, if it is not to be solely decorative, should also have a deeper rationale for being in art; it should be intrinsic to the

meaning of the art. The beauty of Robert Motherwell's abstract *Elegies to the Spanish Republic,* memorials to the republic's brutal defeat in the Civil War of the 1930s, is, as Danto perceives it, germane to "the way we respond to death—associating the dead with flowers, reading poetry, listening to the deceased's favorite music." Beauty has a function in Motherwell's art, a reason for belonging.

Danto's theory implies that beauty, which for our purposes could include an aesthetic appreciation for the sublimity of mountains, requires an effort of decipherment on our part to grasp its deeper meaning. Danto, where he cites Motherwell, also quotes the philosopher David Hume, who separated natural beauty from beauty in art, saying that natural beauty just hits you in the face—it is plainly there, and if you fail to recognize it, too bad, no rational explanation of nature's beauty will redress your failure—whereas beauty in art depends on reasoning and critical analysis: people may come around to seeing beauty in art through reasoned argument. No doubt Walter Arensberg saw the beauty of the urinal in part because he came to love the beauty of Duchamp's idea of the readymade. Many Berliners who at first loathed Christo and Jeanne-Claude's plan for wrapping the Reichstag thought it was beautiful once it was done, not just because it looked like a shimmery gray gift package the size of a city block, but because they appreciated the symbolism of turning the new seat of a reunified Germany into a chrysalis and then unwrapping it.

It occurred to me that, having enjoyed the mountaintop but not felt an epiphany on it, I was perhaps in need of further rational enlightenment. Notwithstanding what Hume said about nature's beauty hitting you in the face, all deep understanding of beauty may in fact be acculturated. Back in Vauvenargues, we thanked Daniel, packed up, and drove a

couple of hours north to a *chambre d'hôte* outside Malaucène, the town from which Petrarch had started his ascent up Ventoux. We planned to climb it the next day, weather and our aching thighs permitting. A farmhouse with a small vineyard that was invisible on a starless night, the *chambre d'hôte* belonged to a young family. We were the only visitors. I was given the attic, which had a desk, a mattress on the floor, a space heater, and a tub but no hot water. It was cold. I was assured by our hosts, as I desperately fiddled with the space heater, that I would have a good view of the mountain peak from my window when the sun came up. I couldn't miss it, they said, because after a recent storm it was now covered with snow.

They were right. The following morning the weather was crystal clear and cool, so we had no good excuse to avoid climbing. We met Thierry, our next guide, for an early start, Ventoux being, at 6,263 feet, twice as high as Sainte-Victoire. Thierry, younger and more talkative than Daniel, was a local, so he kept us constantly updated about the passing flora. We paid intermittent attention. Our trip began gruelingly, over steep, sliding stones for what seemed like hours but was probably twenty minutes, before we arrived at a dirt path through thick woods. We were already bushed and had hardly begun.

Our route next cut across a shale cliff, the effect of which was like walking diagonally through space: the world seemed wildly tilted. We paused, two-thirds of the way up, to lean against a tree in the sun, munch butter cookies, drink sweet tea, and gaze at the Alps. This was the first true feeling of awe I had had so far, and I nerdishly fished out some photocopied pages of Petrarch from my backpack. "I stood like one dazed," he wrote. "I beheld the clouds under our feet, and what I had read of Athos and Olympus seemed less in-

credible as I myself witnessed the same things from a mountain of less fame."

Petrarch was not the first man in his day to climb a mountain for the sake of the climb. German writers in the tenth and eleventh centuries described various ascents, and Jean Buridan, a Parisian, left an account of climbing Ventoux early in the fourteenth century, just before Petrarch. But Petrarch wrote more extensively and better about the experience than anyone before him. His account is full of aesthetic gratification. Hence mountain climbers regard him today as sharing their outlook, though his work compels a more nuanced interpretation: at the moment of his deepest satisfaction, on top of Ventoux, he is overcome by doubt. As he tells it, he picks up his copy of Augustine's *Confessions,* which he has taken along, as I had taken along his writings, and by chance, he says, his eyes fall on a passage chastising people who wonder at "the heights of mountains" when they should recognize God's presence in humbler circumstances. "I closed the book, angry with myself that I should still be admiring earthly things, I who long ago should have learned from even the pagan philosophers that nothing is wonderful but the soul. I was satisfied that I had seen enough of the mountain, I turned my inward eye upon myself, and from that time not a syllable fell from my lips until we reached the bottom again."

So beauty, to Petrarch, is ultimately a spiritual matter as well as circumstantial. Having polished off our tea and cookies, Alan, Daphne, and I trailed dutifully behind Thierry to reach the final leg of the climb, a long hike across a switchback through ice and thick snow. A few small pines and plants broke the white carpet. The name Ventoux derives from *vent,* the French word for wind, which, when it gets going up there,

can blow you out of your boots, but it wasn't bad on this day. I slogged ahead of the others, desiring less to be first to the top than to get the whole thing over with as soon as possible. One turn led to another and another and another, and the path never seemed to end, even though, for the longest time, the summit looked as if it were just a few feet away. Then, finally, I hoisted myself up onto—a paved highway.

At the top of Ventoux are a military outpost and a restaurant, which was closed. There was, I felt, something deflating about trekking six thousand feet up a mountain to dodge civilization, only to be passed by cars at the summit.

This odd anticlimax made me wonder, once more: Why, since awe wasn't always an expected response to mountain peaks, has our attitude toward mountains changed? We are inclined to attribute the change to urbanization and the conquest of nature: as cities grew, enhancing by contrast the appeal of the countryside, and as travel became easier and less dangerous, mountains came to seem less forbidding and more enticing. Fear gave way to pleasure. But this isn't altogether accurate historically. Crossing the Alps wasn't much safer for Horace Walpole in 1739 than for Thomas Coryat in 1610, but by the time Walpole crossed the Alps, terror had become part of a new aesthetic experience, exemplified by mountain climbing. Awe and fear were supposed to mingle with joy. Kant defined the experience as "the terrifying sublime," which is "accompanied by a certain dread or melancholy." This was a change. The Old Testament says, "Every valley shall be exalted, and every mountain and hill shall be made low." For centuries in the West, the Bible's embrace of the lowly mixed with a classical belief in proportion and balance. Mountains were irregular and wild. The transformation of attitudes therefore had to involve a renewed appreciation for vastness and asymmetry in nature.

And this began to happen, as the historian Simon Schama has noted, when optics, mineralogy, geology, and astronomy provided a new, enlarged view of the universe. The change is best summed up by the scholar Marjorie Hope Nicolson in a classic work on English mountain literature, *Mountain Gloom and Mountain Glory*: "Awe, compounded of mingled terror and exultation, once reserved for God, passed over in the 17th century first to an expanded cosmos, then from the macrocosm to the greatest objects in the geocosm— mountains, ocean, desert."

For Petrarch and Cézanne, of course, size itself was never the issue. Mountains were, to them, metaphorical as much as they were physical. We, on the other hand, have lately come to view them as recreation. They're now like glorified Stairmasters for the upwardly mobile. Jon Krakauer's *Into Thin Air* encapsulates our current state: even Everest retains its grandeur only as a stage set for absurdly perilous commercial escapades. For my part, the experience atop Ventoux was enjoyable but, like the experience atop Cézanne's Sainte-Victoire, not sublime, and the reason, I came to realize, may partly be that the ante has been raised. We can all, of course, still feel something like the sublime in nature. I recall a rush of excitement at the sight of an approaching squall on the Great Salt Lake on a perfect summer afternoon. The natural sublime is not inaccessible to us. But when climbing even the most remote mountains in the world becomes a package tour for rich hikers, then the experience of nature may have too little of the mystery and divine terror that Kant talked about; it can become like a drug, the dose of which must be increased constantly to maintain the illusion of a feeling of profound emotion. Until the early 1970s there was actually an auto race to the top of Ventoux, and to this day the Tour de France occasionally includes a nasty stage up the moun-

tain. It is, I am sure, a heroic feat to reach the summit on a bicycle. But would you call it sublime?

From the peak, while Alan used his cell phone to call his wife in Paris and his son in London, assuring them that he was still alive, I wondered if anything had replaced the mountain as a new paradigm of sublimity. It almost seems odd to talk about the sublime today. We are programmed now to expect awe in certain circumstances, and are therefore doomed to be disappointed when, inevitably, we don't feel it. It is the disappointment that many tourists experience when they go to see the *Mona Lisa,* a sublime painting, encased behind protective glass. This is because when nothing is truly strange or foreign any longer, everything having been predigested, we then demand to be shocked, shock being an experience that still seems genuine to us. Thus we mistake shock for awe.

Perhaps it is expecting too much now even to associate the word *sublime* with outings in nature that most people undertake simply for a little pleasure and exercise, with no grander ambitions. Maybe only those who engage in extreme sports, risking their necks doing crazy death-defying stunts, filtering natural beauty through excessive bodily strain, are hunting for the "terrifying sublime," without their necessarily putting it that way. Or maybe the natural sublime resides today in huge photographs like the panoramas by Andreas Gursky and Thomas Struth, vistas of cinematic glamour so eye-poppingly, almost unnaturally gorgeous that they seem unsettling, the camera being another kind of filter. Call it the new technological sublime, which lasts only until the technology becomes commonplace or obsolete, as it swiftly and inevitably does. In these temporarily awesome vistas we may be reminded how small we are in nature. Art becomes our entrée to the sublime. It illustrates that beauty is not something sta-

tic and predictable and always there at the top of a mountain, but an organic, shifting, elusive, and therefore more desirable goal of our devotion, which we must make an effort to grasp.

Alan and I lingered briefly on top of Ventoux. It was getting late. By a different route, we marched down the mountain as quickly as possible. The walk seemed increasingly harried as darkness fell.

THE ART OF MAKING ART
WITHOUT LIFTING A FINGER

O N A FRIGID January morning in 1995, the body of Ray Johnson was found floating in the waters off Long Island, hands crossed over his chest as if he were drifting on his back in a swimming pool. The previous evening two teenagers heard a splash off the Sag Harbor bridge and, in the darkness, made out the figure of a man bobbing in the cove, then calmly swimming out to sea. It was Johnson, executing his final and most mysterious work of art.

Life itself might be a work of art. That has been one of modern art's most radical propositions. In the middle of the nineteenth century the ever-prescient Walt Whitman declared, "All that a person does or thinks is of consequence." He thought the United States itself was "the greatest poem,"

and that "the majesty & beauty of the world are latent in any iota of the world." He added, "I do not doubt there is far more in trivialities, insects, vulgar persons, slaves, dwarfs, weeds, rejected refuse, than I have supposed."

Susan Sontag, a century later, in response lamented how many modern artists had taken up Whitman's "program of populist transcendence, of the democratic transvaluation of beauty and ugliness, importance and triviality" by fixating only on "discontinuity, detritus, loneliness, greed, sterility." She was thinking of artists like the photographer Diane Arbus, missing Arbus's essential humanity and tenderness. But there has also been a different strain of modern art that embraces Whitman's upbeat view regarding the real. Certain artists have optimistically imagined art to be a state of mind, something that might just reside in our heads. It might be the way a person acts and speaks. Andy Warhol was Andrew Warhola's master-piece. Joseph Beuys, a kind of self-designated shaman who created a private mythology of his past as a Nazi pilot and gave eccentric lecture-performances, made an art of playing Pro-fessor Beuys. He declared, not unlike Whitman, that "the en-larged conception of Art includes every human action." On yet another plateau of fame, Yoko Ono, who was a clever, iron-willed artist before she became Mrs. Lennon, made her mar-riage into a kind of public art performance with their mutual "bed-in for peace." "Conceptual art is not necessarily logical," noted Sol LeWitt, one of conceptualism's founding figures.

Neither is life, of course, and we may learn from these artists something about how to conceive of our own ordinary existence—about how to live, and die, more constructively or at least alertly. Ray Johnson, who was fascinated by LeWitt, once told a friend, "I like to say that I'm the ocean, and like the tide, I mash up everything." His death on January

13, 1995, at the age of sixty-seven (6 + 7 = 13, Johnson's friends noted, knowing his numerological bent), became his chef d'oeuvre, or best-known work, which was curious, since his life was otherwise fairly unobtrusive. Though hardly a recluse, he lived by choice—or so he claimed—on the margins, quietly devising mischievous little collages and other eccentrically elegant and zany objects he squirreled away in his nondescript suburban house or disseminated to friends and strangers via the U.S. Postal Service. Considering that Johnson coolly calculated everything he did—as if all of life were a game, played by peculiar rules only he understood—the impression left by his death must surely have been deliberate on his part. And if that makes him, and by extension his work, more mysterious and even slightly creepy, this was also in keeping for a man whom even his closest friends regarded as a permanent puzzle. The sculptor Richard Lippold, who was Johnson's lover for many years and probably knew him as well as anyone, said when Johnson jumped off the bridge, "Now that I think of him after his death, I don't think I really knew who he was. It's very hard for me to say that. But who was this man? He kept so much of himself to himself."

Johnson was a kind of whiz as an artist, a man of fastidious and arcane temperament, with a voracious appetite for information and gossip, for whom the world was made up of amazing coincidences, serendipities, and karmic gags, all of which inspired his art. It consisted of mailed photocopied drawings and assemblages of found images—collages, elaborate, visually punning, and clever—stuffed into envelopes, often customized for particular people and conceived to be chain letters with little instructions to be followed, if the recipient so chose, and then passed on. He sent out thousands of these, as he did invitations to shows that weren't taking

place at galleries that didn't exist, which he named Wood-pecker or Willenpecker.

At around 3:55 on that January afternoon, Johnson tele-phoned his old friend William Wilson (there are thirteen let-ters in Wilson's name, Wilson himself later noted). Johnson told him he was going to perform a "mail event." On previ-ous occasions Johnson talked about the drowning of Hart Crane and how Tennessee Williams had wanted his own corpse dropped into the sea where Crane drowned. Johnson was also fascinated with messages in bottles, dropped into the ocean like letters into a mailbox. He sometimes threw bottles with messages into the waters off Long Island and tossed small wrapped packages off the Staten Island ferry. Who knows what was in them? He thought a body floating in water was beautiful, he once told Coco Gordon. In recent months he had written cryptically to his friend Jon Hen-dricks about both death and the impending prospect of his most important work ever. Johnson checked into Room 247 (2 + 4 + 7 = 13) of the Baron's Cove Inn at Sag Harbor Cove (both of which total 13 letters). Maybe he asked for the room because of its number or maybe not. Maybe it was the only room available. He wrote "New York Correspondance School" (he often deliberately misspelled it), his made-up ti-tle for his mail art enterprise, in the inn's registry.

He stayed about ninety minutes. He had nothing with him. He made no phone calls, having already called the people he wanted to speak with during the previous weeks—no one knew his call was a farewell until later, of course. Shortly before 7:00 P.M., he drove about one minute from the inn to a 7-Eleven. He parked his old Volkswagen in the park-ing lot and climbed onto the bridge's walkway. The two teenage girls who heard the splash remembered it being

about 7:15. The numbers add up, but the girls aren't certain about the time. After that, they saw a man backstroke in the cove. The temperature of the water was 39 degrees; it would have taken between fifteen minutes and an hour for hypothermia to set in.

As a young abstract painter studying with Josef Albers at Black Mountain College in the late 1940s, Johnson had first realized that by doing pretty much the same thing over and over, with minute variations, as Albers did, he could achieve remarkably different effects. He had gifts for color, shape, and design—he could have stayed an abstract artist—but he was more fascinated by mundane materials, pop artifacts, and Zen-derived chance effects, the sorts of things that interested John Cage and Robert Rauschenberg, who were also at Black Mountain.

So collage became his principal medium. He used shirt cardboard, newspaper clippings, and Elmer's glue. He loved finding puns, anagrams, palindromes, rhymes, slips of the tongue, and visual and verbal jokes. Gertrude Stein became his ancestral soul mate. Warhol and Joseph Cornell became his friends, although unlike Warhol, Johnson made art that was not big and glossy. Over the years, Johnson recycled, chopped up, and modified his collages, as if keeping them in a constant state of possibility and flux, and they accumulated more and more obscure and hermetic meanings along the way. By the end, his art became a dense, private code, sometimes morbid and occasionally, like his death, painfully hard to fathom.

The morning after he jumped off the bridge, Johnson's body was spotted. He had $1,600 in his wallet, which surprised many people who knew him because it was widely assumed he had no money. For years he said he lived on rice. In

THE ACCIDENTAL MASTERPIECE

fact, he was simultaneously obsessed with money and put off
by it. He composed ghostly silhouettes of hundreds of
people, including Mort Janklow, the literary agent, who has
recalled the time Johnson suddenly asked to do his portrait,
then made twenty-six collages based on his silhouette.
Johnson began a negotiation with Janklow over the price
that dragged on for years and became as comical and byzan-
tine as some of the collages, which was evidently the con-
cept: everything, including wrangling over money, was
fodder for Johnson's art. First, Janklow recalled, Johnson
asked him for $42,200, a curiously precise number, then
halved the price, then offered eighteen collages plus an unre-
lated work for $13,000, or all twenty-six for $18,232, with a
different work thrown in along with portraits of Paloma
Picasso and the king of Denmark added on top of some of
Janklow's silhouettes. The negotiations came to nothing,
naturally, except that, in the retelling of the story, they joined
the collages, as Johnson had no doubt intended, to become
part of the art.

Another time Johnson rented a helicopter and dropped
sixty foot-long hot dogs over Riker's Island, sending the bill
to his unsuspecting dealer, Richard Feigen. Johnson ex-
plained that he had been tracing people's feet, which brought
to his mind foot-long hot dogs, as if that explained any-
thing. For decades, Johnson hemmed and hawed about an
actual show at Feigen's gallery—until just before his suicide.
He would do nothing, he told Frances Beatty, the gallery's
vice president. Because Johnson called his performances
"nothings"—his version of 1960s "happenings"—it wasn't
clear to Beatty whether he meant that he would do a nothing
or would do a show that had nothing in it, or just do noth-
ing. What was clear was that nobody was likely to make a

dime out of the occasion. Johnson wouldn't allow money to be a measure of his value, only of somebody else's character. When the artist Peter Schuyff, a friend, haggled over the price of a Johnson collage, offering three-quarters of the amount Johnson asked, Johnson literally cut one quarter out of the picture and sent Schuyff the remaining three-quarters. Johnson took some collages to Harry Abrams, the publisher, who agreed to buy ten of them for $100 each, a fair price at the time, but then Abrams asked him to throw in an extra—not an unheard-of request. Johnson felt so humiliated that he wept afterward.

But it turned out that he had $400,000 in the bank when he died, an inheritance from his relatives. He was content for people to think that he led what he described to Grace Glueck of *The New York Times* in the 1960s as "a life of deliberate poverty." It was part of the outsider image that he cultivated for himself, which ensured a certain measure of insider fame. In 1968 Johnson decided to leave New York City, after he had been mugged at knifepoint and Warhol was shot. He settled into a nondescript little suburban split-level in Locust Valley, New York, a white house he perversely called "the pink house," about as remote from the art world as he could be—or to be precise, exactly as remote as he chose to be. Few people were allowed to visit him, although he kept in touch with hundreds of people by mail and by phone, people who may have seen him rarely or never, and often did not know one another, or much about him. He was a kind of recluse about town who always needed to be in touch, but many of whose relationships remained oblique and ephemeral, like his art, because, in the end, they were his art. "It takes a lot of time to be a genius," Gertrude Stein once said. "You have to sit around so much doing nothing, really

doing nothing." But Johnson kept very busy, in his way. When a man in Philadelphia announced that he had predicted the death of Elvis Presley, Johnson phoned him and began a correspondence. It lasted precisely until Johnson decided it was over. It was another performance with a limited run. Even Bill Wilson, to whom he was as close as anybody for years, visited Locust Valley only with the policemen investigating Johnson's death.

They found no suicide note. But the house, which was a Chinese box of shelves and boxes meticulously arranged, turned out to be an elaborate riddle Johnson had left behind. Beneath a poster conspicuously protruding from one shelf was a green box containing collages with texts, including one about a certain Andrea Feldman, who "plunged to her death." "No one takes me seriously because they think of me as a joke," the text quotes her saying, then goes on, citing an unnamed source: "But Andrea was loved, and you can see this by the shocked expression on the faces of her friends who cannot believe she came to this."

Upstairs, all the art had been deliberately turned to the wall, except for three portraits of Johnson, including a large photograph of him by Chuck Close, which was leaning on the floor, not at eye level, but at foot level—"a feeting, as in the foot-long hot dogs" dropped from the helicopter, Wilson later ventured—creating a shrine to Johnson and a spooky joke: Johnson's last laugh.

It has been said that Johnson threw himself off the bridge because he never received the recognition he wanted—because he was tired of being famous for being unknown. In a film made about Johnson after his death, Close tells a story about being asked to organize a show of portraits from the Museum of Modern Art's collection, during which he noticed that the museum had no portraits by Johnson. He called Johnson,

who, Close believes, would "be goddamned if he was going to put himself in a position where they were going to reject him." So Johnson found an alternate route: he mailed works to Clive Philpot, the museum's librarian, who Johnson knew would keep them in the museum library's archives, because Philpot didn't throw artist correspondence away. Johnson thereby insinuated his portraits into the museum's collection through a loophole.

Who knows why anyone chooses a particular moment to die, and with Johnson, why (was he physically ill?) may be less interesting than how. All the numerology, the sniffing for clues and connecting of dots, may be silly speculation, but this is the collagist mindset, which Johnson's art inspires. Collage, after all, is about piecing things together. It is also about accretion: elements can forever be added or altered; a collage to which more and more is done may become turgid and unattractive, or newly beautiful. Either way it remains a single collage. Elements join and become a whole: one plus one equals one. Near the end of his 1987 movie monologue *Swimming to Cambodia,* Spalding Gray, who committed suicide by jumping off the Staten Island Ferry and who earlier tried to kill himself by jumping off the same Sag Harbor bridge that Johnson jumped off, talks about finally achieving a "perfect moment" in the water off a beach in Thailand. Overcoming his fear of waves, currents, and sharks, he swims farther and farther out until "suddenly, there is no fear, because there is no body for sharks to bite, there are no more outlines, there's no 'me.'" He and the ocean became one. I found this related passage by Wilson in a book about Johnson: When Ray dropped himself from a bridge, Wilson wrote, "he was sending a message as he surrendered himself to oceanic absorptions which would overwhelm differences, at last losing his consciousness, which was necessary because

consciousness is what kept him from being at one with the Cosmos as he understood it."

Wilson added, "One drop plus one drop equals one drop."

RAY JOHNSON, *Unititled (Water is Precious)*

BUT WE HAVE BEEN dealing with the art of a death, a somber topic, whereas for Johnson life was an art. "Art has been veritably invaded by life, if life means flux, change, chance, time, unpredictability," the American sculptor Scott Burton observed during the 1960s, Whitmanesquely. "Sometimes the difference between the two is sheer consciousness, the awareness that what seemed to be a stain on the wall is in fact a

work of art." Art on one level already may be a state of mind. Of course it is first of all a physical object with which we interact in the moment. But after we have seen a work, what do we take away except a memory of it? And memory is thought, a mental seed planted by the artist, which is reproduced in as many different variations as the number of people in whom the memory exists. What makes art good is partly its power to proliferate as a variable memory, an intangible concept, filtered through individual consciousness. We instinctively associate touch with art, although we call architects artists, good ones anyway, even though they don't lay bricks. Composers are artists who write music that other people play. Sculptors and painters have always employed assistants who wield chisels and brushes, but we still call a Rubens a Rubens if his assistants worked on the picture, so long as he claimed to have had some hand in it. During the Middle Ages, as the art historian Hans Belting has pointed out about objects of religious reverence that we now consider works of art, images were often more prized for being unconnected with the touch of an artist's hand. The veil of Saint Veronica would have lost its luster if Jesus's face were proved to have been printed by an artist, rather than impressed miraculously through contact with Christ. Personal handiwork was naturally less significant than spiritual power, which transcends aesthetics and logic. Visual culture, even much of what has ended up in art museums, has of course never been solely about aesthetic quality. In the Philippines, enraged citizens destroyed billboards of Marcos; Soviets tore down statues of Lenin; Americans in Baghdad helped topple a statue of Saddam, then Iraqis burned stuffed and painted canvas dummies of President Bush in effigy. Ancient Egyptians lopped noses off despised pharaohs' statues, lest the sculptures breathe in the souls of their subjects and thereby

give them sanctuary. Ancient Greeks, the historian David Freedberg reminds us in *The Power of Images,* used to chain statues to prevent them from fleeing, while Buddhists in Ceylon believed that a figure in a painting could be brought to life once its eyes were painted.

Call it aura. Art always has had to do with aura—spiritual aura in the past, individual aura in modern times—and this applies not just to visual art. Religious music, for example, was written to express piety and honor the church. Court music was composed to compliment the king. But in the modern era, secular symphonies arrived. What were they supposed to celebrate? The temperament of the composer. As the pianist Charles Rosen has written, pure instrumental music came to have "its own law, its own reason for existing: it [was] produced by the artist not for a purpose but because he must—out of an 'inner necessity.'" Which is to say that the new musical artist sought to make a living by selling his soul—his individual sensibility.

For visual artists, this sensibility came to be most commonly measured by touch. The Industrial Revolution, providing machine-made objects to the masses, distinguished touch even further as a virtue. "The artist's touch became the basis of aesthetics and connoisseurship," as Arthur Danto has put it. And it was against this backdrop that Marcel Duchamp bought his machine-made objects like shovels and urinals, signed them, and declared them art, and thereby did more than just question traditional standards of beauty; he challenged the prestige of the handmade. Duchamp was upending the notion of art as an object of physical and material distinction, individually put together. It was a short step from the urinal to Duchamp's bottling of Paris air and calling the "empty" bottle a sculpture. If bottled air were art, the only question left was, What was art not?

Soon Robert Rauschenberg was erasing a drawing by de Kooning and declaring this act to be its own work of art. Yves Klein was inviting Parisians to an opening of an exhibition at which there was nothing to see. He called the show *Le Vide* (The Void), and a mob of 1,000 people jammed the empty Iris Clert Gallery, spilling onto the surrounding streets (the police and firemen had to be called in), drinking special blue cocktails, a mixture of gin, Cointreau, and methylene blue mixed for Klein by La Coupole, the famous brasserie, which caused the urine of drinkers to turn blue for about a week, roughly the planned run of the show. A visitor who refused to brave the crowd and didn't get the point of the whole event yelled to Klein from the door of the gallery, "I'll be back when this void is full." Klein shot back: "When it's full, you won't be able to come in."

A global farrago of other artists—Warhol, Ono, LeWitt, Claes Oldenburg, Lygia Clark, Hélio Oiticica, Allan Kaprow, Robert Irwin, George Brecht, La Monte Young, Nam June Paik, and many, many more, including the sly Gutai group that included Atsuko Tanaka, who once devised and wore an "Electric Dress" with wires and flashing colored lights, in which she paraded around Japan—also conceived of art as potentially something other than an object made for a pedestal or a wall and passively contemplated. It might be a collective enterprise, a happening. Everyone, and anyone, might participate in making a work of art. John Cage, famously sitting at a keyboard for exactly four minutes and thirty-three seconds, doing nothing much except occasionally opening and shutting the piano lid to suggest the breaks between movements of a composition, upset the standard of a serious musical performance involving a player actively making sounds before a captive audience. He turned the event into a happening at which ambient sounds became the de

facto score and listeners became the work's de facto performers. As Scott Burton had said, the difference between art and life became sheer consciousness and semantics.

Much of what has followed Cage's silent coup is lamentable art, but it is the thought that we should consider here. Be alert to the senses. Elevate the ordinary. Art is about a heightened state of awareness. Try to treat everyday life, or at least parts of it, as you would a work of art. None of these ideas are such unhealthy or radical propositions. And haven't we all known someone who has made something artful out of something mundane or routine? My late friend Alex was the first person I ever knew who threw books away. When we met, he was a slight, bespectacled young man with an unruly bush of curly hair, a permanent five o'clock shadow, and a big smile that revealed bad teeth. He was always squinting into a plume of blue smoke rising from a Gauloise. His affect hovered between that of a Russian poet and a French movie star, which he came by fairly: his grandmother was a famous Russian pianist, his father an English gentleman turned photographer; his mother (his parents were divorced) published short stories in *The New Yorker*. Alex arrived at college from a French-speaking boarding school in Switzerland, where he developed a deep admiration for Vladimir Nabokov and decided to become a novelist. Like Nabokov, he contrived to view the world with a sharp eye for absurd details, a disdain for lazy bourgeois thinking, and a coolly humane temperament. A helpless romantic at heart, he had a changeable temper, impeccable manners, a cunning sense of humor, and rigorous judgment in matters of female beauty.

Because he had little or no patience for what he considered to be halfway, whether it was a book or fashionable art (he thought my taste in art far too catholic), he was fre-

quently disappointed by women who did not seem to love him as much as he was willing to love them. There were women who did love him, after their fashion—when he was dying, his hospital room was full of pretty, grieving young women—but somehow, whether the fault was theirs or his I don't know, the result of their affection was never a lasting relationship. In the only novel he had a chance to finish writing, his hero is a lovesick young man like Nabokov's hero in *Glory,* who contemplates a trip to Soviet-occupied Afghanistan to impress a girl who jilted him. The book ends with a remark that conceptual art aficionados would appreciate, which Alex must have felt carried double meaning after he came down with leukemia. "Life makes sense not when reason tells you that everything is as it should be," he wrote. "Life makes sense when some imponderable and apparently random event confirms your most irrational prejudices about the world."

Nonetheless, he tried to make some order out of existence with his library. He accumulated books in his tiny studio apartment, which was in one of those vanilla brick buildings on the East Side of Manhattan. A narrow foyer with a decrepit Pullman kitchen opened onto a shoebox-shaped room with windows at the far side. Alex lined the long walls with wood shelves. Neatly arranged volumes quickly came to fill the shelves, so that if a book were added, one at least as thick had to be subtracted. I hesitate to make too much of a typical dilemma for apartment dwellers, and I doubt that Alex thought of his library as a masterpiece, exactly. His books were neither expensive nor rare. His was the opposite of a collector's horde—it was a resource for an aspiring novelist. But Alex was too fastidious and judgmental to do what most people do, which is to make piles, to put off judgments, to

countenance all the objects of our indecision. So his evolving library—because that is what it turned into, a real library, albeit modest and small—became his version of a garden, tended and, at a given moment, representing what he regarded as beautiful in the world. It was like a surrogate self-portrait, a work of art in that it was Alex's aesthetic and heartfelt expression. I am not sure how many other friends of Alex initially looked at it this way, or even noticed what he had quietly been up to, since he made no special point of it. I realized it only because I tried but failed to do what he was doing, and admired his ruthlessness and clarity of purpose, an artist's traits. But I was not alone, it turned out. When I visited Alex's father in London after Alex's death, he showed me around the house. As I was leaving, I spotted rows of pale wood bookshelves, incongruous in that context, recalling Alex's apartment. There, preserved and re-created, shelves and all, shipped intact from across the Atlantic, was Alex's entire dog-eared library.

SO ARTFUL THINGS may often be ordinary and can go easily unnoticed. See a plain line drawn by a pencil, Sol LeWitt said. See that it can be straight, thin, broken, curved, soft, angled, or thick. Enjoy the differences. This simple test of sensory acuity is not hard to pass if your eyes and mind aren't shut, and your concentration is full.

Much of LeWitt's work has consisted of similarly prosaic instructions, which may be only a thought you are meant to contemplate, or plans for drawings or actions he devised that could be carried out or not. Sometimes these plans derive from a logical system, like a game; sometimes they defy logic, so that the results cannot be foreseen. LeWitt, follow-

ing Cage's example, has said that the input of others—the joy, boredom, frustration, or whatever they feel—is part of his art; it accounts for how the same work may produce a variety of results.

"Twenty-one isometric cubes of varying sizes each with color ink washes superimposed," LeWitt's directive for a work titled *Wall Drawing No. 766*, sounds unbearably dull until you see what it can look like realized: playful geometries in dusky colors nodding toward Italian Renaissance fresco painting. Or realized another time, the colors might look different. "On a black wall, all two-part combinations of white arcs from corners and sides, and white straight, not-straight and broken lines," his instruction for *Wall Drawing No. 260*, is not even easy to read. But the work, when drawn on all four walls of a room, as he prescribes, can make you feel as if you are bobbing in black water at night, lights coming at you from every direction. Other drawings with similarly bland instructions produce opulent psychedelic cousins to Matisse cutouts on the scale of wide-screen movies, or they may become gossamer lines, barely visible.

LeWitt turned to conceptualism as an alternative to the abstract expressionist painting of the previous generation, the supreme modern exemplar of exalted touch. LeWitt had tried to paint like Jackson Pollock and the other abstract expressionists, but realized he had nothing much to add to what had already been done. Then while working behind a book counter at the Museum of Modern Art to pay the rent, he met other young artists, notably Dan Flavin, the future fluorescent light artist, and he saw a way forward.

It was to go backward, "to recreate art, to start from square one," as he said at the time, beginning literally with squares and cubes. Back then, during the early 1960s, lin-

guistic theorists were talking about words and mental concepts as signs and signifiers, and now here was LeWitt devising a grammar and syntax of cubes and spheres, a kind of personal theory of visual signs. It was theoretical but not mathematical. He began with propositions for images, which became something physical only if they were translated by him or by other people into drawings or sculptures. He didn't care about making precious one-of-a-kind objects for posterity. Objects are perishable, he realized. Ideas need not be. And to the extent that his art found a home merely in another person's mind, as an idea planted there, his work usefully blurred the distinction between art and the rest of life.

Other artists did this in different but also evanescent ways. Before people started thinking of her as "that woman," Yoko Ono was in her twenties, living in New York, an admirer of Cage, creating her own kind of conceptual art: like LeWitt, she made up haiku-like instructions to be performed or just imagined: "Light a match and watch till it goes out." She had a cold-water loft on the top floor at 112 Chambers Street in Lower Manhattan, art-world Siberia in those days but a neighborhood for like-minded dreamers, and with La Monte Young she presented a series of performances and other avant-garde happenings. Duchamp attended and so did George Maciunas, an impresario of the avant-garde who ran the AG Gallery on Madison Avenue. *Smoke Painting* was an Ono canvas people were invited to burn. *Painting to Be Stepped On* was just what it sounded like. Maciunas noticed the work and invited Ono to have a show at his place. At the time, there were two other shows at the gallery. One was *Nothing* by Ray Johnson.

Ono came from a rich Japanese family on her mother's

side and aristocracy on her father's. Her great-grandfather was a viscount. Her grandmother married a samurai who became president of a bank. Her father wanted to be a classical pianist before joining the family profession. Brought up Buddhist and Protestant, she went to an exclusive school for children of the imperial family along with the emperor's son, Akihito, and the future writer Yukio Mishima, and she was trained to sing German lieder and Italian opera and took piano lessons. When her father was transferred to America, the family moved to Scarsdale, New York, and she enrolled at Sarah Lawrence College. Beatles fans presumed she was a nobody who glommed onto John Lennon, but in her modish art circles and at the most rarefied levels of Japanese society she was a somebody with cultural credentials who fell for a pop singer with cultural pretensions, albeit a very famous one. The relationship, it would seem, was at least mutually beneficial.

Cut Piece was one of her first radical performance works. She sat impassively, a kind of bodhisattva, onstage, while people slowly cut off her clothes—a feminist manifesto before most people knew what feminism was, and a work of sexual exhibitionism that rebuffed her highborn upbringing, while its element of ritual violence was, if not quite seppuku, some theatrical version of self-sacrifice, a theme she would exploit in what became her very public life.

At the time of Ono's first show at Maciunas's gallery, Maciunas and others were coming up with the idea for what they called Fluxus, to designate an anarchic, wry multimedia movement that mixed music, Cage, happenings, Buddhism, vaudeville, guerrilla theater—everything Ono was up to then. The essential spirit of her early works was passive. It frequently entailed her removing herself, stepping aside, letting

someone else take over. Incompleteness, displacement, and whimsy were among its motifs. Ono designed a vending machine to dispense bits of sky. For a show in Tokyo in 1962, she translated some of her works, like *Smoke Painting,* into directions for gallery visitors to follow. These directions were written longhand in Japanese by her husband at the time, the composer Ichiyanagi Toshi, and Ono photocopied what he wrote, so that the work, as exhibited, became a copy of a thing written by someone else of an idea that required a different person to complete. There was an obvious musical parallel: the composer whose work is realized only by the musicians who play it, music being a touchstone for Ono, who throughout her career blurred the distinctions between music, performance, writing, and art. Music and performance were obvious connections to Lennon. Only the size of the audience changed once they met: in the early 1960s she lighted matches onstage in front of a few dozen art addicts; by the end of the decade she could simply get into bed with her husband and alert the media.

Lennon had wandered into the Indica Gallery in London in 1966, climbed a ladder to read a panel Ono had stuck to the ceiling with "yes" in tiny print on it, and fell in love with the work and its maker. He collaborated on various projects with her. In *Film No. 5 (Smile)* Lennon smiles at the camera in slow motion, a variation on an early Ono sculpture called *A Box of Smile.* Ono made several films. For *Rape,* she had a camera crew pursue a woman into her apartment, to her mounting alarm—like *Cut Piece,* a work about violation, now with Ono's celebrity as the obvious subtext.

It was the sort of art you would either meet halfway or fail to get entirely. It accommodates both reactions, as do Ray Johnson's collages and the library of my late friend Alex. We may see ourselves in our reaction to it. *A Box of*

Smile (open the hinged top and find your reflection in the mirror inside) was a simple, hokey idea. But it was emblematic of the life-as-art philosophy. Smile into the mirror. That's all. A tiny prod toward personal enlightenment, the art of positive consciousness. Very Zen.

THE ART OF COLLECTING
LIGHTBULBS

A FEW YEARS AGO I met Hugh Francis Hicks, a dentist in downtown Baltimore with an office on the parlor floor of a big old brownstone just up the street from the Walters Art Museum. One afternoon he took me into his building's basement to show me a collection he has been putting together for nearly seventy years. Dr. Hicks, who died at the age of seventy-nine in 2002, collected lightbulbs. He had 75,000 of them. You probably won't be surprised to learn that this was the largest collection of lightbulbs in the world. Dr. Hicks had officially turned it into a museum, the Mount Vernon Museum of Incandescent Lighting. It contained what used to be the world's biggest bulb (at 50,000

watts and four feet high, it was the size of a shrub) and also the smallest, which you could see only by looking through a microscope. Edison's early experimental bulbs were there, with their original Bristol-board filaments. One of them still worked. The bulbs were decoratively arranged in crowded glass-and-wood cases, like the ones that turn-of-the-previous-century museums used to have, the cases accompanied by yellowed typewritten labels full of arcane information, detailing the source of the name Mazda (a Zoroastrian sun god) and the history of tungsten filaments. Dr. Hicks had what lightbulb collectors evidently considered to be an incredible collection of "B" type Mazdas. He amassed a definitive variety of switches, sockets, and adapters, and he also had many one-of-a-kind, or nearly one-of-a-kind, treasures: the headlamps from Himmler's Mercedes and three lights from the *Enola Gay*. There were also joke bulbs shaped like Dick Tracy and Betty Boop, men's ties that lighted up, and a display documenting the history of Christmas lighting. A kind of rabbit warren, the basement included a room at the end with a big round table covered by a plastic flowered tablecloth where Dr. Hicks served cookies to visiting schoolchildren. Before visiting, I phoned ahead, and he met me in his office—there were no patients around—then took me downstairs and turned on the lights.

Why do people collect? The consolation of art comes in many forms. For some it is making, for others it is having. For Dr. Hicks, it was the hunting and gathering of illuminating trophies. For many of us it may simply be appreciating what people like Dr. Hicks have collected—it may be just looking at constellations of someone else's extraordinary things. Dr. Hicks said that his obsession began in the crib. His mother noticed one day that he was bored with his toys, so for some

reason she gave him an old lightbulb to play with. He survived this brush with danger and began devising school projects entailing electricity. In time, he discovered other bulb enthusiasts and began to trade. He was not above thievery. Once, on vacation in Paris, he spotted a row of 1920s tungsten bulbs along a wall of a Metro station and hurriedly swiped one, whereupon the whole station went pitch-black because the bulbs were wired so that if one were removed, they would all go out. Unable to fit the stolen bulb back into the socket, he decided to flee. At his museum, he displayed his booty in a case marked "Hot Types."

Psychiatrists came to interview him about why he collected, and he told them about William J. Hammer, one of Edison's engineers, who before 1900 collected 130,000 different electric bulbs, which were evidently later dispersed. Hammer died the month that Dr. Hicks was born. "Do you believe in reincarnation?" he asked the psychiatrists. They seemed stupefied.

Some people collect because collecting can be a great art if earnestly engaged in. That is why we enjoy looking at great collections, even if we are not collectors. Collecting is a way to bring order to the world, which is what museums, our public collectors, do. It is also a way to define some idiosyncratic niche for the collector, as art does for an artist. There are people who collect candy wrappers without the candy, thimbles, and inedible food. If you look up Dr. Hicks's museum on the Internet, you will find links to various collections of technological artifacts, from slide rules to chopsticks to pocket calculators to mimeograph machines. Over the years, I have visited a museum of trash and the basement of a churchgoing teetotaler in New Jersey who had collected several thousand miniature liquor bottles and several dozen

miniature Vargas pinups from old cigarette packs. (He didn't smoke, either.) I have toured the Nicholas Roerich Museum on the Upper West Side of Manhattan, an obscure shrine to a once-famous Russian mystic (or charlatan, depending on which accounts of him you read), which collects his eccentric paintings. I have seen a few of the cars and planes that James Turrell, the sculptor of light, has collected in Arizona. Turrell is like Donald Judd and Dan Flavin, archetypal American minimalists, purveyors of the sparest sort of modern art, who were in their private lives aspiring packrats. Like the tee-totaler who loved liquor bottles, Turrell is the quintessential paradoxical collector. His art consists of the most ephemeral and insubstantial thing of all, light, while his collecting entails big bulky machines, which I must assume fill some private need, aside from the practical one of getting him from one place to another, and this other need may be partly aesthetic but is also, no doubt, psychological. Judd collected cars, modern furniture (a warehouse full of it), Indian crafts, and buildings along with books; Flavin, who also made art out of the light cast by colored fluorescent tubes, collected Stickley furniture, Rembrandt etchings, Asian pottery, Indian jewelry, nineteenth-century American drawings, Japanese prints, and sketches by modernists he admired, like Brancusi and Malevich.

It is taken for granted that Rembrandts are worth collecting because they are art and expensive, but collectors, as Dr. Hicks proves, will collect pretty much everything, without necessarily thinking that what they collect has aesthetic or monetary value. Prestige, like taste in art, is often in the eye of the collector, and true value may be greatest when the value is only symbolic. Collected objects become symbolic when they lose their utilitarian purpose. A former prisoner in

a Stalinist labor camp, for example, collected keys to locks that were no longer in use. A key is no longer just a key if it belonged to the Bastille, nor a sewing kit just a sewing kit if Betsy Ross sewed with it. As Philipp Blom, a writer on collecting, has put it: "As often as not the objects collected are the cast-offs of society, overtaken by technological advance, used and disposable, outmoded, disregarded, unfashionable." Their uselessness becomes their asset: they turn into totems and fragments of the lost worlds they came from. So the arm of Teresa of Avila is prized not because it is practical to medical science as a specimen of muscle and bone but because it is connected, as Blom says, "with otherworldliness, as a key to heaven, to a world infinitely richer than our everyday existence." It becomes a holy relic.

Just as art promises wonderment—an access to a realm beyond the everyday, through the experience of which we may understand the everyday better—a collection of things, even everyday things, promises wonderment, too, as these things become no longer everyday, having been enshrined by a collector. Walter Benjamin, who collected books, said that "one of the finest memories of a collector is the moment when he rescued a book to which he might never have given a thought, much less a wishful look, because he found it lonely and abandoned on the marketplace and bought it to give it its freedom—the way the prince bought a beautiful slave girl in 'The Arabian Nights.'" He added, "To a book collector, you see, the true freedom of all books is somewhere on his shelves."

For Benjamin, collecting makes sense of a senseless world. Collectors take up "arms against dispersal. The great collector is touched to the core by the confusion and the dispersal in which things are found in this world." Collectors

impose their own private rationale on what they own. They make order out of chaos. Albert C. Barnes made a fortune at the turn of the last century with an over-the-counter antiseptic remedy called Argyrol, and with the money he made put together one of the world's most spectacular and idiosyncratic collections: he amassed great Cézannes, Matisses, and African art, along with metal knickknacks and folk doodads like door locks and a tiny acorn sculpture in the shape of a cricket. Famously, he displayed these all together at a mansion outside Philadelphia, in odd, mixed-up arrangements, seemingly arbitrary to the uninitiated—arrangements he vigorously explained according to an elaborate private dogma of decoration, partly inspired by John Dewey, which he and his cultish disciples, at a school he founded on the premises specifically to perpetuate his artistic beliefs, preached with a kind of quasi-religious fervor through pamphlets and books. Pictures might be put together to convey a triangular or diagonal scheme that Dr. Barnes thought he perceived in their compositions. A great Seurat could thereby share real estate with *Balloon Man,* a painting by somebody Dr. Barnes came across named Liz Clark. Works that looked optimistically attributed to El Greco, along with dozens of pinheaded Renoirs, mostly awful but some great, hung with sublime landmarks of the most intelligent sort of modern art like the mural by Henri Matisse that Barnes, in a stroke of genius, commissioned. Matisse evidently enjoyed Barnes's eccentricity. He declared the weird juxtapositions a help to the public, since people could "understand a lot of things that the academics don't teach," which was true. Nobody else looked at art the way Barnes did. Self-taught in this regard, from a working-class background, having earned his way through medical school playing professional baseball, he developed a notorious chip on his shoulder toward what

he considered the art establishment, and he feuded publicly with anyone he thought hoity-toity. His collection was only open to "the plain people, that is men and women who gain their livelihood by daily toil in shops, factories, schools, stores and similar places." The eminent art historian Erwin Panofsky supposedly had to dress up like a chauffeur to sneak in.

Nine months before he died in 1951 at the age of seventy-nine, when his Packard collided with a ten-ton truck, Barnes decided, in another stroke of eccentric philanthropy, to bequeath everything to a small, historically black school in Chester County, Pennsylvania, called Lincoln University, which had little, if any, experience with art collecting. He stipulated that the school maintain the museum untouched where it was, ensuring years of legal wrangling, financial crisis, and limited access for almost everyone, including plain people, to some of the most important modern art in the world—that is, until 2004. Overriding Barnes's will, a judge ordered the straitened museum to be reconstituted in Philadelphia, as a partial simulacrum of itself, more convenient to tourists and with money from several local foundations that had made its move downtown a condition of their support. The decision would have horrified Dr. Barnes, who acted, you could say, like a jealous lover (the erotic aspect of collecting has always been much commented on): he wanted to control these objects of his desire, even beyond the grave.

He was not merely being perverse. His collection, he realized, was itself a novel expression of creativity. You might never have noticed a connection between Persian miniature painting and the early American modernist painter Marsden Hartley unless Barnes had put them together. His unorthodox installations, so unlike what other museums did, inclined you to look at his art fresh, which is what museums

should do. Barnes imposed himself onto great works of Georges Seurat and Matisse by insisting they be viewed only as he saw fit, which meant that a colorful and ornery former baseball player and medical entrepreneur declared a kind of aesthetic authority over cultural figures of enduring consequence—not a perfectly defensible position for advocates of serious art who believe art should really be as accessible as reasonably possible to the public. But Barnes (whose Argyrol, by the way, was a remedy for conjunctivitis in newborns, an aid to seeing) opened more than a few eyes with his display techniques while demonstrating that there was an art to collecting—and, by extension, to appreciating a great collection.

It is a fair question to ask whether collectors like Barnes devise their own museums because they are exhibitionists or promoters of some private philosophy or have a sense of civic responsibility, or all of the above. Not all collectors are eccentrics, of course. Most aren't, although the best often are: out of passion and private conviction, they collect what may not yet be ratified, as opposed to what fashion and the market already prize, in the belief that public taste should someday catch up. The combination of public service and the strength of one's conviction is what defines an admirable collector. Like artists, collectors may also collect in a vain hope of achieving immortality. Collections, as Blom says (and this certainly pertains to Barnes's), "have always had overtones of burial and interment. Graves are filled with objects symbolic of future use, shoring up the deceased against irrevocable loss, allowing him a symbolic afterlife with all the comforts of the here and now. The greater a collection, the more precious its contents, the more it must be reminiscent of a mausoleum, left behind by a ruler deter-

mined not to be forgotten, not to have his memory squabbled over and his most immediate self disintegrate to dust."

This even applies to benign collectors like Dr. Hicks, whose museums of artifacts can have a fascination that is indistinguishable from that of art museums. I don't mean that, aesthetically, lightbulbs or slide rules are as compelling as paintings. I mean that the museum, whether it is a collection of art or something else, derives from the old *Kunst- und Wunderkammern,* or art and wonder cabinets, and it retains its original aspirations to wonderment.

Kunst- und Wunderkammern began to proliferate more or less in the sixteenth century, the result of humanist curiosity, technological advances in things like optics and engineering, a revival of interest in antique texts that were preoccupied with the marvelous, and global exploration, which exposed Europe to what seemed like a strange new world. Sophisticated banking systems also made the exchange of rare and precious worldly goods easier. Trading empires, like the Dutch and Venetian, fostered and facilitated rich collectors who sought the most wonderful objects. Wonderment in the sixteenth and seventeenth centuries came to be perceived as a kind of middle state between ignorance and knowledge, and wonder cabinets were theaters of the marvelous, museums of accumulated curiosities, proving God's ingenuity. They contained whatever was the biggest, the smallest, the rarest, the most exquisite, the most bizarre, the most grotesque. Art, astrolabes, armor—man-made wonders— were cheek by jowl with monkeys' teeth and pathological anomalies like human horns. A German doctor named Lorenz Hoffman had a typical *Kunst- und Wunderkammer:* he owned paintings by Albrecht Dürer and Lucas Cranach, a skeleton of a newborn, two dozen miniature spoons hidden within a

cherry pit, an armband made of elks' hooves, mummies, and various rare musical instruments. In the middle of the sixteenth century the Dutch collector Hubert Goltzius could list 968 collections he knew of in the Low Countries, Germany, Austria, Switzerland, France, and Italy. In Amsterdam, nearly 100 private cabinets of curiosities were documented between 1600 and 1740. Calvinist propriety discouraged the Dutch from displays of wealth in public, but in the privacy of their homes they stuffed fancy mahogany cupboards with coins, cameos, and statues, capped off by precious porcelain, the archetype for modern bourgeois drawing rooms with their obligatory glass-fronted cabinet in which to show off the family china.

Wonder cabinets of the past were, in part, meant to encapsulate the world in microcosm: again, order from chaos. Blom reminds us about Philipp Hainhofer, the great Augsburg envoy and collector, who, in designing various cabinets for princes, devised one of the most extraordinary pieces of seventeenth-century furniture: a vast chest, topped by a huge rare Seychelle nut, in which objects were methodically arranged to represent the animal, plant, and mineral worlds, the four continents, and various human activities, with painted *vanitas* scenes on the front to remind everyone that death is part of life. The drawers contained exotica like bezoars, calcareous concretions from the stomachs of Persian goats, believed to be antidotes to poison, vastly expensive; musk pouches; cups of *lignum Guaiacum,* a West Indian wood of medicinal powers, and objects "for vexation," like gloves with no openings for the hands, fake fruit, and pictures that came into focus only when viewed through special mirrors.

These early cabinets of wonderment became occasions

for collectors to exercise their artistic skills at display. The art of museum exhibition has its roots in this impulse. Frederik Ruysch, a Dutch anatomist and famous collector, concocted wild tableaux made of flowers, skulls, kidney stones, and diseased organs in his *Wunderkammer* in Amsterdam. One of the first museums in the United States, which belonged to the Philadelphia artist Charles Willson Peale, was a kind of *Wunderkammer*, containing fossils and stuffed birds as well as paintings. In 1822, Peale did a painting of himself holding open a curtain onto his museum, like a carnival barker invit-

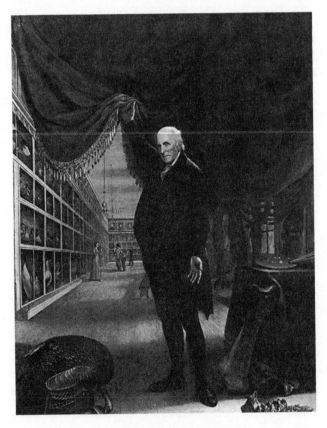

CHARLES WILLSON PEALE, *The Artist in His Museum*

ing visitors into the big top. Collecting, for Peale and the others, put the world together like pieces of a puzzle.

While driving to Dr. Hicks's in Baltimore, I noticed a sign on the highway for a museum of hunting decoys in Havre de Grace, Maryland, so I pulled off at the exit for a visit. Havre de Grace is a sleepy place on the Susquehanna Flats, where the Susquehanna River meets the Chesapeake Bay. It is duck hunter's nirvana, although a series of laws during the 1930s and '40s curtailed market-gunning or hunting ducks for restaurants. The Decoy Museum preserves hundreds of duck decoys by local carvers. Astonishingly, the carvers are also preserved behind glass, right there in life-size, full-length polyvinylacetate figures, like decoys, you might say, of the decoy makers. There's a big tableau that lights up when you press a button, à la Madame Tussaud's, showing local carvers sitting around a stove in one of the town's decoy shops in 1942. Display cases are dedicated to different expert decoy makers. At a glance, I couldn't always tell the difference between the works of R. Madison Mitchell, a local funeral director, who was evidently the Giotto of Havre de Grace, and the works of Bob McGaw, who perfected a way of decorating his decoys that, I learned, is called scratch painting. But no doubt the distinctions are obvious to the people who have looked at the decoys a lot longer than I did. Connoisseurship entails making distinctions through slow, comparative observation, whether it involves paintings or wooden ducks.

Partly it was a desire for a more methodical approach to collected objects, a system for spreading connoisseurship, that ushered in a new age of museums two centuries ago. Museums began to specialize. Elks' hooves went one way, paintings another. The balance tipped from delight toward

instruction. The new museums set out more systematically to categorize things, to create order, or at least to imply that there is an order to life. René Descartes, who called wonderment the first of all the passions, also wrote that an excess of wonder can "pervert the use of reason." The age of wonder cabinets turned into the age of Descartes and the encyclopedists.

But the spirit of the wonder cabinets never altogether died. Art museums, and even modern collections of lightbulbs, though they may not be true wonder cabinets, preserve what's marvelous to show us what is rare and what we can't see otherwise, and thereby help us see, with heightened curiosity, what is around us. Thomas Dent Mütter was a Philadelphia surgeon who went to Paris in the 1830s, when it was the medical mecca. There he saw hospital wards arranged according to diseases, so that doctors could compare the conditions of patients suffering from the same things; he also saw collections of tumors, aneurysms, bones, and so on. He returned to Philadelphia inspired by the systematic connection of morbid anatomy and clinical pathology. Soon he began to build his own teaching collection of anatomical and pathological specimens for the benefit of medical students. In the nineteenth century, medical students regularly learned about scientific anomalies like human horns or conjoined twins by looking at collections of dried dissections, wax models of skin diseases, and papier-mâché models of reproductive organs. To this end, Mütter accumulated hundreds of air-dried specimens, specimens preserved in alcohol, plaster casts, watercolors, and oil paintings—1,344 items—all of which he bequeathed in 1858 to the College of Physicians of Philadelphia, a private medical society with some of its own oddments whose founders in-

cluded lettered men like Benjamin Rush, a signer of the Declaration of Independence.

Mütter understood novelty as a kind of collector's bait. So he also collected the bladder stones removed from Chief Justice John Marshall by Philip Syng Physick, the father of American surgery, in 1831, and the deformed skeleton of a woman whose rib cage had been compressed by tying her corset too tightly. In time, the college added to his oddments. The Mütter Museum, as it came to be called, now occupies part of a big, somewhat forbidding Georgian building behind a tall iron gate in the center of the city. A two-story anachronism of polished wood cases, thick burgundy curtains, and brass lamps, it looks much as one imagines Peale's museum to have looked. In recent years it has streamlined its display, making it more attractive to tourists but somewhat skewing the public's perception of the historic function of the museum by showing only what's most striking or unusual or catchy. The collection today boasts of having the connected livers of the Siamese twins Chang and Eng; a piece of the thorax of John Wilkes Booth; a tumor removed from the jaw of President Grover Cleveland; the skeleton of a seven-foot-six-inch man from Kentucky who suffered from a condition called acromegaly, a hyperactive pituitary gland; a bound foot from China; the remains of the so-called Soap Lady, whose corpse decomposed into a grayish white fatty, soapy wax substance called adipocere; and more than two thousand objects removed from choking victims, the objects carefully arranged in narrow drawers in a filing cabinet according to type: meat, nuts, pins, buttons, toy jacks. These last items came to the museum in 1924 from a pioneering broncho-esophagologist named Chevalier Jackson, who devised a technique for extracting them from patients' throats.

In the collection is also a photograph of Dr. Jackson him-

self, looking a bit like Sigmund Freud, unsmiling, in bow tie and a white doctor's gown with natty trim, stiffly pointing to a large diagram on an easel showing a safety pin stuck in a throat.

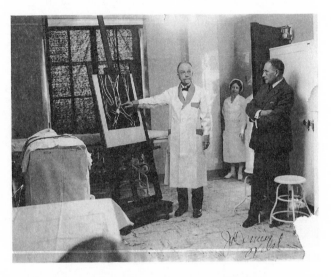

J. DENNIS WELSCH, Dr. Chevalier Jackson pointing to diagram of safety pin lodged in throat

It is now possible to see much of what the Mütter keeps on view as art: Théodore Géricault, the great French Romantic artist, painted severed limbs; Kiki Smith, the contemporary artist, has made sculptures of flayed figures; Nayland Blake and Damien Hirst have in recent years devised artful arrangements of medical instruments; and to see the Soap Lady, her mouth wide open, is to be put in mind of the paintings by Zoran Music, a Holocaust survivor who became a painter in Paris, of screaming figures. The Mütter's dried skeleton of a newborn child, hanging by its outstretched arms, head back, can even make you think of some great crucifixion by Peter

Paul Rubens, with Jesus's eyes upturned, as if in a state of spiritual ecstasy.

But I wouldn't want to push the connection too far; I only wish to stress how a place like the Mütter, notwithstanding its original medical function, can seem neatly to blur the distinction between science and art by dwelling in the marvelous. Its collection causes us to react in a way that, like art, goes beyond reason and touches our nerves. Was Dr. Mütter motivated merely by scientific inquiry? Maybe he was, but many collections, including his, suggest an obsession on the part of the collector that exceeds practicality. A Manhattan psychoanalyst, Werner Muensterberger, once wrote a book called *Collecting: An Unruly Passion*, in which he argued that collecting is, among other things, more or less a form of displaced childhood in which the collector longs for parental comfort, his or her collected objects becoming, like sucked thumbs, stand-ins for a mother's breast. They are the lightbulb in Dr. Hicks's crib. I am not a collector. I can't say. Collecting, the issue of financial investment aside, is clearly some form of consolation to many collectors, as is its appreciation by others. Beyond that, it can be a wonder and a mystery.

In his prologue to *Invisible Man*, Ralph Ellison wrote, "In my hole in the basement there are exactly 1,369 lights. I've wired the ceiling, every inch of it. And not with fluorescent bulbs, but with the older, more expensive-to-operate kind, the filament kind. . . . When I finish all four walls, then I'll start on the floor. Just how that will go, I don't know. Yet when you have lived invisible for as long as I have you develop a certain ingenuity."

Dr. Hicks, our lightbulb man with his basement museum, told me about those psychiatrists who came to interview

him. "They were something," he said. "They didn't blink their eyes. They were interviewing collectors from all over the world. After spending $4 million, they concluded that collectors collect for the fascination of an object and for no other reason. Heck, I would have told them that for $1 million."

THE ART OF MAXIMIZING
YOUR TIME

SOMETIMES ART can be a refuge from life, and in extreme cases it is a second chance at life. Another way to put the familiar phrase about the relative lengths of art and life is to say that what makes great art great is that it remains eternally young, while we don't. It is a commonplace observation that a Henri Matisse or Pablo Picasso or Vincent van Gogh becomes like a new artist every decade his work is shown because, as time passes, circumstances change, generations change, but the artist's work continues to have something new to say. Although a Matisse painting is a finite and finished object, it remains in flux and permanently fresh, affecting and being affected by other art over time. As the critic John Russell simply phrased it, "What we have seen this

week will not look the same when we see it again next week." You might also say the best art holds death at bay.

That is part of its eternal attraction. We connect with art to share something larger and more enduring than ourselves. Recent history includes exceptional examples of varied young artists who have given themselves over totally to making something truly grand and previously unseen, whose ambition might have even been beyond them, which meant that their efforts carried a high risk of failure. Art being a gamble on posterity, the higher the stakes, the grander the potential reward. These artists provide us with eloquent models for living life beyond what we fear to be our creative limits—which we can't know, after all, until we try to reach them. Such a life demands some bravery and much independence, and it is perhaps not coincidental that several of the bravest and most independent modern artists who come to mind are women.

An example is Charlotte Salomon, a young German-Jewish woman who produced a mammoth quasi-diary of gouaches and accompanying texts. Not a member of that special group known as prodigies, she left a legacy distinguished by a few years of youthful ardor, reminding us what it means to try to stay young. A coming-of-age story about love before the Holocaust, it was the only important art she ever produced, before running out of time. Salomon poured her whole life into the work, which in turn has become inseparable from her death.

Youthful impatience and tireless effort are often driven by some obsession like Salomon's. A more recent case is the artist Jay DeFeo, who in 1958 started working on a large canvas from which she had recently scraped remnants of a couple of paintings, one of a mountain, the other, prophetically,

on the theme of Jacob wrestling the angel. DeFeo worked in a studio at 2322 Fillmore Street in San Francisco, where various other artists and musicians lived. At twenty-nine, she was already somebody among the Beat poets and painters in the Bay Area, a smart, gifted, outgoing, pretty, free-spirited woman, who, not incidentally, held her own with the guys. She began on this large rectangular canvas by loading white and gray paint in a pattern resembling the cross-section of a whole orange or grapefruit, radiating from a point just off-center on the canvas. Over time, she built up and scraped away the paint, again and again, gluing the work to an even larger canvas to center it more precisely. Every day she went to work on what she finally decided to call *The Rose,* although it never resembled one. For years she did almost nothing else, surviving, it was said, sometimes on brandy and cigarettes. Increasingly, she withdrew from company. People started to talk. The work went through phases and

Jay DeFeo working in her Fillmore Street studio with *The Rose* in bay window, about 1960–61

names. "There was a kind of archaic version at six months," she told a curator in San Francisco. "Then followed a very developed, geometric version, which gradually transformed itself into a much more organic expression. Curiously, this stage got thoroughly out of hand at one point (baroque), and I managed to pull it all the way back to the final 'classic' 'Rose.'"

By then, the painting weighed nearly a ton, from all the accumulated pigment. I have no idea whether DeFeo knew much about Bonnard, but it happens that for years he worked on his own painting of a rose, an off-balance composition hung near the staircase of Le Cannet. He told a friend that he was obsessively struggling to recenter the rose through the accumulation of paint: a rose was like female flesh, he said, a bodily allusion. But this was just a small picture, almost bashful. DeFeo's *Rose* grew to be eleven feet tall and eight feet wide, built up at its thickest to eleven inches, like some geological formation—"a marriage of painting and sculpture," as she fittingly described it, adding that she had had in mind at the start only "an idea that had a center to it."

The work and DeFeo's obsession with it became notorious. In 1959 Dorothy Miller, a curator from the Museum of Modern Art in New York, who had made the careers of various young American artists by exhibiting them in her shows of new talent, visited DeFeo's studio and offered to include what DeFeo was then calling *Deathrose* in *Sixteen Americans,* a show with Jasper Johns, Robert Rauschenberg, and Frank Stella—a dream for a young artist. DeFeo said no. The work wasn't finished, she told Miller, and offered other works for Miller to show instead. She also turned away solicitous gallerists.

She had no apparent interest in commerce or a career. She was fixated on completing *The Rose,* which still wasn't finished in 1965, when DeFeo and her husband, Wally Hedrick,

split up and were evicted from Fillmore Street. Eight movers had to cut away two feet of windowsill and wall and use a forklift just to get the painting out of the building. Bruce Conner, a friend of DeFeo's, made a short film about the move, *The White Rose,* to a moody soundtrack by Gil Evans, which became the main way people got to see the painting. But that wasn't the end of the story. DeFeo tinkered with the picture some more while it languished in a storage room beside the lobby at the Pasadena Art Museum, where by default it was deposited for safekeeping. A curator at the museum remembers DeFeo arriving each morning in a white lab coat and white cotton gloves with a small bottle of Christian Brothers brandy in her purse and packs of Gauloise cigarettes: "She was so very sweet and vulnerable. And then at the museum, you'd see her up on the ladder—she was a little woman—so confidently working away on this huge, bold painting."

Finally, in 1969, eleven years after she had begun working on it, *The Rose* was exhibited, but by then the art world had changed. Conceived in the era of Jackson Pollock and the Beats, the painting, a massive gray monolith of strange delicacy and gloomy bohemianism, emerged in the age of Pop Art and psychedelia. A reviewer dubbed it "a glorious anachronism." It was falling apart. Slabs of paint were sliding off it like lava from a volcano. Museums didn't want to buy it, fearing it would cost a fortune to restore, and DeFeo refused to give it away. Offering temporary shelter, the San Francisco Art Institute, where DeFeo taught occasionally, agreed to bolt it to a wall in a conference room. It quickly became part of the furniture. People spilled coffee and stubbed out cigarettes on it. It was then encased in chicken wire and plaster for protection, and finally literally entombed behind a fiberboard wall.

And there it remained, hidden and buried, for decades. Having been a carefree hipster, by the late 1980s, when she was dying of cancer, DeFeo was a mature artist facing mortality and intent on preserving this youthful gamble on posterity, her first and last big hurrah and the centerpiece of her fragile legacy. Outside the Bay Area, the work was now familiar only to a small and dwindling audience. They knew her as the sad, tiny woman on the fire escape of 2322 Fillmore Street, watching her life's work lowered from a forklift into a Bekins moving van in an obscure seven-minute art film.

"Life doesn't last, art doesn't last," a twist on the cliché, might have been DeFeo's black comment, but in fact it comes from yet another artist, Eva Hesse, who, like DeFeo, worried that her work, heroic and just as physically vulnerable, was also sliding toward oblivion along with her health. To Hesse, the tenuousness of art and life linked the two. As she somewhat oddly put it not long before she died, "They became closer enmeshed." Her response was dark humor. "Absurdity is the key word," she declared, declining to sentimentalize or romanticize the circumstances of her life, preferring to produce art that pushed at the conventions of abstraction, eroticism, and sheer ugliness. When made at a youthfully ecstatic, refined pitch, even grotesque art may seem the most joyous and important thing in the universe. Joy, in fact, is as much the message as is misery with Hesse, although people who talk about her focus reflexively on the obvious negatives: that her family fled the Nazis when she was a child; that her mother killed herself; that her marriage to another artist soured; that she battled chronic depression and then was found to have a brain tumor. Hesse died at thirty-four, in 1970.

But Hesse's art, even at its darkest, represents, as does DeFeo's *Rose,* a hope of inventing something entirely unfamiliar and strange. For Hesse, as for DeFeo, this required a

willingness to fail, which is generally a sign of optimism as well as a prerequisite for making good art. "I think art is a total thing. A total person giving a contribution," Hesse insisted. And by packing so much art into such a short time, a decade or so, Hesse created some of the most radical and significant works of the second half of the century, which look more human now for being maybe even a little desperate.

I am here referring partly to the desperation of Hesse's generation, which came of age during the 1960s, hell-bent on reinventing the world from the bottom up and naive enough to believe it was possible. Back then, driven artists like her wished to regard nothing as a given, either in art or in life. So Hesse was open to new materials, chemicals that allowed her to create new shapes, and whose dangers she embraced or ignored, fatally perhaps, because what mattered most urgently in that moment was making something original and beautiful. She was looking for a fresh, obdurate eloquence, which would make you look twice. Easy, conventional beauty was

Eva Hesse's Bowery studio in 1966

passé. Surrealism was a natural source for Hesse; but not the free-loving, tongue-in-cheek kind of surrealism, André Breton's kind—instead, an aggressive and ungainly surrealism, witty in a ludicrous, Samuel Beckett way, which dares you to adapt to its tough, idiosyncratic terms, as all difficult art does. Hesse's shapes were abstract and organic, like innards or genitals, or they were geometric—tubes or boxes or buckets—except that the forms bent and looked malleable, as if the boxes were melting or made from putty or rotting. Hesse constructed sculptures from tangles of rope or wire, which were also the opposite of geometric, charting a territory between minimalist order and expressive chaos.

Light was Hesse's spiritual tool. Light seems to come from the inside out in her gouaches of windows. Light reflects against wire in the twisted sculptures, and it shines through her translucent boxes and tubes, made of fiberglass and resin. Hesse also conjured up a kind of heavenly light by erasing, rubbing, and methodically reworking her superdelicate, exquisitely imprecise drawings of plain grids so that the polished pages seem to shimmer. Light reflects off the dappled mesh surface of her signature metal cube, *Accession II,* thirty inches square, a minimalist box à la Donald Judd, set on the floor but unlike Judd's work woven with long strands of plastic tubing inside, resembling thick hair. An object both industrial and organic, of obvious sexual innuendo, it required, not unlike DeFeo's *Rose,* a painstaking amount of labor to complete when Hesse's time was running short. By then she had jotted in a diary, "All my stakes are in my work. I have given up in all else. Like my whole reality is there—I am all there."

It was, and she was. That was Hesse's declaration of ardor and commitment, for which she was willing to bet the house.

Sol LeWitt had encouraged that attitude in one of the great freewheeling examples of an inspirational letter from one artist to another. "Learn to say 'Fuck You' to the world once in a while," LeWitt told Hesse. "You have every right to. Just stop thinking, worrying, looking over your shoulder, wondering, doubting, fearing, hurting, hoping for some easy way out, struggling, gasping, confusing, itching, scratching, mumbling, bumbling, grumbling, humbling, stumbling, rumbling, rambling, gambling, tumbling, scumbling, scrambling, hitching, hatching, bitching, moaning, groaning, honing, boning, horse-shitting, hair-splitting, nit-picking, piss-trickling, nose-sticking, ass-gouging, eyeball-poking, finger-pointing, alleyway-sneaking, long waiting, small stepping, evil-eyeing, back-scratching, searching, perching, besmirching, grinding grinding grinding away at yourself. Stop it and just DO.

"Don't worry about cool. Make your own uncool. Make your own, your own world."

LeWitt's admonition to Hesse brings us back to what Salomon had done, more than two decades before, making her own world as a bulwark against impending oblivion, but, unlike Hesse, with almost no encouragement or prospect of public success. To grasp the special inspirational relevance of Salomon's art, it may first be useful to put aside the grim death that has boxed her into the eye-glazing, inviolate category of Holocaust artist, a disservice, distorting the real message of her work. That message, counterintuitively, seems surprisingly upbeat to me, like Hesse's. It is about the redemptiveness of art.

Salomon was a young woman so outwardly undistinguished that people who knew her for years could barely remember her. One person dimly recalled her being "uncommonly inarticulate." Another said, "She had no definite

characteristics at all." She was variously described as a lamb, lethargic, a nonperson who left behind no private letters, participated in no public act, does not exist in history outside her work. In a school photograph, she is the gangly girl on the edge of the picture, staring vacantly off to the side while everyone else beams at the camera. "Withdrawn, seri-

Charlotte Salomon, upper right, with her class at the Furstin Bismarck Gymnasium, about 1931

ous, pale, tall and nondescript," remembered a family friend who knew her about as well as anyone excepting Charlotte's father and her stepmother, who tartly recalled that "Lotte did not have a lot of friends. Lotte had us."

Who knows how many Charlotte Salomons there are in the world? She would have lapsed into oblivion if she had not taken up art. For years no one in school noticed that she had

the slightest aptitude for or interest in art. But through her work, which she did on her own, as a young woman with no reasonable expectation that anybody might even care to see it, she became a gifted autobiographer, humorist, and visual fantasist with, in particular, a precocious sense of film's potential to reshape the way paintings can tell stories. She did this for herself, by herself, just for the sake of it.

Sometime between 1940 and 1942—a year before she died in Auschwitz, twenty-six and pregnant—Salomon while in exile on the French Riviera produced a roughly 1,300-page quasi-fictional diary of text and pictures. These are gouaches about the size of sheets of typing paper, cued to musical themes culled from opera and elsewhere. Their style varies, intermittently echoing Marc Chagall, Amedeo Modigliani, Edvard Munch, and the fauves but remaining somehow itself. Some of the gouaches have semitransparent sheets taped over them, like gauzy screens, with script written on them, which you can peel aside. She called the work *Life? or Theater? A Play with Music.* It is the outpouring of a young woman for whom the hugely ambitious idea of integrating music, text, and image became an inspiration. She tells a story about a woman squeezing a whole life into one tour de force, and if it is imperfect, which inevitably it is, in the end her energy is redeeming. It is a civilizing energy.

Salomon was born in 1917, the daughter of a taciturn surgeon and his depressive wife, in the affluent Berlin neighborhood of Charlottenburg. It was a household typical of assimilated German Jews of that time, with a tree at Christmas and, in Charlotte's mother's family, loyal chants of "Deutschland, Deutschland über Alles" as late as 1932.

Depression ran in the family. Charlotte's mother killed herself. Charlotte, then nine, was told that her mother died of influenza, and she didn't learn the truth until she was an

adult in the south of France. In *Life? or Theater?* she portrays herself as a little girl, having received the bad news, vainly waiting for her dead mother to return as an angel. Her father remarried. Paula Salomon-Lindberg, a singer, as outgoing as Salomon's father was reserved, introduced Sabbath candles on Friday nights and visits to synagogue on Saturday mornings. Charlotte had a bat mitzvah. She became enamored of Paula. As a singer, Paula had performed under Wilhelm Furtwängler and Otto Klemperer and sang Wagner at Bayreuth. She was known on stage as Lindberg, and Nazi reviewers praised her—"the real Christian was the alto"—until word got around that she was not a Christian, and then critics called her "Judenschwein," the Jewish pig. She was barred from performing for anyone but Jews. So Paula organized musicales at home. Meanwhile, Charlotte's father lost his professorship. Charlotte's grandparents fled the country for France. Charlotte quit school before it started expelling Jews. She had made so little impression there that her absence was barely noticed.

Then, despite being told she had no talent, she became an artist. As a shy, silent witness to the gatherings of Jewish artists and intellectuals that Paula arranged, Charlotte met Paul Hindemith, the architect Erich Mendelssohn, Albert Einstein, Albert Schweitzer. In *Life? or Theater?* she paints herself listening to a concert in the house. She also took private drawing lessons, improved, and applied to the State Art Academy in 1936, where Nazi policy restricted Jews to only 1.5 percent of the class, favoring applicants whose fathers had fought in World War I. Charlotte's father had been a doctor at the front. The minutes of the admissions committee, from February 7, 1936, state that "the artistic abilities of the full Jew Fräulein Salomon are beyond doubt. Her behavior also is recognized to be modest and reserved. There is no

reason to doubt her German attitude. In spite of this, Herr
Scheunemann protested on principle the admission of non-
Aryan female students because they present a danger to the
Aryan male students. Professor Bartning, however, pointed
out that this danger does not apply in the case of Fräulein
Salomon because of her reserved nature."

So she was admitted, the only female Jew in her class.
Despite the shouts of "Juden raus" in the hallways, Charlotte
recalled school fondly, or so it seems: she paints it colorfully
in *Life? or Theater?* Modern art having been deemed degen-
erate by the Nazis, her exposure to advanced culture must
have come from meeting Jewish artists at home and from the
Kulturbund Deutscher Juden, a refuge for Jews founded by
Kurt Singer with special permission from Joseph Goebbels's
Propaganda Ministry. In his mid-forties, with a long gray mane
of hair, Singer was a charismatic figure, a conductor, doctor,
psychiatrist, and hypnotist who, through the Kulturbund, orga-
nized concerts and, thanks to cultural connections abroad,
smuggled Jews out of the country. He was close to Paula.
Charlotte, a childish romantic, imagined Paula had really
wanted to marry him instead of her father, who seemed to
Charlotte drab. Paula remembered after the war thinking
that Charlotte herself had a teenager's crush on Singer.

Then a man entered Charlotte's life. In photographs,
Alfred Wolfsohn is slim and pudgy-faced with wavy hair,
round glasses, and an intense look in his eyes. He was a lost
soul, a self-declared vocal teacher who appeared at the
Salomon's doorstep in a shabby suit, hoping for work. Born
in 1896, having lost his father as a boy, shell-shocked at the
front, he found his emotional bearings writing a memoir that
made reference to the Orpheus myth, *Orpheus; or, The Way
to a Death Mask.* He invented a poetic theory about singing.
"Singing has always been the most primal form of artistic

satisfaction for me," Charlotte liked to quote him saying. "The infant cries because he is hungry. The true singer should have to sing in the same way." Paula thought Wolfsohn was "a really gifted man but a dangerous dilettante." She dismissed his vocal teaching.

But Wolfsohn took Charlotte seriously, or seemed to her

CHARLOTTE SALOMON, *Life? or Theater?* Wolfsohn as Daberlohn asks, "Do you know, child, that some of your pictures are quite excellent?"

to—he was the first man who ever did. So she was smitten. In *Life? or Theater?* he becomes Amadeus Daberlohn, her lover. Who knows what really happened between them? Perhaps nothing. Events overtook them not long after they met.

Charlotte's father was sent to Sachsenhausen. Paula managed to procure his release with help from the German resistance. Charlotte, still not twenty-one, was dispatched by her family on a train to the south of France. Paula remembered Wolfsohn rushing to the station. "May you never forget that I believe in you!" were his parting words, a concise equivalent, you might say, of LeWitt's exhortation to Hesse, which made an equally huge impact. Charlotte went off to join her grandparents in Villefranche, where they were sheltered by an American woman, Ottilie Moore. Charlotte's grandmother was despondent, and not much later she committed suicide. Charlotte was now left alone with her grandfather. After the occupation began, they were interned by the Germans, then released. Charlotte suffered a breakdown, for which a doctor, knowing her background, prescribed art.

So, with Wolfsohn's words as an inspiration, she began to paint the gouaches for *Life? or Theater?* The work starts in 1913, four years before Salomon was born, with the suicide by drowning of her mother's sister, also named Charlotte. Suicide, it turns out, was highest in Weimar Germany among Jewish women. Germans linked suicide to mental illness, a dangerous association for Jews once Hitler came to power. We see at the beginning of *Life? or Theater?* the lake where her aunt drowned. In the last image, Charlotte paints herself on the beach facing the sea, contemplating her fate. The picture is accompanied by a curious text, which alludes to Wolfsohn: "So she was in fact the living model for his theories, and she remembered his book, 'Orpheus, or The Way to a Death Mask,' of which he had said that he regretted not having written it as a poem. And with dream-awakened eyes she saw all the beauty around her, saw the sea, felt the sun, and knew: she had to vanish for a while from the human plane and make every sacrifice in order to create her world anew out of the depths."

Salvation through sacrifice. That was the final message. Water is a leitmotif in Salomon's work signifying death; but it is also a symbol of life, Salomon's flowing water the familiar metaphor for life's journey. The paradox of water as both life and death relates to a larger idea Charlotte adopted from Wolfsohn, who in Salomon's work pontificates fuzzily about self-knowledge as a journey toward a state of consciousness somewhere between life and death. Wolfsohn likened this trip to Orpheus and Eurydice: the descent into the underworld to regain love.

I don't want to skew the work's tone. It is frequently light and ironic. Salomon's text mischievously cues the entrance of Daberlohn/Wolfsohn—bespectacled and middle-aged, his hands behind his back—to the toreador's song from *Carmen*. He is given a halo in another scene, a further poke at his pomposity. Salomon also makes fun of herself from time to time, for being a fool in love. She clearly loved two people most in the world, Wolfsohn and Paula, whom she names Paulinka Bimbam in *Life? or Theater?* Paula represented everything Wolfsohn did not in terms of a career as an artist: successful, experienced, with a practical cast of mind. Salomon's work negotiates between the two positions represented by Daberlohn and Paulinka to find its own voice, impassioned and clear-eyed, like the symbolism of water as life and death, another reconciled paradox.

This was her complete work of art, her Wagnerian *Gesamtkunstwerk*—a connection that would not have been lost on her. Salomon developed by herself the strategy necessary to adapt the largest nationalistic cultural model, Wagner's, to a story whose subtext was contemporary Germany: a Germany that denied not just her nationality but also her right to exist. She said the work was intended to cleanse the world.

So the message from Salomon in *Life? or Theater?* has to do with self-affirmation through art, but left like that, her art still sounds sacrosanct and perhaps best avoided. Some people make dutiful obeisance to sacrosanct art (or any art connected with the Holocaust). Feigning indifference to it as a sign of sophistication is just as much a reflexive pose. Both attitudes, obeisance and indifference, abdicate the actual jobs of looking and thinking, which is what Salomon's work, like all serious art, deserves. So let me put it this way to avoid the sanctimony: you feel in good company with Salomon's pictures, which, in return for demanding your concentration, flatter your intelligence. Beyond that, there is her youthful passion—too much of it sometimes, but it is refreshingly genuine. We've all no doubt met someone like her, outwardly unremarkable but with a deep reservoir of ambition and feeling, who startled everyone, as Salomon startled even her own family when her work turned up after she died. Art didn't save her life, obviously, but it gave her purpose and clarity about the world while she was around.

She completed the work in a hotel room she rented in 1942 on the Riviera. She and her grandfather were barely speaking by then. He regarded her as distant and sulky; she considered him stuffy and egotistic. Moore, who had supported Charlotte and her grandparents, was now in America, having left behind an Austrian lover, another refugee, Alexander Nagler, with whom Salomon took up, perhaps because he was simply around and she was lonely, maybe because, like Wolfsohn, he showed some interest in her work. "Mrs. Moore left me a friend," Charlotte said matter-of-factly. "I didn't quite know what to do with him." That her grandfather regarded Nagler as socially beneath the family possibly encouraged her in the affair. When her grandfather collapsed on the street one day and died, Charlotte was free to marry

Nagler, who went to the police station for a marriage license and, unable to contain himself when provoked, ended up tipping the Nazis off to the couple's whereabouts and to the fact that they were Jews. A bit like Orpheus, who could not keep from turning around to look at his beloved before exiting the underworld and thereby losing her forever, Nagler could not restrain himself, with disastrous results.

That is all after the fact, though. Moore, Nagler, and Salomon's last months in France don't figure in *Life? or Theater?* because the work was finished before then. So it is not about her impending murder, although a sense of doom clearly spurred her to complete what she was doing quickly. The work is about her life, and mostly about her love life, imagined or real, with Wolfsohn. Wolfsohn supplied the spark that ignited her to paint *Life? or Theater?* which is, in the end, a meditation on the connection of love and art, made in circumstances of extreme loneliness. How curious to recall that Salomon and Bonnard were both in the south of France at this time, when the world was coming apart, making works that in many ways could not be more different but that are inspired by their mutual isolation and buoyed by a faith in the conciliatory power of art. As it happens, the Orphic cult in ancient Greece maintained that the soul could be liberated from its inheritance of evil and achieve eternal bliss through transmigration, which for Salomon was an artistic process: her work preached deliverance through everlasting love. It would not be any less admirable or interesting as art if Charlotte had survived the war, as did Wolfsohn, who made it to London. Charlotte's father and stepmother hid in Amsterdam and also survived, becoming friends with Otto Frank. One day he showed them a diary that his daughter had left behind. Did they think it was worth publishing? he asked.

Salomon had given *Life? or Theater?* to Georges Moridis, a doctor and friend who was in the French resistance. On September 24, 1943, a Gestapo truck pulled up to Charlotte's house and dragged her and Nagler away. She was four months pregnant. On arriving at Auschwitz, three weeks later, she was killed. Becoming an artist had not spared her life, but it had been an indispensable act of preservation. "Take good care of it," she had bidden Moridis about her work, shortly before she went off to die. "It is my whole life."

So it was.

When the work was turned over to her father and stepmother after the war, they were flabbergasted. For a while they kept the paintings in boxes lined with red cloth, unsure what to do. After the works were exhibited, the inevitable comparison to Anne Frank guaranteed Charlotte's fame. A work made under the worst possible circumstances, by luck, ended up better off than Charlotte had probably ever imagined.

DeFeo's *Rose* has improbably survived, too. The Whitney Museum in New York raised more than a quarter of a million dollars during the 1990s to excavate it from that wall in San Francisco, although it wasn't even clear then that it had not already disintegrated. A rejuvenated *Rose,* its air pockets filled with space-age plastic, a new structural support built to hold it in place, had a coming-out party in a show at the museum. With the new support, its weight now topped 3,050 pounds. Eight riggers took a day to hang the painting. It was later shown with DeFeo's drawings and other works from before and after *The Rose.* Weight, scale, material experimentation, muted color, and centripetal form: these turn out to be among the conceptual through-lines in her career, along with mystical ideas, conveyed (but never stated outright) via transparent signs of her own physical exertion. *The Rose* is like a mandala and also an artifact of intractable effort, with

a tough, mysterious beauty that you can appreciate only when you stand in front of it and see how light plays across its face, in which there seem to be buried pentimenti of color.

More than one person compared the work's removal from the studio on Fillmore Street, via an opening cut below a window, to an episiotomy, which is not so fanciful when you consider *The Rose*'s difficult gestation. Art, not unlike raising a child, may entail much sacrifice and periods of despair, but, with luck, the effort will produce something that outlives you.

DeFeo once described a waking dream in which, reborn as someone else in the future, she wanders through room after room of a museum and suddenly finds *The Rose*, restored, a person staring intently at it. She walks up to the person.

"You know," she says, "I did that."

THE ART OF
FINDING YOURSELF
WHEN YOU'RE LOST

COLLECTING, while it may have its fiscal risks, is a docile endeavor, and climbing modest mountains in Provence is only mildly exerting. They can be stimulating, which is enough for many of us. But true stress and danger, as we saw with Salomon, bring out the best in some people and inspire art in a few.

Douglas Mawson, the Australian explorer, led an expedition to Antarctica in 1911. He set out in a thirty-five-year-old, 600-ton sealing vessel christened the *Aurora*. The men he assembled—split into five parties and assigned to head east, south, and west into the most inhuman conditions to see what they could find—ended up surveying a stretch of icy coastline 2,000 miles long and 400 miles deep. They were

given a deadline to rendezvous back at Cape Denison, from which the *Aurora* would sail back home. Mawson himself chose to go with two of the men on the farthest eastern trek, the most treacherous route; a month into the trip, one man plunged to his death in a crevasse with the six fittest sled dogs, the tent, spare clothing, and almost all the rations. Mawson and the other man, Xavier Mertz—an experienced mountaineer and Switzerland's ski-running champion, who had helped train the dogs—were left 315 miles from home with food to last barely more than a week. On average days, when gale force winds didn't kick up, they made six miles. They had to eat the remaining dogs to stay alive. Mertz died polishing off what was left of the sledging rations. That left Mawson alone, a hundred miles from anyone, his skin erupting in boils, his hair falling out, rubbing his deteriorating body with lanolin and antiseptic lotion, then stripping naked to lie in the sun for as long as he could bear the subzero cold to soak up healing rays. Unable to walk because his toes were black and festering and the soles of his feet had begun to come off, he would crawl on all fours, retreating into a dank sleeping bag when blizzards rolled in, which they did all the time, praying that the snow wouldn't bury him alive. Finally he stumbled onto a cairn, covered by black bunting, built by a search party—which, to make matters worse, he had just missed by a few hours. He somehow made it from there to Cape Denison in time to see the *Aurora* departing, a speck on the horizon. It had taken him nearly three months from the time he and the other two men first left base camp to reach the cape; he had to spend another year waiting for the ship to come back to fetch him.

Frank Hurley, one of the men who took part in Mawson's expedition, was in the search party that built the cairn. Like Mawson, he thrived on hellish circumstances. He brought a

camera along on the journey, with the result that he made great art out of absurd adversity. Art wasn't Hurley's original intention: he was supposed to record the expedition for scientific purposes. But it was the unmistakable outcome. Hurley, who had plenty of other things to worry about on his trip with Mawson into Antarctica, and even more so on a second trip there with Ernest Shackleton, which he undertook shortly afterward, nonetheless went to hair-raising lengths to get the most advantageous angles and photogenic scenes for his pictures, jury-rigging rickety platforms under a ship's jig-boom or clambering to the top of a mast or scrambling across thin pack ice or ascending a snowy mountain peak. He was almost literally willing to die for his craft. In later years, working under less strain and with an eye toward amplifying his popularity, Hurley began manufacturing photographic magnificence by manipulating his prints and contriving melodramatic images, mixing exposures to create fictional scenes. He thought these techniques heightened reality, and they certainly made his work commercially successful, but in the process they undercut the straightforward majesty and swashbuckling dash of his best Antarctic photographs, and he became much less interesting as a photographer. His best work depended on the severe restraints imposed by straitened conditions. Long odds produced better returns.

There are many cases of this phenomenon in art, lofty and low. Picasso painted some of his most melancholic pictures in occupied Paris, where the deprivations of food and freedom inspired him to invent fresh metaphors of claustrophobia and anger through still lifes that depicted scanty rations, dark rooms, and scary cutlery. Nearly a century earlier a man named John Tracy, a captured Union soldier confined in the Confederates' Libby prison in Richmond, carved baseball scenes onto a cane to pass time and save himself from

going nuts. The cane turned out to be a fine work of folk art. Black women in Gee's Bend, Alabama, have sewn quilts for decades. Gee's Bend is a poor, remote hamlet occupying a bulb of bottomland, a U-shaped peninsula five miles across and seven miles long, hemmed in on three sides by the Alabama River. The single road in and out of town was paved only in 1967. That was roughly the time ferry service, the most direct route outside, stopped; whites in Camden, the county seat and nearest city as the crow flies, had decided they didn't appreciate Benders crossing the river to register to vote. Isolation has always been the place's curse, but it has also, by protecting the community and providing a means of incubating art, proven to be a blessing. For generations the women of the Bend have passed down an indigenous style of quilting geometric patterns out of old britches, cornmeal sacks, Sears corduroy swatches, and hand-me-down leisure suits—whatever happened to be around, which was hardly anything. They made the most of what little they had. Quilts made of worn dungarees sometimes became the only mementos of a dead husband who had nothing else to leave behind. They provided comfort and warmth, piled on top of cornshuck mattresses or layered six or seven deep for the cold nights. They also became declarations of style, flags of independence hung to dry on wire lines for the neighbors or anyone else to see. The women, bound by family and custom (many Benders still bear the slaveowner's name, Pettway), spent their precious spare time—while not rearing children, chopping wood, hauling water, and plowing fields—splicing scraps of old cloth to make what have turned out to be some of the most miraculous works of modern art America has ever produced. Imagine Matisse and Klee arising not from rarefied Europe, but from the caramel soil of the rural South and the most limiting circumstances.

Along the same lines, Ray Materson sewed portraits of ballplayers in New England. As a nine-year-old Little Leaguer in 1963, he idolized the great New York Yankee team of Mickey Mantle, Roger Maris, Elston Howard, and Whitey Ford. Thirty years later, Materson was in prison in Connecticut, serving a fifteen-year sentence for armed robbery. He took up embroidery, of all things, improvising with the rim of a plastic plate to make an embroidery hoop. Materson embroidered with unraveled sock and shoelace threads, using scraps of boxer shorts for backing. He sewed sports logos, flags, a group portrait of his prison baseball team, but most strikingly, pictures of his former Yankee heroes. They're each about three inches by two inches, smaller than baseball cards, 1,200 stitches per square inch: miniature portraits of amazing delicacy, each of which took him about fifty hours to complete. He embroidered a picture of Mantle swinging for the upper deck; Tony Kubek scooping up a grounder at shortstop, the bleachers behind him packed with fans; and Clete Boyer crouching at third base, baked by sunlight, casting a shadow toward the outfield. In Materson's embroidered memories, it remained 1963. The Yankees were still facing the Dodgers in the World Series, which they hadn't yet lost, and Materson was not yet in prison but nine years old and playing in the Little League on a perfect autumn afternoon that seemed like it would last forever. Materson, a lost soul, became an artist not despite his difficult circumstances but because of them.

The same could be said of Hurley, our Antarctic hero, born in Sydney in 1885, the irrepressible, egocentric, and resourceful son of an indulgent working-class father who was a typographer and trade unionist. Frank fled school at thirteen, found a job as a fitter's handyman at an ironworks at Lithgow, and earned a transfer back to Sydney to work on a ship at the

docks, from which he developed his yearning to travel to exotic places. Meanwhile he studied engineering at night. A fellow engineering student introduced him to photography, and it instantly became his obsession. "From the time I first gazed wonderingly at the miracle of chemical reaction on the latent image during the process of development," he later wrote, "I knew I had found my real work, and a key, could I but become its master, that would perhaps unlock the portals of the undiscovered World." He bought a camera, a fifteen-shilling Kodak box, which he paid off in installments of a shilling a week. He published his first picture in 1905, a seascape, and quickly developed a reputation for dramatic photographs of crashing waves, which required his own derring-do. In 1908 he started a postcard business, specializing in twilight scenes and pictures of steam trains bursting out of tunnels, further solidifying his reputation both for showmanship and moody theatrics. Some of these atmospheric photographs share formal attributes with artsy pictures by the early-twentieth-century Pictorialists, then fashionable in highbrow circles, but this was never Hurley's source or intended audience. He aimed for a mass public that, during the years just before World War I, gradually stopped collecting picture postcards in favor of the new illustrated newspapers and magazines. So Hurley's postcard business soon petered out, around which time he heard about Mawson's expedition. Bribing a train conductor to let him share Mawson's compartment on a trip from Sydney toward Melbourne, Hurley implored the explorer to take him along, arguing that he could hunt, ski, and do carpentry, was trained in electrical and iron work, and could haul sledges, sew sails, cook, and take photographs—almost whatever Mawson wanted. Mawson wanted him to learn to use a movie camera, so Hurley did. Robert Scott had already taken Herbert Ponting, the great

explorer and photographer of wildlife and landscapes, to photograph and film part of what turned out to be Scott's fateful Antarctic trip in 1910. Photography and film at that time were needed not just to document, for history and science, what the explorers found but also as a means to spread news of the trip to newspapers, magazines, and, through newsreels, movie theaters. This was partly how expeditions were paid for. Photographs and films could be sold after the expedition to recoup costs and make extra income for the photographer as well as for the team leader on the lecture circuit, through speeches illustrated with lantern slides and movies. Ponting, who could be as stolid as Hurley was gregarious and reckless, an Edwardian Englishman who gave up a career in his family's banking business to become a rancher and miner and to travel across the American West and the Far East as a war correspondent during the Spanish-American and Russo-Japanese wars, survived Scott's expedition and returned with amazing, poetic landscapes and portraits that became classics in the history of travel photography. He was the man to whom Hurley would be compared.

Hurley shipped out with Mawson in 1911, a strapping, blue-eyed, curly-haired twenty-six-year-old. The expedition lasted two years, and Hurley almost died trying to reach the South Pole. In the process, he captured the scale and weirdness of Antarctica, where winds freeze the surface of water and snow into strange waves, called sastrugi. He found that the royal penguin rookery on Macquarie Island provided a panorama that so-called extreme nature photographers dream about: thousands upon thousands of identical birds, stretching toward the horizon, as far as the eye could see, crowded like bathers at Jones Beach. Hurley's gift was in recognizing not just the spectacle but also the romance of the cold south, and this elevated his photographs from nature

documents to popular art: he caught a turreted mass of iceberg, craggy and towering, in the evening as a shadowy silhouette so that it recalled Arnold Böcklin's famously spooky painting, *The Island of the Dead*. In another photograph, two colleagues strain headlong on all fours into a blizzard that the camera registers abstractly as a white streak, the men's base camp dimly visible as a black mass in the background. What Alfred Stieglitz did with the Flatiron Building in New York City in Pictorialist half-light, Hurley did with this atmospheric scene, but without Stieglitz's pretense. He returned from the trip a minor celebrity in Australia, where he honed his lecturing skills.

This was all a prelude to Hurley's greatest work, which required him to take another Antarctic trip, even more harrowing than Mawson's expedition, with Sir Ernest Shackleton aboard the *Endurance*. The story, probably apocryphal, is that Shackleton put an ad in a London newspaper: "Men wanted: for hazardous journey. Small wages, bitter cold, long months of complete darkness, constant danger, safe return doubtful. Honour and recognition in case of success." Hurley applied, although later he liked to say that he had received an invitation from Shackleton, who, like Mawson, wanted his trip filmed and photographed. Hurley's work with Mawson had been circulated and praised; he had also gained a reputation as an able adventurer, notoriously vain (crew members on the *Endurance* would call him "the Prince") but enthusiastic, a workaholic with boundless energy and no fear. Shackleton's captain, Frank Worsley, would recall Hurley bareheaded, without gloves, standing on the deck of the ship in the freezing wind: "a marvel—with cheerful Australian profanity he perambulates alone aloft & everywhere, in the most dangerous & slippery places he can find, content & happy at all times but cursing." Hurley was twenty-eight when they set

off on August 8, 1914, a week after World War I began, with a crew of twenty-seven others in a 300-ton Norwegian barkentine that Shackleton had renamed *Endurance* after his family motto, "By endurance we conquer."

The voyage of the *Endurance,* one of the greatest sagas of modern exploration, privation, and human survival, almost everyone's ultimate nightmare trip, perfectly suited the temperament of a man like Hurley, who seemed to need extreme circumstances to thrive, as did Shackleton. Like Scott and Mawson, Shackleton was squarely in the crazy British tradition of Arctic explorers—impractical, brave, weirdly inured to suffering. He seems like a character out of Robert Louis Stevenson or H. G. Wells, it has been said, a dreamer, a chaser of quick fortune, a determined optimist, steady and indomitable in adversity, an instinctual judge of men, earning their absolute loyalty by being ready to stop at nothing to save them when the going got bad. And bad it got. After an earlier failed trip with Scott to the South Pole, Shackleton failed to reach it on his own, getting within a hundred miles before turning back to safeguard the lives of his team. That was in 1909. In 1911 Roald Amundsen beat Scott to the pole, so Shackleton proposed the absurd idea of crossing the continent by foot, about 1,600 miles from the Weddell Sea to the Ross Sea, simply because that had not been done.

The *Endurance* sailed from England to Buenos Aires, then to South Georgia Island, the last inhabited post, east of the Falklands, before entering the uncharted Weddell Sea in early December 1914. Conditions, which are never good there, were unusually bad that year, and heavy pack ice quickly surrounded the boat. By mid-January the *Endurance* had struggled to within eighty miles of Antarctica, but it was being inexorably drawn clockwise by the ice, back away from land, north. Crewmen tried desperately to saw a lead through the

thick pack but ultimately they were forced to give up. Hurley photographed the trail the ship made in the water, an eloquent knife-thin slice through an endless sea of white.

For the next ten months the boat remained trapped in the floes, like an almond in toffee, one of the crewmen said, helplessly drifting and slowly being crushed as if in a vise by millions of tons of pressure. Hurley made the most of this catastrophe. It is useful to recall how cumbersome and troublesome was the process of making pictures in Antarctica at that time. Hurley's equipment weighed forty-four pounds—he preferred a large-format camera—which he had to drag across the pack or lug around the ship's deck in the unbelievable cold. "My camera is a bug bear and using it is a nightmare," he wrote in his diary. "Every time I have to set the shutter I have to take a number of tiny screws from the front"—with his gloves off—"and bend the mechanism into shape." The screws would stick to his frozen fingers, and had to be ripped off.

But this was evidently part of the pleasure for Hurley. He had taken magnesium powder to make flash photographs, and he rigged the ship for pictures at night. To Shackleton, this was a useful distraction for the crew when the boat was trapped and there was nothing else to do. For Hurley, it was a way to make the most striking and detailed pictures of the frost-encrusted masts and rigging, which in the photographs resemble fine spun sugar against a black sky.

On October 27, 1915, the *Endurance* finally began to sink. The crew, abandoning ship to camp on the ice, took what provisions they could. Hurley risked his life to film the ship's last moments, capturing the splintered masts as they crashed within a few feet of where he was standing. Weight was a problem, so Shackleton ordered Hurley to leave his film and bulky glass plates behind; but Hurley, insubordi-

nate, dived into the gloomy, wrecked hull, precariously poised over the deep ocean, and fished them out anyway from the mushy ice in the ship's bowels. He then persuaded Shackleton that, for commercial reasons, at least some of the pictures and films were worth taking along. More than 500 plates were retrieved. Hurley went through them all, smashing 400 right there on the pack ice to forestall second thoughts and saving about 120, plus his movie film, along with an album of photographs he had already printed, twenty color transparencies (color photography was still a precious rarity), and a vest-pocket Kodak with three canisters of film. Who knows today what was lost among those smashed photographs? Of what he kept, Hurley wrote, "I had to preserve them almost with my life, for a time came when we had to choose between heaving them overboard or throwing away our surplus food—and the food went over." So the crew also played a critical role: these historic pictures have come down to us not simply through Hurley's determination and effort but through an act of group sacrifice.

A few of Hurley's photographs come straight out of Romantic landscape painting, stagy but exquisite: a stunning panorama of snowy South Georgia, for instance, that mimics Caspar David Friedrich. We see crewmen atop a cliff, overlooking the island, with the *Endurance* in the harbor below, before shipping out. At sea and then on the ice, Hurley climbed to the crow's nest for pictures of the *Endurance*'s shadow on the water, amazing images that organize and give depth to an essentially impossible white-on-white vista by projecting the linear geometry of the ship's mast against it. Hurley walked great distances across the pack ice to shoot the *Endurance* in the distance across a meadow of ice flowers, crystallized ice formations resembling carnations, illuminated by the high morning sun. And he took beautiful,

melancholic color photographs of the ship marooned in pack ice, predominantly blue and pink.

Hurley's pictures have a calm, abstract beauty. The immensity of the subject tempered his inclination to melodrama, and the results suggest the more eloquent work by Ponting, from whom Hurley, as the experts Michael Gray and Gael Newton have observed, clearly picked up pointers. An adventurer but also an aesthete, deliberate in his methods and oriented toward an audience familiar with art galleries and highbrow periodicals, Ponting aimed for classic design and elegance. He was encyclopedic in his approach, and his portraits are carefully lighted and characterful. Hurley's portraits don't approach Ponting's—Hurley wasn't the sensitive type. More attuned to the wildness and enormity of the scenery, Hurley loved to devise dramatic lighting effects and striking ways of framing his scenes. In his photographs, the crew are often not shown as individuals suffering or in despair but as groups of men, reflecting the character of an expedition whose members depended so completely on each other for their lives. Men peaceably gather around a stove, staring into the light, puffing on pipes, their faces picked out by the flames, as in a Rembrandt. Clothes hang on lines to dry; men, like sled dogs, haul their boats, black silhouettes

FRANK HURLEY, *Hauling the* James Caird

against empty whiteness. The best of these images have an extraordinarily modern quality, stark and stirring; their reduction to irregular geometric forms brings to mind Alexander Calder or Ellsworth Kelly.

The quiet and calm rectitude of the best of these photographs, true to the crew's ethos, gave no hint of their grave predicament. Without the *Endurance,* the men, marooned on the floes, struggled to stay afloat for five months in horrendous weather on thin, unpredictable, melting ice that finally cracked open beneath them. They desperately launched the three lifeboats they had salvaged toward the last small island reachable before the certain death of the ocean void. Picture something two or three times as big as a Central Park rowboat. Now picture rowing it in a winter squall across the North Atlantic for a week. Somehow the men ended up reaching Elephant Island, an uninhabited speck in the sea, far from civilization, the first dry land they had come to in 497 days.

Now their real troubles began. Elephant may be the most inhospitable island on the planet. There is no shelter. Two boats were overturned to make some crude place for the crew to huddle under. Shackleton's only option was to seek help by sailing the remaining boat with a small group of the men to South Georgia Island, 800 miles to the east, skirting the Drake Passage, the worst stretch of ocean anywhere. Winds gust over eighty miles an hour. Temperatures are subzero. The Cape Horn rollers, as they're called, swell above sixty feet and move at speeds close to forty knots. Every few seconds the boat would be lifted to the height of a six-story building, then plunged down into a trough so deep the sail would go slack. No one had ever undertaken a journey even vaguely like this. Since Shackleton, no one else ever has. Guided by Worsley, a genius at the helm, the tiny crew somehow found South Georgia after a week, landing on the wrong

side of the island, almost crashing into the rocks and drowning when a hurricane suddenly hit them, then having to traverse more than thirty miles of uncharted ice-covered mountains with virtually no equipment. They straggled into a whaling station called Stromness, their faces blacked with soot and hidden behind matted beards, their bodies dead white from soaking in salt water and covered in boils. It was May 20, 1916. With the distraction of the war, people had given Shackleton and his men up for dead. One gruff Norwegian whaler recalled in broken English his reaction to the sight of the unrecognizable man who identified himself as Shackleton. "Me—I turn away and weep," he said. The whalers at Stromness knew the Drake Passage better than anyone, and they could not fathom that the Southern Ocean had been crossed in a tiny wood boat with some tattered shirts for sails. They held a dinner, and silently, one by one, they lined up and shook the hands of Shackleton and his crew. Shackleton later said it was the greatest tribute ever paid to him.

Back on Elephant Island, Hurley had kept his pocket camera and, typically, made the most of the long wait to be rescued. He photographed the departure of Shackleton's boat, with the men left behind waving good-bye from the water's edge. On calm days, he wandered across the island into ice caverns and rock caves, to shoot distant mountains seen through scrims of overhanging icicles. He shot the men waiting on the shore, looking out to sea at nothing. The castaways built snow statues of buxom women, played cricket with stones and driftwood, and were finally contemplating cannibalism when one of them, on the beach, spotted what at first he thought was an iceberg. It wasn't. The men frantically lit a fire to send up a smoke signal, and Hurley grabbed

his camera and snapped pictures of the boat as it approached. It was a tug steamer called the *Yelcho,* which Shackleton—having failed three times to defeat the pack ice around Elephant in ships borrowed from Norway and Uruguay and pleading to no avail for help with British naval officials, who were then otherwise consumed by the war—had requisitioned with a Chilean crew. Several months had passed since he had left. Hurley wrote with characteristic bravado in his diary about the ordeal on the island: "As those noble peaks faded away in the mist, I could scarce repress feelings of sadness to leave forever the land that has rained on us its bounty and been salvation." The day after the *Yelcho* arrived in Punta Arenas, Chile, Hurley skipped the governor's reception to borrow the darkroom of a local photographer, then worked for three days straight developing his film.

He had clearly loved every minute of the trip. And he never did better work. On his return, he began to experiment with composite images, cooking some of his *Endurance* pictures to clarify the narrative or make them seem more dramatic. He inserted animals, clouds, whales, and figures. A hero after the expedition, in 1917 he went to photograph the war in Europe, hoping to make Australian soldiers look like heroes, too. He made more composites, adding sunbursts through storm clouds to give a divine light to images of dead soldiers on the battlefield. Military censors thought the photographs too graphic, while Hurley's superior, an official war historian, Captain C. E. W. Bean, regarded them as egregious fakes. The public loved them. Hurley next traveled to the Middle East and spent years photographing in the South Pacific. In New Guinea he filmed a travelogue, *Pearls and Savages,* then shot a feature-length movie, *The Jungle Woman,*

whose outlook on the native populations and their white colonizers was even then regarded as unsophisticated. Never a subtle man, Hurley remained a nineteenth-century bloke in a twentieth-century world—impatient with pomp, as indifferent to documentary protocols of objective journalism as he was to the aspirations of art photographers like Edward Weston or Ansel Adams. A showman and businessman, Hurley marketed his books and films in an effort to make a buck while keeping up a great craftsman's level of quality print production, a throwback to the days before automatic cameras. He was a master technician, but increasingly, he left behind the plainspoken magnificence of his Antarctic work. By the end he was grafting the Palestine sky onto a photograph of the outback for a picture book about Australia. He had witnessed two world wars but never again faced the same hardships and constraints as he had with Mawson and Shackleton, and it is probably not coincidental that he never again took pictures that were quite as memorable.

In 1848, when Germany revoked censorship laws in response to the revolution, Heinrich Heine wrote: "Ach! I can't write anymore. How can I write when there's no longer any censorship? How should a man who has always lived with censorship suddenly be able to write without it? All style will cease, the whole grammar, the good habits!"

If we are affluent enough today, we live amid a mounting glut of distracting choices, killing our time mulling over what food to eat, which clothes to wear or gadgets to buy, where to go on vacation. We can easily lose our way. When Hurley gained choices, he lost his focus. Wearing the same clothes, eating the same seal pemmican, staying in the same place, day in and day out, he was better able to concentrate on making the most with what he had at hand. That's perhaps his most enduring lesson.

Hurley died in 1962 at the age of seventy-six, upright in a chair after a typically hard day's work, knowing he was dying but refusing to lie down, an adventurer from the era of masted ships who lived long enough to see men in space.

FRANK HURLEY, *14 January 1915*

THE ART OF STARING
PRODUCTIVELY AT
NAKED BODIES

URING THE EARLY 1960s, Philip Pearlstein was among
various American artists who began painting deadpan
people. He has been doing it ever since. In his case, they're
nude models, combined with elaborate still lifes of antique
toys and other eccentric paraphernalia. All of us have our
daily routines, from which we hope to derive comfort and
sustenance. For Pearlstein, this has been staring at naked
men and women.

It is a Tuesday in early January, and Pearlstein is starting
a new painting, another entanglement of toys and nudes,
which, if the work goes at its usual deliberate pace, he pre-
dicts should take four months of sittings every Tuesday to
finish. I have decided to watch him work through the process,

to observe the routine of his life. Born in 1924, Pearlstein is still fit and muscular, a short and pixyish man who usually wears suspenders, T-shirts, sneakers, and rolled-up jeans. He is in many ways a typical painter. By this I mean that he has been doing basically the same thing for half a century while the art world, which keeps to its own strange rhythms, has decided he is in, then out of, fashion. He paints in a style that has become recognizably his own. It is an absurdly complex, painstaking sort of realism, with naked bodies, folk objects, weird perspectives, mirrors, and more or less buried art-historical allusions. Painting nudes still seems to shock many people, maybe even more than it used to when almost all painters painted them. Pearlstein's paintings have been vandalized and his shows canceled, and one curator was fired because he exhibited some of the nudes, which is odd because the art is the opposite of pornographic. It is graphic, but you would hardly call it erotic. If anything it is peculiarly austere, considering how baroque and eccentric Pearlstein's compositions sometimes become.

Other painters may paint with more superficial panache and variety, although panache and variety can be judged in different ways. There is subtle variety in Pearlstein's work. As to his work routine, on the other hand, he does essentially what most of us do whether we are in an office or we teach in a school or we drive a truck or we raise children at home: he follows pretty much the same schedule, day in and day out, trying to make something constructive of it. Contrary to the myth that artists are eccentrics, leaping from one peak of inspiration to another, Pearlstein exemplifies the greater truth that most artists live as they work: incrementally, day by day, in the same way that they build up a canvas or chisel a sculpture. They are creatures of habit. The dancer Twyla Tharp wakes up every morning at five-thirty and takes a cab to the

gym—a trite ritual but, as she has written, "a lot of habitually creative people have preparation rituals linked to the setting in which they choose to start their day. By putting themselves into that environment, they begin their creative day." Frédéric Chopin played Bach preludes and fugues. Beethoven took a walk with a sketchpad to jump-start his mind and jot down rough notes. Novelty in creative endeavors usually arises from routine—you have to be familiar with something before you know what is novel. The artist Chuck Close, Pearlstein's old friend, paints, draws, and makes prints out of small, nearly identical dots or marks, in themselves neutral, but arranged on grids of varying size that add up to an image. He has been doing this for nearly as long as Pearlstein has been painting nudes. Depending on how the marks are put together, the images resolve into different faces. Close's working process is painstaking, repetitious, and methodical. "My favorite analogy is a brick building," he says. "Stacked up one way the bricks make a cathedral, another way they become a gas station. Having a routine, knowing what to do, is crucial because I'm naturally lazy. A routine is what keeps me from going crazy. It's calming. My working methods are almost Zenlike, like raking gravel in a monastery."

The illustrator Al Hirschfeld is another edifying example of a habitual workaholic. He caricatured Broadway actors for the better part of the twentieth century. Once, after he returned home from a run-through of Ariel Dorfman's *Death and the Maiden,* he told his wife that the play was about Germany after the war. The play was about Chile after dictatorship, but Hirschfeld had not been paying attention to the plot. He saw Gene Hackman onstage gagged and tied to a chair and assumed he was a captured Nazi. It didn't really matter anyway. Hirschfeld's interest was in gestures, manner-

isms, the way an actress dashed across the stage or cocked her head while Hirschfeld sat in the dark of the auditorium jotting shorthand impressions to take home and translate into drawings. Bent over rough pencil sketches at his drawing board, Hirschfeld then meticulously, slowly traced each line inch by inch with his pen dipped in ink until those pirouettes and curves looked as if they had happened all at once. He had developed this process through more than seven decades. Like the theater, the impression of rapid motion, conveying an actor's animated personality, entailed an illusion, perfected through routine.

Hirschfeld, Close, and Pearlstein, as it happens, all went through a similar transformation to become figurative artists. They flirted with abstraction but, in different ways, for personal reasons, gravitated to what has naturally preoccupied human beings since the first man or woman rubbed colored dirt on a cave wall. Close was an abstractionist at Yale during the early 1960s before he settled on painting people. Hirschfeld went through a flirtation with what was new and radical when he was young, which meant the modernism of the 1910s and '20s. A few of his caricatures of actors, drawn once he returned to New York from the requisite sojourn to Europe (he bought passage on a steamer for $65 and lodged in a cold-water flat in Paris, earning cash tap dancing and playing the ukulele), toyed with European styles of the time like constructivism and cubism. He passed through a political phase next, making lithographs for the *New Masses* magazine in a knockabout style consonant with the leftist taste of the era, but dark political satire and working-class salutations did not come naturally to a gentleman like Hirschfeld, whose milder demeanor led him toward comedies of customs and manners. And so he settled into his routine. His subjects often said Hirschfeld's caricatures captured in them

what even they couldn't see of themselves, a livelier self, which inspired them to imitate how he saw them. Another way to put it is that his portraits projected onto everyone a vivacity that we all wish we had. Both Hirschfeld and Close, very different modern artists who decided against abstraction as an end in itself, developed their own routines for drawing and painting people, one outwardly lithe, the other seemingly mechanical, although not really so—both full of life.

For his part, Pearlstein started out in the 1950s painting soupy, roiling abstractions, like almost every other young artist who wanted to be fashionable at the time, but by the late 1950s he and other Americans, like Alex Katz and Alfred Leslie, were asking why, exactly, painting figures had become a defunct and academic pursuit. So he did a radical thing: he became a conservative, sort of, painting nudes, except that his nudes were not idealized bodies but real people with sallow flesh. The style was aggressive, unromantic, uniform, literal, and unnatural in that it showed what were clearly contrived setups, not everyday scenes, sometimes brutally cropped, with an impersonal touch that was the deliberate opposite of abstract expressionism, with all those drips and slashing lines. Pearlstein and Leslie wrote a list of no's: no atmosphere; no sentimentality; no soft lighting. There was something of minimalism's dedication to just plain facts in Pearlstein's approach and a commitment to an underlying abstract geometry that gave a contemporary edge to the work, although this was not immediately easy for some people to grasp. Pearlstein was difficult to pigeonhole. He was not a political artist, painting protest art. Nor was he an erotic artist in the spirit of the swinging sixties, nor a feminist making radical art out of women's bodies. Although he mixed Pop elements into the pictures, painting nudes with Mickey Mouse, Godzilla, and

the Empire State Building, no one mistook him for Warhol or Roy Lichtenstein, either. Over the years his compositions became increasingly complicated and crammed with props and mirrors, but even so he kept doing essentially the same thing—since the early 1980s in a converted factory building in Manhattan's garment district, where he and his wife, Dorothy, still occupy an entire floor. Like his art, the studio is overstuffed with things they have collected, mostly cheaply, from flea markets, galleries, and antiques shops. Over in one corner is a Han dynasty horse, in another, a mechanized Mickey Mouse marionette on a cardboard stage, a gift from Desirée Alvarez, one of Philip's models. There are bulging shelves of neatly stacked brushes, solvents, paints, and glue; a metal rolling table is piled with videotapes that the Pearlsteins shot on vacation, which they like to take in remote and far-flung places. There's a plastic blowup chair of the *Star Wars* character Darth Maul, another joke gift, and a toy dirigible, about the size of a sofa, hanging from the ceiling. And in the next room, where everybody eats lunch at a long wood table, there are pre-Columbian sculptures, antique weather vanes, old painted carousel horses, cracked potsherds, American Indian flints, a glass eyeball, rusty painted wind-up toys, an ancient Cypriot head (the kind with the big nose, a work the Metropolitan Museum owned but sold off years ago), Mayan tools, tiny Eskimo baskets from the turn of the last century, minstrel puppets from the 1850s made by African carvers, Japanese prints, Roman heads, marionettes from Burma (where Pearlstein once vacationed), various house-plants, now forty years old, which have grown to occupy one entire end of the room, and a life-size sculpture by a friend, Anne Arnold, of the Pearlsteins' dead dog, who was a medium-sized Hungarian puli named Lassie Shimmel. The studio is about

4,000 square feet, but, with so much stuff in it, the Pearlsteins sleep on a Murphy bed to save space.

Pearlstein used to paint every Monday through Friday, ten to four. Now it's Tuesday through Thursday, not counting the occasional portrait he will do on a weekend. Although these days he has trouble hearing, he is sneaky, like his work, and sometimes he can surprise you with a joke when you think he's not listening. He's an endearing man, and his humor is often at his own expense, but as he's prideful and, like many artists, a little thin-skinned, the jokes may tend to be double-edged. One afternoon during a break, he launched into a story about a landscape he painted that was reproduced in *Arts* magazine during the 1950s. That reproduction gave his career a big boost. Years later he met the editor and thanked him. "The guy told me that back then he had just been fired for being an alcoholic, and as a parting shot he put my picture in the magazine because it was the ugliest thing he'd ever seen."

His model, Desirée Alvarez, a fabric artist and painter in her thirties, has posed for Pearlstein for more than a decade, becoming a kind of surrogate daughter. Some years ago she brought in a friend of hers, Alexander Matte, a young waiter turned nursing student, a sweet, burly man with a cheerful, wide-open face, to pose with her. Artists' studios can be like any other offices. They may be businesslike and formal or casual and friendly. Pearlstein's is the latter, but with a strict timetable. The atmosphere is familial and calm. Like all good bosses, Pearlstein has cultivated supportive relationships with his favorite employees. The models who stick around get to know each other and can watch themselves age in his pictures, an alarming sight for some of them. Because most artists' models model part-time, Pearlstein uses differ-

ent models on different days and therefore works on several pictures at once. This has its disadvantages and advantages: he has to drop what he's doing at the end of each day, but several days or a week later he returns to it fresh. His studio, being enormous, is divided up by partitions, like sideshow booths in a fair, lined up against one long wall, each partitioned area dedicated to a picture in progress. For this painting, Philip has set up a scene using a child's red antique toy tractor and a toy airplane that his eldest daughter, Julia, gave him. (He has three grown children.) The plane dangles from the ceiling. Alvarez's Mickey Mouse marionette and its cardboard stage are on a stool next to the tractor, and Pearlstein's easel is a couple of feet away, propping up a canvas five feet square, stretched slightly loose because otherwise, Pearlstein says, "the canvases become accident prone; every dent shows up when they're stretched too tight." Because he doesn't want to deal with the problem of natural light, which keeps changing, blackout curtains cover the windows and block out street noise. Models have affectionately taken to calling the studio the Batcave. It is cozier than that implies.

I settle into a chair about ten feet away from Philip and pull out my notebook. This will become my routine for the winter and spring, the studio my own little sanctuary from my usual job every Tuesday. I jot down that Pearlstein is wearing baggy corduroys rather than jeans with his T-shirt and suspenders (his clothes vary about as subtly as his pictures). In his left hand he holds a paper towel, and he usually keeps that hand behind his back while he works, standing erect, like an admiral on the deck of his ship. He employs a palette knife that he has had since college; a pile of half-empty tubes of paint are on a plastic tray with a glass jar of cloudy solvent and a makeshift cardboard backsplash taped to one end of the tray to prevent paint from spraying onto the

canvas when he mixes it. The tray is perched precariously on a metal stool. A second stool has more tubes of paint and a jar for brushes. They are near to each other and to him. When he paints, he constantly slides the stools around to make way for the easel, which also has to be moved around, but somehow, through experience and an oddly balletic instinct, he never knocks the stools over. It seems almost miraculous.

Up to a point, he lets the models pick the poses. After half an hour of trying different possibilities, Alvarez ends up sitting on the tractor, half-turned toward Pearlstein; Matte takes a position on the floor, legs extended across a patterned carpet, his back leaning against a heating riser, so that his body is partly blocked from Pearlstein's view by the Mickey Mouse stage toy in the foreground. Mickey's and Alex's heads now make a little visual rhyme: their receding hairlines (like two cursive capital E's) match, to Alex's horror.

Pearlstein puts charcoal to canvas, lightly drawing two lines for the toy airplane at the top center of the picture, then moves right, to outline Desirée's body: her head, back, the profile of her left breast, and her crossed legs. He roughly marks the edge of Alex's face and features to figure out where Mickey will fit. This early stage, Pearlstein says, is like putting together a jigsaw puzzle. "What I look for in the beginning are shapes, a subdivision of the square. You might say I think in terms of Matisse when I start. In my youth I did color separations for equipment supply catalogs, which was about reducing everything to flat shapes. Before that I did lithographs and prints in the army and learned how to work up an image in stages, so I've taught myself to work the same way in paint: go after the big shapes first, then make them three-dimensional, from Matisse toward Vermeer."

A string quartet feverishly tackles Beethoven on the stereo, but the room has the quiet, uneventful air of a place to which

people have always come to do something familiar and pre-
dictable and where the excitement takes place on canvas via
some unexpected discovery or slip of the pencil or brush.
Desirée, I note in my pad, keeps her eyes open while posing,
partly because, she later explains, she doesn't want to seem like
the passive object of a viewer's gaze. At the same time she care-
fully looks away from, not at, Philip, because she knows from
experience that to look directly out from the picture would
make the painting seem more like a portrait. Pearlstein's mod-
els are people in his work, but they are objects, too, like the
Mickeys and the airplanes. They are not portrait subjects. The
critic Sidney Tillim once derided the "unsociable view of man"
in Pearlstein's art, where figures don't relate to each other ex-
cept as formal elements in the picture. Men are splay-legged,
supine, their genitals limp; women passive, weary. Desirée is a
more attractive woman and Alex a more animated man in real
life. But in the work everything is subordinated to an unforgiv-
ing style and to the geometry of the composition. It's this
allover abstract armature that some people find most off-
putting in Pearlstein; but others find it fascinating. Desirée
thinks that reactions like Tillim's miss the point. "It's all artifice
in Philip's work: he paints naked people in little spaces with
odd objects, so to apply the rules of social conventions to this
very artificial world makes no sense to me. I see the works as
philosophical paintings. I find the history of civilization in
them—in the combination of objects and people: the rugs have
history, they're Navajo or Turkish, and so do the folk objects.
I've modeled with a Greek head. The geometry of the paintings
is what it is all about: it's about how we choose to see form and
make sense of it. If that's not philosophy, what else is it?"

Alex falls asleep while posing, miraculously awakening at
the breaks, which come every twenty minutes and are strictly
observed—Desirée keeps an eye on a timer on the floor. The

models dress, tumble into odd lawn and office chairs scattered near the stereo, and riffle through the newspaper while Philip tinkers with the painting. It is a peculiarity of Pearlstein's art that his models look relaxed to the point of seeming comatose in his pictures, but their poses are often painfully awkward to hold. Scrunching onto the seat of a toy tractor is not particularly enjoyable, so for models the breaks become the second most necessary events of the day after lunch, which, unless Alex is worried about gaining weight, is takeout from Manganaro's Hero Boy, a few blocks' walk north, or cheap Chinese up the street. It is carried back and ceremoniously served with glasses and silverware on the dining room table. Alex makes the espresso. Dorothy, Philip's wife, appears. She is Pearlstein's alter ego, a former painter, a clever and discreet analyst when asked to comment on his pictures, the one who clears space in Philip's life to make it possible for him to work. The two of them look like a pair of nesting dolls. They are inseparable. She is very funny. The models adore her.

After lunch on this first Tuesday, Pearlstein decides he doesn't like what he did, so he rubs away the accumulated charcoal with a paper towel. Although his compositions would seem to require elaborate preparatory sketches, Philip prefers to plunge in on the canvas. He declines to work from photographs or from a photographic projection, eyeballing his subjects the old-fashioned way. He'll make the figures bigger, then smaller to get the perspective and proportions mapped out right from the start. It's painstaking. At one moment I calculate that Desirée would be nine feet tall if she were as large as the figure Philip drew. "At a certain point I have to accept what I have seen," he tells me. "Otherwise I will keep shifting the image around forever, like a Giacometti. It would be easier to work from photographs, obviously, but there's an energy, an urgency working from life

that doesn't come from a photograph. You're capturing something elusive, something you're not always sure of, and you're trying to capture it before it vanishes." Pearlstein's art is about experiencing fully the here and now, he believes, which is always right before his eyes, but fleetingly. He replaced the spontaneity of the abstract expressionists of the previous generation with his own shifting scrutiny of the moment. Stare at anything long enough, and it will seem to move and change before your eyes, he points out. Models move; they can't help it. Their poses change slightly hour to hour, week to week. Like all realists, Pearlstein must wrestle these unruly visions into cogent shapes. It's a challenge, his routine. "Lucky artists are the ones who hook into a problem beyond solution," he adds. "I stumbled into it. I'm interested in the Japanese artist Utamaro and in Egyptian art because I like art that involves variations on a theme. I like Indian ragas, too. The alternative sort of artist is Picasso, who kept changing. But I hate those last things he did as an old man. He was desperately looking for novelty, turning art history into a crazy comic book."

FOR AS LONG AS there have been artists there have been different strategies for depicting the nude. Some Paleolithic sculptor, 30,000 or so years ago, carved the tiny limestone Venus of Willendorf, whose enormous breasts and stomach suggested fecundity and health at a time when famine was commonplace. The sculptor presumably started with some real body, then fiddled to make what may have been a talisman or a magic charm. Other prehistoric artists devised their own ways to express ripe sexuality or fertility. There is the tapered, lozenge-shaped female figurine nicknamed "La

Polichinelle" in the museum at Saint-Germaine-en-Laye, with its swollen stomach and buttocks; and the predynastic Egyptian figurine of the priapic god Min.

Artists have mostly not drawn, painted, and sculpted exactly what they saw when they depicted naked people. What they saw, as we discussed before, were imperfect bodies with the inevitable wrinkles and lumps. What artists drew and painted derived from some abstracted concept of the nude. This might be the concept of the bull men and horned demons of earliest Mesopotamia, or the voluptuous and seductive copulating men and women of Indian sculptures, or the striding nudes of Archaic Greek art, or the Apollonian gods and goddesses of Hellenistic sculpture, or Leonardo da Vinci's *Vitruvian Man,* with his outstretched limbs fitting miraculously into a perfect circle and square. Nudes were erotic, because beautiful naked bodies tend to be so, but the naked form, in its abstract beauty, was at least ostensibly also meant in the West to convey some high-minded spiritual and intellectual ideals. The New Testament said, "The Word was made flesh, and dwelt among us." Leon Battista Alberti, the great Renaissance Florentine who wrote the book on painting, said that painting the naked body was, like studying perspective, a necessary part of humanistic education. The Florentines of Alberti's day, as Kenneth Clark has put it, "valued a demonstration of anatomical knowledge simply because it was knowledge and as such of a higher order than ordinary perception." So it was, in the West anyway, from the Greeks into the nineteenth century, when the proliferation of traditional art academies meant that art students and their teachers produced, often as if by rote, vast quantities of boring, academic nudes and comparatively few versions of the body as original as Jean-Auguste-Dominique Ingres's odal-

isques: serpentine sirens of preposterous proportions, perversely stretching the limits of academic standards.

In the way that extremes in life often beget their opposites, the nude as a classroom exercise opened the door for modernists. Gustave Courbet, Edouard Manet, Edgar Degas, Paul Gauguin, and Paul Cézanne were among those who took up the challenge to invent fresh forms for—and inject new life into—this exemplar of academic tedium. True realism was one response. Courbet's fleshy nudes were definitely, even aggressively, corporeal. Matisse and Picasso carried the agenda of revolution forward during the early twentieth century, egging each other on to greater extremes of formal violence, with works like Matisse's *Bathers with a Turtle* and Picasso's *Demoiselles d'Avignon,* which even a century after they were painted look shocking. As the art historian Kirk Varnedoe put it, modern artists believed that the old rules of academic style were "not something you play by," they were "something you play with"—which is to say that the old rules still mattered, they were still ingrained. That's what made modern art startling. It sustained the memory of what it rejected. It is what comes to mind every time Pearlstein paints his droopy models today: his work is inevitably measured against this long legacy of representing idealized naked bodies in art.

By February I have come to feel almost part of the gang in the studio, although I am doing nothing except watching and occasionally getting in the way by asking a question. I wake up Tuesdays looking forward to the peace and quiet and concentration—to the guilty pleasure of having an excuse not to be in my office or at my computer for a few hours. Pearlstein's routine has become a relief from my own.

He has begun to put paint to canvas. He starts, after wiping the excess charcoal from the canvas, by mixing cadmium red dark, black, Alizarin crimson, and white and attacking part of the tractor. Squeezing blue onto the palette, he traces the trim of the airplane wings and the top of Mickey's stage with a thin brush and maulstick. He does curves freehand, fluently. The paint starts to make the image leap into perspective. "I put in the things first that I think will jump out and which everything else will have to compete with," he says. "When I develop the figures, they will have to compete with the airplane, which is very bright and busy, and so I need to know what to measure the intensity of the figures against. I got that partly from looking at Bonnard, his busy wallpaper competing with his figures." The balance will change drastically when the words printed on the side of the toys are painted. They'll catch the eye first. The words *jumbo jet* on the airplane "will be almost like the word 'God' in a medieval painting," Pearlstein says, meaning they will leap out. This is evidently the first painting he has done with so many words in it. He says it just happened that way, as if the choice to include the words in the picture were not his—as if he merely records whatever happens to be in front of him. "Letting things happen by chance: that's a little Duchampian, I suppose."

Pearlstein studied Marcel Duchamp and Francis Picabia in graduate school at NYU. He had come to New York from Pittsburgh. In high school he won an art contest for painting a carousel. That painting, an Ashcan-style scene in brown and orange, hangs in a corner of his studio. Enlisted in the army and stationed in Florida during World War II, he designed and silk-screened infantry training charts; then at the end of the war he was in Italy painting traffic signs. After that he went to the Carnegie Institute of Technology on the

GI Bill. When he and a classmate, Andy Warhola, graduated, they decided to share an apartment in New York. To support himself in the city while he painted (he was experimenting with images of Superman and dollar signs before Warhol invented Pop), Pearlstein landed a job with Ladislav Sutnar, the émigré Czech designer, putting together catalogs of American Standard bathroom fixtures like urinals, sinks, and toilets. Partly this inspired his interest in dadaists like Duchamp and Picabia when they were still not really taken seriously by art historians. Meanwhile, he painted. "My first ten years in New York I had full-time jobs, working for Sutnar, and I got used to a routine then. Sutnar was so disciplined. He had to be. I learned a lot from him about how to solve problems, about organization and design—about how to organize a creative routine. I would paint every night, eleven to one. Andy used to be up all night drawing. He worked very hard. He would get assignments as an illustrator and do five or six versions for the art director to choose from the next morning."

By the late 1950s Philip was spending Sunday nights at the studio of the painter Mercedes Matter, drawing models from life. "It was a group of us, Philip Guston, George McNeil, Jack Tworkov. Sometimes Meyer Schapiro, the art historian, came. Mostly nobody looked at anybody else's drawings. Everybody was working in different ways. McNeil had two big fat brushes, one in each hand, and his eyes seemed to be closed when he painted. One day somebody noticed what I was drawing and expressed complete surprise. I was the only one in class drawing a complete figure, with closed contours, you know, a fairly traditional nude, which looked revolutionary in that company. For me figure drawing was like a game. I saw the body as a compositional problem, which related to my previous abstractions. When I was in Rome after the war I did wash drawings of the ruins at the Forum, which in-

spired closed shapes in my abstractions. I went to Maine and drew rocks. The same thing happened. So at first I saw bodies the way I saw rocks. Then I hired a few models, a male model, a man and a woman. Male models had just stopped using jockstraps. When I showed the works to my dealer, I realized that I was doing something shocking because he said he couldn't stand looking at the paintings and that he'd be arrested for showing them. A painting in a group show in Philadelphia ended up being moved to a separate room. At the time I was teaching at Brooklyn College with Ad Reinhardt, the abstract artist, who trapped me in an elevator at school one evening and said, 'Don't you realize you are responsible for the souls of these people in the paintings?' He was dead serious. He thought figure painting was a betrayal of everything abstract artists like him had struggled for."

PROGRESS REMAINS steady through the spring on our painting, the image gradually emerging as does a photograph in developing fluid, almost magically. Dorothy, wandering in one afternoon, suggests only half jokingly that Philip quit while the brushwork is still loose and obvious. Loose brushwork looks expressive, she says. Philip has heard this argument before. "The hardest thing for me when I settled on how to paint was getting rid of the active brushwork, which abstract expressionism was all about. That's what I was brought up on. De Kooning was the Vladimir Horowitz of the brushstroke. It was incredible. But I'm going for a smooth, finished surface. Each area still has its own subtle texture, the skin, the metal of the tractor. A painting is never really flat. When you really look at a Mondrian, you see it's lumpy. The surface is alive. He built up paint over time, through changes based on staring so long at the pictures that the lines began

to move in front of his eyes. That's the time element in Mondrian. I used to stare at his *Broadway Boogie-Woogie* in the Museum of Modern Art just to watch the forms start jumping."

Philip's goal is a surface subtly alive like the surface of a Mondrian, an effect that takes time to achieve—ample time being crucial to his routine—although he complains that arthritis in his fingers slows him down now, making it hard even to squeeze paint from the tubes. He seems to me to paint fairly effortlessly. At one point he paints the shadow that Alex's head casts on his neck and chest, a kind of cowl shape, and glancing at Alex, I notice the head has another, lighter shadow. Turning back to look at the canvas a second later, I see that Philip has already painted it. With a few flicks of the wrist, up then down, he sketches in the chest hair and pink nipple. The torso snaps into depth.

Desirée finds his fluency impressive but is as taken with his steadiness. "He has become a role model for me, not in that my art is anything like his but in terms of discipline and day-to-dayness and commitment to work even when it isn't going well. The setup of the still life and model in his studio becomes much more than just a boring routine. I know Philip is interested in Zen monks and in that whole Zen tradition of calligraphy. Monks spend all those hours meditating. They have their routines, because they think that within routine, and only within routine, enlightenment comes. There is a routine to modeling, too.

"There have been moments," she adds, "when a model suddenly starts sobbing. You've got all those hours to fill, and you can end up somewhere inside yourself, at the same time that you have shed all those layers of clothing. It's strange. You're naked. But that's just when as a model you can leave your body."

THE WORD *PORNOGRAPHY* was invented in the nineteenth century. As the late French philosopher Michel Foucault pointed out, the Victorians' obsession with analyzing and repressing sexuality only made sexuality a more conspicuous part of society. While busily legislating decency, Victorians also flooded the market with erotica. The new inventions of photography and film thrived in part because of the Victorian public's appetite for nude pictures. Fetishizing gradations of visual morality, Victorians thereby turned prudery and salaciousness into bedfellows, and artists threw themselves into the job of painting what often masqueraded as serious, historically themed nudes for an audience wanting titillation while pretending not to: pictures of depilated young maidens shackled to rocks or bound to herms or draped over the oars of a ship (the boatmen bravely stare straight ahead), and of naked young slaves striking heroic poses while awaiting the lions in the Circus Maximus. Pictures of apple-cheeked English girls vamping as ancient Romans soaking in antique plunge baths or of naked boys exercising on beaches as if they were Greeks skirted the line between art and obscenity at a time when that line was not yet clearly fixed.

A classic Victorian case is Lewis Carroll, whose real name was the Reverend Charles Lutwidge Dodgson and who in his principal career was a mathematician at Christ Church, Oxford, but who in his spare time photographed friends, acquaintances, and their children. A world steeped in psychoanalysis has inevitably come to see Dodgson's photographs through Carroll's looking glass, as the work of a grown man with a disturbing fixation on little girls. He was actually a healthy Victorian adult, a clergyman with a mature sexual

appetite who wrote grown-up love poetry and who was recalled fondly by the girls he photographed when they became adults. Neither a sweet, celibate Oxford don nor a Humbert Humbert, he was urbane and socially ambitious, a serious scholar. Queen Victoria was supposedly nonplussed to receive *Euclid and His Modern Rivals* after she had asked the author of *Alice in Wonderland* for his next book.

Having lost touch with Victorian conventions, we may now fail to see Carroll's photographs as he and his contemporaries did. His pictures of children, mostly clothed but occasionally nude, like his photographs of adults, often entailed elaborate allegories and made-up narratives, as did the photographs of another Victorian, Julia Margaret Cameron, whom no one accuses of pedophilia because we know she was a proper woman. Psychiatrists have had a field day with Carroll's rabbit holes and tiny keys and his stories about Alice growing and shrinking, finding confirmation for their hypotheses in photographs like the famous one Dodgson once took of a girl reclining on a divan. I estimate that she is eight.

LEWIS CARROLL, *Xie Kitchin*

Her eyes are shut. Her left arm falls limply across her stomach, her hand resting just below her waist, in the folds of a loose-fitting dress or nightgown that has come off one shoulder, exposing the upper part of her chest. A strand of hair tumbles over the other shoulder. Her legs are bare. The picture, like the girl, is beautiful: patterned fabric set off against skin, grays against white. The arms of the divan gently embrace the girl, who, we assume, must be aware of our gaze because she is so obviously posing. We stare at her, uneasily across a century of psychoanalysis, inclining toward what the author of *Lolita*, who had no taste for Victoriana, wrote about Dodgson, that photography was his ploy to linger in a room with "sad, scrawny little nymphets, bedraggled and half-undressed, or rather semi-undraped, as if participating in some dusty and dreadful charade."

But childhood meant something different to Victorians than it meant to Nabokov. For Dodgson to write that "a girl of about 12 is my ideal beauty of form" and also that "one hardly sees why the lovely forms of girls should ever be covered up" is alarming today but was unexceptional in his time. The Victorian cult of the child, connected with the cult of the woman, glorified purity and innocence. As the Dodgson expert Douglas Nickel has written, "Dodgson could pose his charges in adult roles, give them guns, daggers and exotic costumes, even portray them as odalisques and half-dressed waifs, because he and most of his audience believed so emphatically in their total insulation from the implications of such postures. These presentations do not so much underscore the latent sexuality of the child (as we post-Freudians would have it) as they do an obvious lack of it." They were, in other words, routine.

"The real distinction between sin and innocence," Carroll once wrote, with good historical reason, is whether the

viewer feels "sinful feelings or not" looking at a picture, and the same applies to how we judge art today, especially nudes, including Pearlstein's. We have in a sense returned full circle to mountains and to the shifting, historic vagaries of our assumptions about familiar, natural sights. We have always looked at naked bodies. We stare at them in the mirror or in the shower or in bed with our lovers. We think we know what nakedness is. But conventions change. They are fluid, like taste. And *convention* is another word for *habit,* which is also a word for *routine.* There are of course many kinds of routines when it comes to art. One is a way of seeing, which shifts over time along with the rest of human culture, good artists hastening the alterations in our habits of looking. Another kind of routine is a way of working, which most good artists practice because it helps them to see more clearly where they are leading us.

As May arrives, with Pearlstein heading toward the last touches on our painting of Desirée and Alex, I become melancholy because the end is in sight. Philip turns to the tricky problem of Alex's foot, jutting, as if disconnected from the leg, up into the lower right corner of the picture, a formal serendipity Pearlstein didn't exactly plan when he first envisioned the setup but capitalizes on. This is the most difficult corner of the work to paint, with the foot, a swath of complicated patterned carpet, and the tractor. Philip has left it until now. He repaints the tractor, lightly at first, then again and again, adding one thin layer after another. Desirée compares Philip's process to rehearsing for a performance, repeating the performance with slight changes each time. Repainting Alex's face as well, Philip puts down a layer of thin beige, which is like a stocking suddenly pulled over the head, the features reemerging as he goes back and gradually picks them out. At one point he calls me over to look at how

Desirée's veins pop because she is straining to hold her limbs immobile, and we both stare at her for a few seconds, as if she were an object behind glass, which causes her to turn slowly, one eyebrow raised. Popping veins are the sort of detail Pearlstein weighs at this point: popping out, they make the figure look cartoonish, and he wants to avoid the impression of a particular instant in time. Awkwardnesses inevitably creep into this sort of clinical realism: an odd, winglike shadow is cast by Desirée's shoulder; her elbow seems to hover above the steering wheel, rather than rest on it; Alex's right leg looks puny. But this is simply what Philip sees from his perspective. "It's what happens when you work with real people and two eyes," he says. "Optical truth reveals the lie of conventional schoolbook perspective. Cézanne was right: a line, like the line of a tabletop, interrupted by an object, like a tablecloth, seems to reappear at a different latitude on the other side of the object, even though that makes no logical sense. It's just how the eye works. That's the nature of realism.

"By the end I feel like a plastic surgeon," he adds. Desirée, half kidding, responds: "If only you acted more like one, we'd all be looking a whole lot better." I ask Philip later about something else she has told me—that she thinks he is more naked than she is during this process. She said she would feel much more naked having to make art with other people watching. He ponders this and laughs. "That's possibly true but I never think about it," he says. "The ecstasy of creation is when, as an artist, you are one with and totally absorbed in the act. It is the same experience whether it is the act of painting, making music, or writing. The experience really obliterates all other considerations at that moment. The act of re-creating the visual experience of the models in front of me is absolutely absorbing, leaving no room for ex-

traneous thoughts, sexual or otherwise. My routine is my way of controlling hysteria. I have come to the conclusion that Mondrian was really a repressed hysteric. His work is tremendously emotional, but the emotion is repressed. There's no way to get rid of emotion in art. It's just a question of making something constructive out of it."

Most artists, like most people, have one good idea or maybe two in life, and that sustains them. In the best circumstances, that's plenty for a career. Giorgio Morandi, the great Italian still life painter, quietly toiled away in Bologna, in the house he shared with his mother and three unmarried sisters, in a bedroom that doubled as a studio, seemingly oblivious and immune to shifting tastes, painting little bunches of bottles, bowls, and biscuit tins. His message—look slowly and hard at something subtle and small—was simple but turned out to be plenty. The work sustained him. Pearlstein is fond of a story that Chuck Close tells about visiting Willem de Kooning, who was then an old man with Alzheimer's. Chuck found him slumped in a living room chair, glassy-eyed, staring at a television. He asked to see de Kooning's paintings. De Kooning rose from the chair, straightened up, and suddenly became focused. He was lucid while surveying his art. Later, as Close was readying to leave, de Kooning shuffled back to the television, hunched, and sank into the chair, his eyes glazing over again.

"All these wild things go on in the world," says Pearlstein. "What happens in the studio, I can control. I can do something constructive in the world. That's a lesson I learned in the army: in war, everything is destruction, so anything else we may do can be a gesture of opposition." Speaking of war, I ask him, might the descending plane in our painting be a 9/11 allusion, with Mickey implying America while the two sleepy naked models are like Adam and Eve, oblivious and

innocent on the verge of a catastrophe? Pearlstein smiles. "I see it, but I prefer not to," he says.

"I paint nudes. I've done my best to make paintings that would sell; it's just not worked out that way." (This is not quite true.) "I expect this one won't sell either. There isn't much of a market for chest hair. But this is what I do. I'm a painter. I wake up every morning and get to work. It's my little contribution to civilization."

PHILIP PEARLSTEIN, *Mickey Mouse Puppet Theater, Jumbo Jet and Kiddie Tractor with Two Models*

THE ART OF THE
PILGRIMAGE

A RT MAY COME to us too readily now. If we live in or
near cities with museums, little sacrifice may be re-
quired on our part to see it. But convenience comes at a price.
Early in the twentieth century, Walter Benjamin predicted
that mechanical reproduction would eradicate the aura of
the original art object for the masses that are "bent toward
overcoming the uniqueness of every reality by accepting its
reproduction." Posters, postcards, newspapers, magazines,
television, and the Internet, proliferating after Benjamin, of-
fered the prospect that eventually any work of art in the
world might be available in reproduction at the touch of a
button or a click of a mouse.

What resulted was exactly the opposite of what Benjamin forecast. The allure of the original seems to have only increased, not declined, in direct proportion to the spread of reproductions. The uptick in museum attendance in recent decades and wild auction prices for unique works have clearly signaled the continuing attraction of the singular art object. This has stemmed partly from a phenomenon that Benjamin also did not take into sufficient account: the jet age of traveling exhibitions and mobile art collections. As reproductions became more widely available, so did originals, which millions of people who have crowded each year into places like the Metropolitan Museum or the Grand Palais in Paris or the Tate Modern in London simply expect to arrive in a bountiful supply unhindered by the obstacles of distance, political differences, and the practical hurdles of transporting fragile items by air, road, or sea. An industry of conservation arose to accommodate this burgeoning phenomenon, spawning new space-age technologies for packing crates with temperature controls to preserve and protect sculptures and glass and painted wood panels and pastel drawings and other especially sensitive works, which now sometimes actually may be safer in these packing crates than in the variably tended galleries they come from. Increasingly complacent, we have received these gifts as if great art were always meant to come to us, like tributes to Caesar, rather than the other way around.

We did lose something during the last century, although it was not, as Benjamin said, a craving for the original. It was a sufficient appreciation for the virtues of the pilgrimage. The Web and mass media flood everyone with the same images, and museums shuttle much of the same art from place to place. On the positive side, this shared culture has created a newly heightened role for the one-of-a-kind encounter. Even

via a benign and comfortable form of travel, a modest pilgrimage may restore to the act of looking at art its desired and essential otherness. It can get us back to the root of art as an expression of what's exceptional in life.

Works like Giotto's chapel in Padua or Michelangelo's Sistine or Angkor Wat in Cambodia or Constantin Brancusi's *Endless Column* in Tirgu Jiu or Le Corbusier's chapel at Ronchamp—the list, of course, goes on and on—being exceptional and immovably rooted where they are, require such a pilgrimage. Some years ago I ventured to Colmar, a prosperous town of old half-timbered houses across the Rhine from Germany in eastern France, about forty-five minutes from Strasbourg. It has a famous restaurant that entices some gourmets, a church that I gather is the second-best example of Alsatian medieval ecclesiastical architecture, and a regional museum. It is not a destination for the usual package tours and coach parties, although it is a pilgrimage site for knowledgeable art lovers because of a single work, Matthias Grünewald's Isenheim altarpiece.

Even in the age of traveling art it is unlikely that this most riveting of all German Renaissance paintings will ever go anywhere, fortunately: it's too big, too precious. Of the handful of the greatest works of Western art, it's the one that may have been seen firsthand by the fewest people, or anyway by the fewest Americans. To see art in its context is always useful—we forget how misleading it may be to confront a painting conceived for a specific chapel in Venice on the wall of, say, a museum in Vienna or Paris—but that is a separate issue from Colmar and Grünewald. His altarpiece was painted for the hospital chapel of Saint Anthony's monastery in Isenheim, a town about fifteen miles from Colmar. Whether in Isenheim or Colmar, the altarpiece remains an object that nearly defies reproduction or even understanding, except in

its presence. Its scale, wild color, and complicated design, with double-hinged panels that open and close, can't really be grasped otherwise, and I am sure that the feelings I had standing before it, like those of countless other people before me, were influenced by the effort of going there—as they also were by the particular chill in the room on that day and by the silence of looking while nobody else happened to be around. All art is site-specific in the moment that we are looking at it, being affected by its surroundings, whether the context is a crowded museum or a friend's living room or an empty chapel, but perhaps especially art that is itself the reason you went to that place.

Grünewald painted his altarpiece to help reconcile sixteenth-century victims of the plague and of syphilis to their suffering. With its panels shut, the work presents a crucifixion of phenomenal violence and pathos. Periodically museum guards will open the panels for visitors. Opened once, the altar reveals a concert of angels with the Madonna and Child flanked by an Annunciation and a Resurrection. Opened farther, it shows apostles surrounded by scenes from the life of Saint Anthony. On a late afternoon in the large Gothic gallery of the museum where it is exhibited, grayish December light coming through pointed windows, the painting—its huge imagination but also its delicacy, which describes and, by virtue of its redeeming beauty, belies the horror it depicts—made me wish to slow the clock to impress the moment more firmly into my memory. Artists make works one at a time, I was again reminded, which is how we should experience them. The ethos of giant exhibitions, with dozens or hundreds of paintings—notwithstanding that these shows can be spectacular—is antithetical to the conception of a work of art. Installation art today, sometimes a catchall for site-specific art, even though much of it is half-baked and badly devised,

seems in part an implicit reaction by young artists to a culture increasingly defined by huge shows, noisy museums, and a distraction-prone public. A work of installation art, in a room or space of its own, compels people, if only briefly and sometimes grudgingly, to focus on just one work. In an ideal world we might experience everything, and everyone, with such complete attention. Meanwhile, we can start with a single work of art in a place like Colmar.

The idea that viewers might bring to looking at a work some small measure of the concentration that an artist brings to making it has inspired a number of venturesome American artists, beginning in the late 1960s and '70s, partly in disillusioned reaction to the failed utopianism of the earlier '60s, to place some gigantic sculptures in very obscure spots, requiring that interested people travel to see them. It occurred to me not long after visiting Colmar to take them up on this challenge. I knew this would require crisscrossing large swaths of the American West, occasionally in small planes and bumpy jeeps. It seemed like a modest adventure. The locales were already obvious to aficionados of so-called earth art, the fuzzy term to which almost none of the relevant artists, being mostly prickly and individualists, subscribed.

My first stop was Walter De Maria's *Lightning Field,* a grid of four hundred shiny stainless steel poles, two inches thick and up to twenty feet tall, lightning rods, one mile by one kilometer, in an extremely remote stretch of scrubby New Mexico: a man-made forest of industrial materials and perfect geometry set against wilderness and stars. People reserve the chance to be driven to the site and dropped off to spend a Zen-like twenty-four hours in a small Spartan cabin De Maria designed, where they eat a vegetarian box meal and do nothing much except watch day turn to night and sunlight pass across the poles. On the rarest occasion the poles may

WALTER DE MARIA, *The Lightning Field*

be struck by lightning. The enforced concentration is meant to focus the mind on details, which in that context become meaningful.

It works—or it can if you're open to it. The project is about light, more than lightning, and about time. I had my epiphany looking at the unobstructed bowl of stars at night, then watching the poles spark to life with the first rays of the rising sun.

Nancy Holt's *Sun Tunnels* in the desert north of Wendover, Utah, also harnesses nature. It consists of four eighteen-foot-long concrete pipes, large enough to stand in with your arms raised, aligned to frame the sunrise and sunset on the summer and winter solstices. They explicitly pick up where Stonehenge and the petroglyphs of the ancient Pueblos or Anasazi left off, monuments marking celestial events and framing heavenly views. Holes in the tunnels are cut in the patterns of four constellations, Capricorn, Draco,

NANCY HOLT, *Sun Tunnels*

Columbia, and Perseus. Like *Lightning Field,* Holt's project is simple, deriving its subtle power from the attunement of visitors to its surroundings: it amplifies your awareness of the locale. Your sense of scale shifts, seeing the tunnels from a distance, where they look small in the midst of the Great Basin Desert, and then seeing them close up and finally from the inside.

NANCY HOLT, *Sun Tunnels*

More people know the work of Holt's late husband, Robert Smithson. His *Spiral Jetty* is 6,650 tons of black basalt and earth in the shape of a coil or fiddlehead, 1,500 feet long, projecting into the remote shallows of Rozel Point on the northeast shore of the Great Salt Lake in Utah, where the water can be rosé red from the local shrimp and algae. Since Smithson built the jetty in 1970, it has been underwater and invisible much of the time. But over the years the water level has risen and fallen, the salt coating the basalt white, like melted wax. When the lake is dry, the spiral rests on the salt bed, marooned, yards from the water's edge. About fifteen miles away is the nearest outpost of civilization, the Golden Spike Monument, a tourist shack with an antique railroad display, where the east and west ends of the transcontinental railroad met up in 1869.

To drive from the monument to the jetty in summertime is a spectacularly beautiful ride through an empty valley rimmed by mountains, with rushes of cranes flying overhead and fields of black-eyed Susans rising into the rocky slopes, the valley spilling suddenly down to the lake. The landscape is littered with a few rusting cars and a decrepit pier, not far from Smithson's *Jetty*, the contrast between eternal nature and man-made decay being part of the artist's motivating philosophy, although nature overwhelms everything, including the detritus and, finally, Smithson's art. A steady flow of hopeful acolytes makes the trek each year to the *Jetty*, its aura enhanced by Smithson's dramatic photographs of the site, by his ingenious writing, by his posthumous reputation as the Buddy Holly of American art (he died in a plane crash at thirty-five, scouting another earthwork site), and also by a film he made documenting the *Jetty*'s construction, in which trucks and loaders look like dinosaurs lumbering across a prehistoric panorama: the modern artist as primordial designer. In a sense, Smithson

devised three distinct works, the *Jetty*, his film, and his text about it, grasping Benjamin's point that people today experience art through words and pictures—but in turn that the words and pictures enhance the aura and mystery of the original. Through the film the *Jetty* becomes a kind of mythic site.

Smithson's allusions were to lost worlds and imaginary cosmologies. He admired the science fiction of J. G. Ballard; the red water evoked a Martian sea to him. The jetty jutting from the shore was, he said, "the edge of the sun, a boiling curve, an explosion rising into a fiery prominence." He was also inspired by geological formations, and by religious ritual: the required pilgrimage became integral to the sculpture. Call it controlling if you want, but the time spent looking and thinking about a work is often proportionate to the effort made to get to it.

This was further confirmed for me in Arizona, where the artist James Turrell has been trying for decades to turn a remote black and red volcano called Roden Crater into a monumental work of art. Overlooking the Painted Desert, on the edge of a Navajo reservation forty miles north of Flagstaff, it looms at the end of a dirt road that rambles for about eleven miles off a two-lane highway across open range, past Turrell's grazing cattle and a few stray shacks and ranchers' houses. On various trips I have spotted eagles and prairie dogs along the way. Because Flagstaff is around 7,000 feet in elevation and you descend about 2,000 feet from there to Roden, aspens and ponderosa pines give way to piñon and juniper, then to scrub like Mormon tea and Apache plume. Turrell likes to say that since he first flew his plane over Roden in 1974, landed it in the crater's bowl, and acquired the place for just under $6 an acre during the late 1970s, his daughter was born, went to college, and married. His hair turned white. He has had more than 150 shows of his installations of light

and other work around the world. And increasingly obsessed with the locale of Roden, he became a rancher to preserve and pay for the land, which accounts for the cattle. The first time I went to the crater, I found him doing what he had been doing for years, shuttling people around the rim—museum directors, collectors, writers, anyone who might help him raise money—to explain what he has had in mind. There he was, a bearded cowboy in a ten-gallon hat and jeans, escorting skeptical Japanese businessmen in their jackets and ties across the dusty crater bowl, pointing out how a few million dollars would be awfully useful to move several hundreds of thousands of tons of dirt to make way for the tunnels and rooms and pools of water he imagined constructing.

He finished the main tunnel inside the crater a few years ago: 854 feet long, gently rising 150 feet from the side of the volcano to under the center of the bowl, toward what looks like a circle of light, a moon-size spot in the distance, until you near the top. There the ground levels, the ceiling keeps rising, and the circle reveals itself to be an elliptical opening to the sky in a huge pitched elliptical room (Turrell calls it the East Portal) below the slope of the bowl. It is entered through an immense keyhole-shaped doorway, spectacular like a pharaoh's tomb or a Mayan ruin. Light through the opening casts an ellipse on the curved walls. By a different tunnel you then can descend farther back into the crater. A fork in the tunnel leads to a second, circular room called Crater's Eye, which feels like a bullring, with a circular opening in its roof (he dubs all these rooms "skyspaces"). If you turn the opposite way at the fork, you head up to the bowl itself. Turrell is a sculptor of ambient space. Roden is about the relationship of the tunnels and rooms to the sun, stars, and land. It's about the hours you spend silently looking, and about light or the absence of it when the sun goes down: you

are meant to experience Roden over a long day, or better, overnight, in a little lodge he has erected on the side of the crater. This is a pilgrimage toward which heightened perception is the goal: becoming more aware of how you see, not just what you see. "I want to address the light that we see in dreams," Turrell told me one sunny day as we stood on top of Roden looking across the rim of the bowl toward the Grand Canyon. "You know, for years I was a lapsed Quaker. I always tell people that my grandmother, who was a Quaker, said to me, 'Go inside and greet the light.' Whether that caused me to make art out of light, or whether it affected how I think about light, I can't say. If you think of all the cathedrals and sacred places in the world, there aren't many that don't involve light as a spiritual element. We also have a physical relationship to light—we drink it as vitamin D. Our health has to do with light. Light is sensual. Anything sensual, while it can attract you toward the spiritual, can hold you from it, too; it can keep you in the physical world, and that's an explicit part of my work, which I think is sensual and emotional in the way that music is sensual and emotional."

He likes the music analogy. Music, after all, while you listen to it can seem to occupy a space bigger than the room you hear it in, and like light it is intangible. At Roden there are various deliberate sound effects: Turrell showed me how, midway up the tunnel, before construction was finished, his voice projected, as if by ventriloquism, to the elliptical room four hundred feet away or, if you turned around, back to the room at the low end of the tunnel—the Sun and Moon space, as he calls it. In the middle of the Sun and Moon space is a fifteen-foot monolith for catching various solar and lunar events, some daily, some not. Every 18.61 years, the moon will briefly align perfectly with the tunnel. Because only a dozen

people or even fewer can stand in the Sun and Moon space at a time, not many will ever see this happen, which doesn't seem to matter to Turrell. A work based on geological and celestial calendars, which has taken him what can seem to many people—in this age when so many artists produce so much—like eons to build, is not meant to be convenient. Roden is supposed to last for ages, so those handfuls of visitors will add up over time to blockbuster numbers. Besides, remoteness and exclusivity are attractions to those who appreciate the privileged view. Its obligation as art is not to be accessible to everyone, anytime, like electricity or drinking water.

The tunnel to Crater's Eye was pitch-black (the electric lights inside weren't working yet) when Turrell first led me to his skyspace, both of us feeling our way along the wall. The alarm of darkness heightened the feeling of relief when we arrived. "My spaces are sometimes dim because low light opens the pupil, and then feeling comes out of the eye as touch, a sensuous act," he said while we sat, otherwise silent, on a ledge he had had cut into the wall for a bench. For a while, we stared up at scudding clouds through the opening in the roof. I noticed how the sun cast a curving shadow on the opposite side of the room, which slowly moved. "Sure, you surrender to the darkness, which is part of my work. You surrender when you go to the doctor. A doctor's office is a body shop. Well, we're talking about healing the soul here." Then we climbed up to the rim, about 600 feet above the desert floor, where the San Francisco peaks were visible in the distance, covered with snow, as was Navajo Mountain in Utah, 140 miles away. A jet passed overhead, trailing white plumes. The delayed rumble of the engine interrupted the surrounding peace. In the bowl, Turrell has constructed four plinths: low, flat, tilted platforms around the oculus of Crater's Eye. He invited me to try one out. I reclined. Supine,

you register the sky as a half-sphere with the crater rim as its edge on the periphery of your vision. The bend of space into a bowl is an optical illusion, an experience, I suddenly thought, strangely not unlike Colmar in that I felt myself briefly alone in the presence of some immense and singular sight.

I spoke with the painter John Currin later. An ironic and nervously ambitious man, he is, like many other artists, absorbed by the spectacle and fashion of art in New York. He complained that earthworks, rather than seeming heroic to him, were depressing and sanctimonious. "I don't like religion," he told me. "And this sort of work appeals to a type of spirituality I've never been able to work up enthusiasm for. You're supposed to be modest, supplicant before it—and it's religion without the fun stuff, the guilt part about having done something you shouldn't have. The pilgrimage idea only reminds me of standing in line at a movie. Those artists are also implying that there's something corrupt about New York and the commercial art world and about painting, as if to like painting makes you a bourgeois bumpkin, whereas they're pioneers, scientists of the future, advancing art in the fresh air."

I knew what he meant, but I had another experience. Some people also complain about the costs of works like *Spiral Jetty, Lightning Field,* and Roden Crater, which run into the millions of dollars. To their detractors, artists like Turrell and De Maria are snake-oil salesmen selling spectacles that pass for art and that obscure in the public's estimation the crucial difference between a Grünewald and a dormant volcano in New Mexico. Years ago, the art historian Michael Fried used the word *theatricality* to deride minimal art, by which he meant art that requires a viewer's conscious assimilation of it as such: bricks placed in a gallery become some-

thing else, sculptural objects, with weight, color, and shape, defining the room, only if a person chooses to see them that way. When the minimalist Carl Andre laid plates of steel on the floor, declared the work a sculpture, and invited people to walk on it, asking that they be alert to how they felt in doing so, those people and the gallery space became integral to the art, which, in a sense, was otherwise incomplete. Theatricality meant art that was no longer a passive, self-explanatory object on a pedestal or an illusion painted on a canvas hung on a wall but that entailed real form in real space, experienced in real time. "Postured ideas," was the critic Clement Greenberg's term for minimalism and its earth art progeny; the emphasis on coups de théâtre, he added, "couldn't help but make any kind of new art that delivered quality seem tame. But tame only in terms of theater." The critics were clearly not placing much value on the experience of the pilgrimage, which to them no doubt was just another symptom of theater and a melodramatic sleight of hand, a distraction from what art was about. Greenberg was thinking particularly of Donald Judd, minimalism's chief practitioner, who during the early 1970s began the vast project on which he would spend the last years of his life: turning a small West Texas cattle town called Marfa into a kind of Lourdes of minimalism.

Greenberg apparently never made the trip to Marfa, which is too bad. A tumbleweed-tossed spot in the high desert plain near the Mexican border known as El Despoblado, "the uninhabited place," it is about two hundred miles southeast of El Paso, which, unless you fly in a private plane, as a handful of gentrifying, art-conscious Texans from Houston and Dallas do on weekends, you reach only by driving several drowsy hours on empty highways through miles of cactus beneath powder-blue skies.

As it turns out, this is nature's perfect prelude to Judd's pared-down art, a kind of natural decompression chamber facilitating your transition from busy civilization by readjusting your senses of scale, time, and light. Despite the Dairy Queen at the edge of town, Marfa (population 2,424) remains an oasis seemingly cut off from mass pop culture except for the infamous Marfa Mystery Lights. These unexplained luminescences, sometimes spotted by true believers from a pull-off on the road a few miles away, attract tourists on their way to find UFOs in Roswell, New Mexico, and whom you'll meet during lunch eating enchiladas and *huevos rancheros* with the border police congregating at Carmen's. The town itself is an isolated clutch of adobe-and-wood-frame houses on streets that trickle into no-man's-land. Marfa developed mostly after the railroad arrived, and tracks bisect the main street. Freight trains rumble by day and night, and occasionally a cross-country sleeper passes through, shaking the buildings and halting traffic, if there is any.

Mostly with other people's money, Judd bought houses and agricultural and industrial buildings. On the south side of the tracks he bought a defunct army base and cavalry post, Fort D. A. Russell. On the north side, he converted a former wool and mohair warehouse into a permanent exhibition site for the crushed-car sculptures of his friend John Chamberlain. On three of the four corners of an intersection in the middle of Marfa, Judd owned buildings. Before he died in 1994, leaving a mess of trouble over the control of his art and a debt-plagued estate, he bought a former bank, a Safeway, the Marfa Hotel, several light manufacturing buildings, and small houses—a virtual fief of austere architecture and perfect, albeit rather insane, homogeneity in the middle of nowhere dedicated to himself and the few living artists

whose work he admired, like Chamberlain, Ilya Kabakov, John Wesley, and Dan Flavin. He also bought a ranch three hours away in an even more remote location nearer the Mexican border. Like Turrell, Judd elected to spend more and more time in relative isolation. "Since the lions won't bother you, it's very safe," he said, "except for the rattlesnakes."

Over the years, Judd's pugilistic personal style and his uncompromising work soured many people and scared off others, to whom he exemplified American art at its most misanthropic and aggressive (some would say masculine) moment. Taste is "inexorable, implacable, merciless, ruthless," said Greenberg, who thought Judd's art lacked taste because it trafficked in "aimless surprise" and a "boredom so undifferentiated as to constitute a surprise all in itself."

Eighteenth-century philosophers like Immanuel Kant and David Hume tried to separate taste from personal interest. Taste was not a quirk of individual personality; if it were, it would be trivial. They believed that taste is connected with beauty, and beauty can't be trivial because it is a moral good. Taste, therefore, has to be a disinterested phenomenon, something everyone can agree on. Kant wrote about a "sensus communis." He envisioned a community taking pleasure in tasteful objects that reflected its common moral standard. Everyone in the community would find satisfaction in sharing those feelings, and be bound by taste. This viewpoint emerged, not coincidentally, with the rise of the institution of the art museum in Europe, which removed objects from their contexts (churches, palaces), orphaning them, as it were, making them autonomous abstractions for the consumption of an emerging middle class. Objects became separated in museums from the whims of private taste and joined part of a collective enterprise. It took Friedrich Nietzsche, among others during the late nineteenth century, and then many

twentieth-century writers to cast doubt on this view and to see social consensus in aesthetics not as a good but as dubious or a negative—to see universal taste, because it sublimates private will and personal delight, as something that weakens the power of the individual.

Judd, the Nietzsche of minimalism, regarded works of art themselves as if they were individuals. "A shape, a volume, a color, a surface is something itself," he said. "It shouldn't be concealed as part of a fairly different whole." He also saw what museums were becoming in the late twentieth century and loathed how curators and museum architects undermined, from his perspective, the integrity and individuality of his sculptures. "Art is only an excuse for the building housing it, which is the real symbol, precise as chalk screeching on a blackboard, of the culture of the new rich," he wrote. Marfa was to be the opposite of a populist palace for spectacle architecture and revolving-door installations. "The space surrounding my work is critical to it," Judd wrote. "As much thought has gone into the installation as into a piece itself. My work, and that of others, is often exhibited badly and always for short periods. Somewhere there has to be a place where the installation is well done and permanent," otherwise "art is only show and monkey business."

Megalomania like Judd's can be off-putting, as it was to Greenberg, who had an ego to match, but it can also be a useful counterbalance to an equivocal and cautious cultural ethos, reminding us what it is to care unreservedly, even ferociously, about art, which Judd regarded as synonymous with life, not peripheral to it. For him, personal taste, publicly and persuasively expressed, was a potent sign of a functioning democracy. As I glanced one day through his library at his house in Marfa, an ascetic compound of former adobe and iron warehouses and storage buildings that he called the

Block, I came across some books by José Ortega y Gasset on Judd's pristine, unpainted wood shelves. Ortega y Gasset wrote that the "bigotry" of modern society manifests itself in the presentation of "culture, withdrawal into one's self, thought, as a grace or jewel that man is to add to his life; hence it is something that provisionally lies outside of his life, as if there were life without culture and thought, as if it were possible to live without withdrawing into one's self."

And that's how Judd thought, too. Up the street and around the corner from the house is the bank where Judd stored some of his earliest works: sculptures and paintings from the early 1960s (a painter first, he continued to regard color as crucial to his sculpture). He converted a row of bank offices, arranged enfilade on one long side of the building, into studios for architecture projects he was working on, one project per room. He would move from room to room, an extravagant, compulsive system. His routine was like the art it produced: drawings, models, photographs, everything was laid out in plain sight on drafting tables and on some of the early modernist desks Judd collected. Nothing was hidden. Judd turned his life into a kind of private fetish, a way of living with an eye toward posterity, his offices for papers and drawings becoming like the edges and rivets of his immaculate aluminum sculptures, everything obsessively given its own space, definition, and attention, in sometimes belligerent disregard for basic comfort and with a puritanical resistance to extraneous form. It was an expression of Judd's monkish religion of visual integrity.

I also spent a day in Marfa filming for television his installation at the army fort in two converted artillery sheds with giant Quonset hut roofs, like twin Gothic cathedrals. It's Judd's masterpiece. Art should clarify space, not just occupy it, he felt, and he arranged in the sheds one hundred

milled-aluminum boxes, 41 by 51 by 72 inches, each different inside. He replaced the old garage doors along the sides of the buildings with big windows to let sun play against the

DONALD JUDD, *100 Milled Aluminum Boxes*

silvery metal, initiating shimmery effects that deflect all pre-conceptions that the sculptures might seem forbidding, heavy, mechanical, or monotonous. The work is revealing of mini-malism's essentially paradoxical character, as well as of the eloquence of the pilgrimage idea. Photographs can't begin to convey the shifting experience of reflected light: of seeing your face in the shiny metal like the upside-down image of a playing card figure, while the sheds are mirrored everywhere in the boxes in the way that Gothic fretwork on Venetian palaces bounces off the Grand Canal. Compulsively repeated form, almost a neurotic fixation, coexists with the serendipity of changing light, the standard prohibition against touching art balanced by a sensual embrace of optical surprise: by razor-sharp metal edges dissolving in waves of soft sun.

By situating the art so it can't be seen without undertaking a journey, Judd left the ultimate decision whether to come up to you. At the same time he restored to art a dignity that becomes a moral point, a metaphor for how to deal with each other, which is to say, one at a time and patiently. Judd resisted reading human figures into his abstract sculptures. But it's impossible to miss the human implications of what he conceived with his faraway shrine.

I thought while I was there how curious it was that such an idea could come from such a difficult man making such obdurate art, but then the ultimate Western pilgrimage site, or at least the most remote, is by a sculptor who has developed an even thornier reputation. Michael Heizer, whom you might call the Howard Hughes of American art to Smithson's Buddy Holly or Judd's Nietzsche, has spent most of his life working in the remotest middle of the Nevada desert. His project has been a sculpture nearly the size of Chichén Itzá, which, because it is still not yet finished, he has permitted almost nobody to see, called *City*. When I first decided to find out what he was up to, I was told that he would never speak to me. He talked to almost no one. I got his phone number. That he answered at all was a surprise. Then he started in. I was another art tourist wanting to make the rounds of earthworks. He had nothing to do with earth art, with De Maria, to whom he used to be close, or with Smithson, another former friend whom he now particularly loathed for, as Heizer believed, ripping off his ideas and stealing the limelight. It occured to me, talking with him, why all these artists chose enormous western states (Texas, Arizona, Utah, Nevada) to work in: perhaps they imagined no puny eastern state was big enough to hold two of them. Heizer added that he also hated critics, who he thought hated him. He complained about a review. I saw my opening. I had not written that re-

view, I said. He didn't want to be confused with other artists, I told him; I shouldn't be held responsible for other writers. He fell silent. I had scored a point.

"A guy called from France," he said. "He was complaining: 'It's not done yet? How long is it going to take?' And I said I was sorry that I hadn't got it done for him. My God, you don't go into a painter's studio unless he wants you there. I got called by a travel agent who asked where the bus stop was. This project has involved a time reference that the art world clearly can't understand. I've lived low for more than thirty years, and privacy is now all I ask. All these rubberneckers show up as if it's entertainment. People fly over the place. This is private property. People presume that I want them to see it. That is a rash presumption."

He was still explaining how the work, not being finished, is a liability and dangerous, when suddenly he yelled into the phone, "Hold on!"

I heard gunshots.

"What was that?" I asked when he came back on the line.

A coyote was menacing his dogs, he explained. Then, a little later, he was gone again. More gunshots. I was getting worried. He returned to the phone. So, he asked, having evidently warmed to me, when did I plan to visit?

A long straight two-lane highway, a vacant stretch 100 miles out of Las Vegas, reaches a turnoff, and another twenty miles or so farther along is an unmarked gate. Beyond that is a dirt and gravel road winding thirty-four miles—almost another hour's rugged drive, on some of what used to be the Denver–San Francisco stagecoach route—across two mountain ranges and three uninhabited valleys (open grazing land for cattle) toward Heizer's house. It's so remote from other people that Heizer learned to his horror that the federal government was planning on running the railway to transport

nuclear waste to Yucca Mountain right past his ranch, partly because it is about as far from the rest of civilization as you can get in the contiguous forty-eight states.

It's a survivalist's compound in a broad, nearly uninhabited valley of yellow rabbit brush and silver sage: an isolated copse of cottonwood and wild plum trees, low cinderblock buildings and solar panels on the south end of the Great Basin. Lately Heizer has started farming alfalfa and raising cattle, and the view is of sprinklers and greenery, a small oasis of lush green pasture in the dry desert. But when I first went, it was a slightly rougher, less developed place. Beside the house was what looked from a distance like a low, U-shaped enclosure, an odd though not particularly dramatic bump in the land. But scale is deceptive in the desert; the bump turned out to be the first phase of Heizer's *City*, the sculpture that has come to occupy most of his working life. That phase, which took him almost thirty years to finish, consisted of three hulking, abstract structures around a curved, sunken gravel-coated court or pit. Imagine some-

MICHAEL HEIZER, *City*, Complexes 1, 2, 3

thing on the scale of the Roman Colosseum, open on one side. The structures—which Heizer, the son of a Berkeley anthropologist, calls complexes, a term archaeologists use for buildings at ancient sites—are concrete and dirt rectangles with sloped sides. Complex 2 is by itself more than a quarter mile long and several stories high. Its irregular surface supports abstract upright slabs that poke up over the top like mountain peaks. The slabs (Heizer calls them steles) rise as much as seventy feet and weigh up to a thousand tons each. Altogether, what existed of *City* when I saw it that first time, driving into the valley, was already one of the most massive modern sculptures ever built—so big, so far away, that for a time it had its own landing strip. Since then Heizer has finished much of the rest of it, extending the work another mile, dwarfing the first complexes.

When Heizer began the sculpture, he lived in a trailer at the site. Over time he built the ranch house, with wood-burning stoves: it has become a comfortable place, with Remington sculptures on the coffee table and a big satellite dish for a television. An outbuilding for solar panels and a generator sits across from the metal shop. A separate concrete outbuilding has beds for guests and for the construction workers who travel hours to get there. For about a decade, two women, Mary Shanahan and Jennifer Mackiewicz, also artists, were his assistants, living out there with him—patient, devoted, practical, and indispensable colleagues. Eventually he married Mary. On my first trip, having driven a small rental sedan unfit for the desert, I got a flat tire from a rock in the road (luckily not quite a mile from the house), which stumped me but was no problem for Mary to change. She gently masterminds everything from the finances to the ordering of the materials, the oversight of the crew, and the management of the house, not to mention that she paints in her own studio

and deals with Michael's perfectionism. There were dogs, cats, horses, sheep, and cattle, along with machinery everywhere: road graders, loaders, tractors, horse trailers, manure spreaders, concrete mixers.

Heizers have lived in or around Nevada since the 1880s, Michael likes to point out. One grandfather, Ott F. Heizer, ran the largest tungsten mining operation in the state; the other, Olaf P. Jenkins, was the chief geologist for California. State maps in California are named after him. Robert F. Heizer, Heizer's father, excavated in Nevada. He specialized in the Great Basin, in California, and in the Yucatán, and he worked in Egypt, Bolivia, and Peru. He was cowriting a book about the ancient transport of massive stones when he died. At the root of Michael Heizer's art are archaeology, geology, and anthropology. About the idea behind the steles on Complex 2, he says, "One source is a verbal description in a book by my dad about La Venta in the Yucatán." La Venta was an Olmec ceremonial complex. Heizer shows me the book. It has drawings of excavated stones shaped like Heizer's sculptures, with complexes of structures like *City*. He swears that the forms are not directly lifted from the book, but were on his mind as abstract shapes. His sculptures also allude to and riff on American Indian tumuli, or burial mounds, and the mastaba on top of Zoser's tomb at Saqqâra in Egypt, where Heizer once went with his father.

He volunteered a few germane childhood details: when he was six, without permission, he made a city out of wire, cans, glass, and rocks on a hill beside his school, which the school janitor destroyed but the principal allowed him to rebuild. His favorite children's book was *Mike Mulligan and His Steam Shovel*, the 1939 classic by Virginia Lee Burton. He spent a year in high school in France, then quit school.

His father took him to Mexico when he was twelve, and to Peru and Bolivia when he was eighteen. He made drawings of the sites. He learned about the famous ancient Peruvian Nazca lines. "I educated myself about historical work that was similar to mine, to provide a frame of reference that wasn't the usual frame of reference of the New York art world and Europe."

Briefly he took classes at the San Francisco Art Institute. In 1966, at twenty-one, he moved to Manhattan and found a loft on Mercer Street. Carl Andre, Dan Flavin, Walter De Maria, Tony Smith, and Frank Stella, friends and acquaintances, were speaking the language of minimalism: of reduction, geometry, and elementary forms. Heizer painted shaped canvases, some with spaces carved out of the middle of them or with forms that implied sculptured masses, holes, or trenches. Then in 1967, he began *North, East, South, West,* which consisted of big holes in the Sierra Nevada. When the work was finally completed for the Dia museum in Beacon, New York, in 2003, it caused a sensation: four vertigo-inducing geometric shapes made of Cor-Ten steel, cut into a concrete floor, up to twenty feet deep, a wedge, a cone, a partial upside-down cone, and a double square, which seems to have been adapted for the winning memorial plan at Ground Zero—awe and fear being attractive to memorial designers. To stare down into Heizer's holes is certainly awesome and alarming, like standing on the edge of a cliff.

Heizer devised in the mid-1960s the first versions of these holes for a site in the Mojave Desert, and in 1968 he came up with *Nine Nevada Depressions:* big, curved, and zigzagging trenches, like abstract doodles on the earth, placed intermittently over a span of 520 miles. His "Dye Paintings" involved big bags of lime powder and concentrated aniline dyes scat-

tered across the desert floor; he also drove a motorcycle across a dry lake bed, the tire tracks like drawn lines. Partly the move outdoors by artists like Heizer, De Maria, and Smithson reflected 1960s art politics, a new eco-spirit and a reaction against the art object as commodity. Works in the land were things that you couldn't put over your mantel; they didn't even necessarily last. Some of them, like *Nine Nevada Depressions*, involved removing dirt to create sculptures out of the spaces left behind. Other artists had begun digging holes in the early 1960s. But *Double Negative* was a 1,500-foot-long, 50-foot-deep, 30-foot-wide gash Heizer cut into facing slopes of an obscure mesa in Nevada, on a site between Las Vegas and *City*, a project that required blasting and scraping 240,000 tons of rock. Documented in photographs at Virginia Dwan's gallery, it quickly became an archetype of earth art. "Negative sculpture" was the phrase Heizer preferred, or un-sculpture, or "sculpture in reverse," to describe sculpture made out of the space left behind from digging—a concept that crept into the mainstream consciousness, even if many people never heard of him. Maya Lin's *Vietnam Veterans Memorial* is a variation of Heizer's negative vocabulary.

The shift outdoors also involved a revolution in materials and philosophy: no longer just paint or clay; now sun and air. Not only Americans were involved in this. Joseph Beuys was in Germany; Richard Long was in England; the Gutai group was in Japan; and the so-called Arte Povera artists were in Italy. But while Long was documenting walks and leaving discreet marks in the countryside, Heizer was blowing up things with explosives. His contribution was to go out West. Jackson Pollock's paintings had been said to refer to the Western landscape. Now Heizer literally made art out of the Western landscape. There was something very American about

the brashness, loopy ambition, and sheer size of his work. A 520-mile sculpture is a very big thing.

Then, in 1972, Heizer hired G. Robert Deiro, a pilot from Las Vegas, to find him property in Nevada. It had sand and gravel, water belowground, isolation, the right climate—and it was cheap. Most of Nevada is public land. This was private property surrounded by public land, so it couldn't easily be homesteaded. Heizer gradually acquired parcels, at $30 an acre. "Even I could save $150 a month," he told me. "Bob helped me get it, parcel by parcel. He went into county records and researched the owners. They all wanted to sell. Why not? Barren land in the middle of nowhere? It was the best thing that ever happened to them."

There was only a weed-covered livestock trail to the prop-erty, and Heizer wore out a new truck every year getting to and from the place. Half the winter he'd be locked in. Once he went for ten months and saw only a couple of sheep trail-ers and the occasional rancher's pickup truck in the distance. He began work on Complex 1 in 1972. A farmer lent him a paddle-wheel scraper to move dirt. Seismic engineers drew up plans for the thirty-ton T- and L-shaped concrete columns that protrude from the complex.

Heizer took me to see it on that first trip. It's at the far eastern end of *City*. When viewed straight on from a dis-tance, its jutting columns align to make what looks like a pic-ture frame around the sloping structure, an optical illusion. The complex's slope seems to flatten within this frame into a monochrome rectangle, three stories high, like one of Heizer's early minimalist paintings. Heizer was able to finish most of Complex 1 by himself. He began Complex 2 and Complex 3 in 1980. But it was becoming increasingly difficult to pay for it all. "A lot of money over the years went into simply trying

to maintain old, useless equipment," he said. He painted and made other sculptures to raise money and keep from dropping entirely out of sight, including one sculpture, in the 1980s, *Levitated Mass,* outside the IBM Building in New York. But he never stopped working on the pit and the complexes, whenever he could afford to. "We're talking crazy optimism here," he said.

He turns out in person to be more softhearted than you might imagine when he is not venting about perceived slights and injustices. "I'm not a dogmatic, purist psychopath," he pleaded at one moment. "There's an unfair image of me—mean, crazy, hostile. I'm really a very gentle person." Gentle or otherwise, he's physically frail now. In the mid-1990s he nearly died. He felt pain in his fingers and toes, which he mistook for frostbite because he had been standing in the cold for twelve hours a day working on his sculpture. When the pain moved to his shoulders and back, a medevac helicopter had to fly into the valley and rush him to a doctor, who sent him home, saying he was drinking and smoking too much. The doctor prescribed Tylenol. The pain became unbearable. Heizer went to New York to see a neurologist and collapsed on his way into the hospital. He had contracted polyneuropathy, a nerve disease, which caused him to lose much of the use of his extremities.

His weight plummeted. After therapy he was just barely able to walk again, but for a while he was pretty much paralyzed on his left side. Cocky about having been able to operate his own big machinery and build what he wanted himself, he found himself in a walker, then relegated to crutches. He's walking on his own now but still feels weak. "At least I'm working again," he told me. "I had set out to do this sculpture by myself as a young man. When I got sick, I figured that

was the end of it." Feeling demoralized, he even considered demolishing what existed of Complexes 2 and 3, leaving just Complex 1, before help turned up. Charlie Wright, and then Michael Govan, Wright's successor as the director of the Dia Art Foundation and a convert after he saw the uncompleted *City*, stepped in with money from Dia, the Riggio family, and the Lannan and Brown foundations. Dia—which had acquired Roden Crater, commissioned *Lightning Field*, and owns Smithson's *Jetty*—had actually offered to underwrite the project at the beginning, but Heizer had had one of his feuds with Dia's founder, Heiner Friedrich, and declined the offer, an irony not lost on Heizer today.

With money, a construction crew was assembled. Decades of pent-up desire on Heizer's part, combined with the crew's inexperience and frustrating weather conditions, made tempers short at first. The men had never worked on a project like this, which involved odd materials, gigantic forms in strange shapes, and periodic storms that would sweep across the valley, in minutes wiping out $30,000 of labor. Heizer is a perfectionist. At one point, he asked that hundreds of thousands of yards of dirt be moved twenty-seven inches to align Complexes 2 and 3.

I woke up just before dawn one day to see *City*. The three complexes combined to resemble a vast, empty amphitheater, silent and expectant. The steles in this half-light seemed like cutouts, stuck on, a stage-set silhouette with the spotlights off. The landscape being mostly obscured from view inside the sunken pit, the mountain ridge in the distance appeared only in the spaces between the complexes and peeking above the sculpture. Views of the surrounding landscape are not the point, Heizer insisted at that time. "That's the reason I put my ranch right next door to the sculpture. I

wanted to prove that I am here for the materials, not for the view. I'd have built this thing in New Jersey if it had been possible. All these so-called experts try to say my work is about the West, that it's about the view, they don't know what they're talking about. I came for the space and because it was cheap land. I don't care if you see the mountains. The sculpture is partly open because, rather than put you in a box, I want you to be able to breathe. But I also want to isolate you in it, to contain you in it, like in all my negative sculptures. It's not really different from *Double Negative*. The sculpture is the issue, not the landscape."

He put it that way then but he has always drawn a distinction between landscape, meaning just a pretty view, and environment, meaning everything to do with the ecology of a place, including its vastness, emptiness, and silence. And as he has grown fonder of his property and fretted about a railway spoiling it, he has come to acknowledge that part of the experience inevitably involves the trip to the site, the isolation of the valley, the light and the weather, and the echoes of *City*'s shapes and colors in the surrounding landscape. From 80 degrees the previous afternoon, the temperature dropped to 15 overnight, causing an efflorescence to coat parts of the complexes, whose masses became shimmering gray silhouettes in the pre-dawn. As the sun rose, daylight fell gradually over different parts of the complexes, which are so big that the sun didn't seem to strike them equally all at once. Time is an element, as it is at *Lightning Field* and Roden Crater: you have a motor-delayed, cumulative experience walking around *City*, climbing over it, taking in the sight. Too big to see all at once, it comes together in your mind later as a memory and sensation, along with the whole pleasurable, otherworldly ordeal of getting there.

"I think size is the most unused quotient in the sculptor's

repertoire," Heizer told me, "because it requires lots of com-mitment and time. To me it's the best tool. With size you get space and atmosphere: atmosphere becomes volume. You stand in the shape, in the zone."

The first men from the construction crew came at 7:15 that morning to complete concrete runoffs for water on Complexes 2 and 3. The silence was broken by cement mix-ers. I asked whether Heizer ever felt lonely in such a remote place. "Nevada is the only place for me that's home," he said. Driving away later that day, back across the valley, I came to what was then still an unmarked crossroad in the dirt that I hadn't noticed on the way to *City*. Puzzled, I feared the wrong road might simply peter out in the desert, and I might become stranded. I had had a flat already. I hesitated and guessed which way to go. It took another nervous hour driv-ing in the dark before I could tell I had guessed right. Later Heizer said the other path would have taken me about seventy-five miles out of the way.

My slight unease, a reminder of Heizer's isolation, came to mind when I arrived at my last stop, Wendover, Utah, to see Matthew Barney filming a scene for *Cremaster 2*. Barney is a generation younger than Heizer and has become known for making cryptic sculptures out of materials like tapioca and petroleum jelly, and for shooting a lush, costly, nine-hour, five-part cycle of incredibly odd, mandarin films called *Cremaster*, whose locales track a path from the American West, where Barney was raised, to Budapest, where his self-described fictive alter-ego in the cycle, the escape artist Harry Houdini, was born. This eastward arc becomes a geographic metaphor in the work for the artistic process, a pilgrimage and trial of unfolding discovery, which requires effort and sacrifice on the part of both Barney and his highly taxed au-dience. The work slyly alludes to artists like Holt, Heizer,

and Smithson. It turns landscape—the salt flats of Utah, for example—into sculpture. For *Cremaster 2,* Barney was building his own fragment of *City:* an arena or bullring made of salt, almost twenty feet high, in the middle of the flats, where the world's fastest cars are speed tested because there is nothing for miles around that they might bump into. Every few years the flats flood with runoff snow, making a vast shallow sea of ice water, mostly knee-deep but in places much deeper, bordered by distant snowcapped mountains. That was the condition this winter.

MATTHEW BARNEY, from *Cremaster 2*

By the time I arrived there, the arena had been constructed, a gleaming white semicircle, capped by fiberglass beehives, the Mormon symbol, one of Barney's visual cues, like flags rimming the top. The arena was miles into the wa-

ter, reachable only by SUVs and slow-moving trucks from a single narrow paved road off the interstate highway. The paved road jutted into the water and then petered out. Trucks took a circuitous path a couple of miles long, devised by the Federal Bureau of Land Management, through the shallowest parts of the flats.

One evening, a photographer and his assistant, who worked for Barney, drove me in their Jeep from the arena as the sun was setting. Borrowing my dying cell phone to chat with friends in New York, they lost their way and became stuck in the salt, far from Barney's crew and out of sight, with water now lapping up to the doors. I volunteered to slog through the icy sea back to the road, still barely visible a mile or two in the distance. Within minutes I was in water that had risen from my shins to my chest, darkness having quickly fallen, the paved road previously in front of me and the jeep behind me now both vanished from view, the arena or bull-ring illuminated only dimly as a speck in the wrong direction. I had no bearings. My cell phone was dead. I was in the middle of a freezing ocean in total blackness, alone. I trudged toward where I imagined the road to have been not knowing how deep the water might become. At one point, I saw a truck depart from the arena in the distance and drive through the water toward the road, its headlights two faraway pinpoints. I yelled, but no one could hear me. The truck went to a remote spot I had not thought was the road, then disappeared, its red brake lights dissolving into the darkness. I struggled through what was now waist-high water in that direction, wandering for what seemed like an eternity—toward a false beacon. Later I recalled the light that Saint-Exupéry, lost in his plane over the sea in the blackness of night, mistook for an airport but which was a star, "golden bait," he said, leaving him "lost in interplanetary space among a thousand inaccessible plan-

ets," seeking "that planet on which alone we should find our familiar countryside, the houses of our friends, our treasures." My wife, as it happened, was due to give birth to our son later that month, and it occurred to me that I had found a ludicrous way to die.

Kept alive by adrenaline, I somehow finally stumbled onto the road. Chelsea Romersa, one of Matthew's assistants, happened to be standing there and stared in disbelief at the sight of me walking as if in from the sea, out of the darkness. Some of Barney's other assistants later told me about their own near-death experiences: Paul Pisoni, a quiet man who helped to make some of Barney's sculptures, recalled having found himself in a crane, eighty feet high, during a storm, hanging the logo for *Cremaster 1* on the scoreboard of a football stadium in Boise, Idaho. "He's sneaky," Pisoni said. "You don't know what you're getting into until you're doing it." During the making of *Cremaster 4*, T. J. Davey, who did rigging and construction for Barney, discovered that part of his job involved climbing the proscenium of the opera house in Budapest as a stand-in for Barney. Davey was also there to help Barney bungee-jump naked off the city's Chain Bridge. Some artists can be ruthless about their art, Barney maybe more than most. He takes absurd risks, both physical and artistic, and his work, requiring sacrifice by those who help him make it and also by those who choose to see it, tests the limits of coherence and endurance. I found myself in the middle of the water in pitch-blackness because I had elected to go to Utah to see firsthand what Barney was up to. I came away pale and queasy but feeling, finally, that the effort had been instructive. In his earliest videos, Barney strained at the end of a tether, trying to make marks with a piece of chalk on sheets of paper affixed to a wall, then he climbed an elevator shaft, and jumped off a forty-foot pier.

These acts may seem like gags or stunts. But they are about the connection between art and effort, and in a sense, Barney expects his crew and everybody around him, including his audience, to take a leap, too, which is another way of saying that not all art comes to you, or even should come to you, easily.

Sometimes you have to go to some length to meet it.

THE ART OF GUM-BALL
MACHINES, AND OTHER
SIMPLE PLEASURES

I HAVE FOUND MYSELF, while on vacation and supposedly relaxing, waiting in an endless line at the supermarket, growing more impatient by the minute while my five-year-old son wanders off to check out the Spider-Man balloons, Hot Wheel cars, and gum-ball machines near the door. At other times, I have been driving around, thinking about this or that, when my rental car has conked out, in what seems like the middle of nowhere. In both scenarios, returning home to tell my wife what happened, I have been unlikely to focus on the wonders of the day: to find beauty in the plain, slow-moving young woman behind the checkout counter pensively adding up our purchases; in the saucepan I chose to buy

because it had Teflon and was on sale, not because of its pleasant shape; in the gum-ball machine, which used to take pennies and now (incredibly!) demands 25 cents per gum ball; or in the countryside where my engine over heated.

But certain artists have fortunately made it their mission to save us from a blinkered, harried existence and open our eyes to what's right in front of our noses. They may do this, as Wayne Thiebaud has been doing since the early 1960s, by painting those same gum-ball machines rimmed in blue halos and glowing with a mysterious light, or by painting candy-colored landscapes and spaghetti entanglements of highways. Were we stuck beside them, we might regard those scenes as nowhere, but Thiebaud shows us they are heavenly.

The paintings of Horace Pippin are similarly based on what Cornel West once called the "rich Emersonian tradition in American art that puts a premium on the grandeur in the ordinary and quotidian lives of people." Emerson had written: "I ask not for the great, the remote, the romantic; what is doing in Italy or Arabia; what is Greek art, or Provençal minstrelsy; I embrace the common, I explore and sit at the feet of the familiar, the low."

Pippin pictured a young black family gathered for Sunday-morning breakfast, a matron playing dominoes with her sullen grandson (it was probably raining outside), a milkman on his route, a quartet of middle-aged men singing on a street corner, and a man sitting pensively on a park bench (Pippin's spiritual self-portrait, said the great collagist Romare Bearden). These works, mostly painted during the 1940s, are filled with calm attentiveness to the beauty of everyday affairs and a nostalgia for life in the 1890s. Born in

1888 in West Chester, Pennsylvania, just a generation re-
moved from slavery, Pippin had one of those quintessential
American lives. He worked as a hotel porter, iron molder,
and used-clothes peddler before joining the army in 1917 at
the age of twenty-nine. Fighting with the all-black 369th
Infantry Regiment in France, he was shot by a sniper and re-
turned, with a Croix de Guerre, to take odd jobs to supple-
ment his disability pension. As therapy for his injured arm,
he started decorating cigar boxes, and by the mid-1920s be-
gan burning images on wood panels with a hot poker. It
wasn't until 1930 that he tried oil painting, propping up his
bad arm with his other hand; he was already forty-three. A
school principal named Joseph Fuggett saw the work, intro-
duced Pippin to an art critic named Christian Brinton, who
encouraged Pippin to contribute paintings to a show that
N. C. Wyeth visited, and, in that improbable way art careers
sometimes happen, the Museum of Modern Art in New
York presented Pippin in a touring show across the country.
He suddenly became famous. (Albert C. Barnes, our Argyrol
tycoon with the museum in Philadelphia, collected him.)

He painted biblical and historical scenes and landscapes,
but as much as anything else his reputation rested on those
views of ordinary domestic life. There was nothing naive or
primitive about them; they just had a plainspoken eloquence,
each object in the pictures meticulously and lovingly de-
scribed and sometimes canted slightly upward toward the
picture plane, like jewelry in a store window, so that we
might inspect it more clearly, his art alerting us to what West
also described aptly as "ways of being human."

The art of the American painter Ellsworth Kelly, although
abstract, has since the late 1950s similarly been based on
noticing eloquent little details in the everyday world—light

hitting a building, or flags flapping in a strong wind, or the corner of a desk, or some squashed pats of butter—then distilling these bare facts into a few basic shapes, dizzily colored, which lead us to consider the charms of their mundane sources. His work depends upon the subtlest of visual distinctions, wherein the difference of an inch in size or in the position of a painted canvas on a wall comes to resemble a moral choice. Kelly's works presume that we, too, are attuned to such subtleties. They seem to say, "You are clever because you see that simplicity is never easily achieved." And it never is. On the other hand, Kelly's pictures tell us that the world is full of small miracles. Its basic democratic message is that these miracles—whether they are squashed pats of butter or fluttering flags—are accessible to all of us, at almost any time, if we are just prepared to look for them.

This is the message of all great art that celebrates the beauty of ordinary things. It counsels patience and calm. Heroic artists like Michelangelo or Picasso could conjure up gods and heroes and mythological worlds, which might temporarily distract us from reality, stir our emotions, and elevate us into a higher realm. But it is the ability of more circumscribed artists to slow our systems, calm our minds, and show us reality as we have probably not considered it that inspired Marcel Proust to say, "Great painters initiate us into a knowledge and love of the external world." For him, the prime example was Jean-Baptiste-Siméon Chardin.

Every great painter is great by his or her own terms, Antoine Watteau's terms differing from Gustave Courbet's, Jacques-Louis David's from Wassily Kandinsky's. Chardin was as great as any artist by the terms he set for himself, which were incredibly narrow: for almost his whole career, spanning half a century, nearly every minute of it spent in Paris, Chardin focused on what was not much farther than three or four feet

in front of his nose. He painted the same brown crockery, some fruit, eggs, and dead rabbits, sometimes mingled with French maids and scrubbed children whose calm and immobility harmonized with the inanimate things around them. These people are made to look arrested in motion, suspended, like the people in Jan Vermeer's paintings, only more solid and real. Vermeer's people are more otherworldly, almost divine—objects of light, there in the pictures for the sake of miraculous atmospherics. Chardin's people are maids and schoolteachers and wives, absorbed and inward turning, oblivious of us. Their absorption becomes the emotional essence of the work. When a little girl glances in a mirror while her mother adjusts her bonnet, or when a nurse, balancing a long-handled saucepan against her arm, peels a hard-boiled egg, Chardin somehow makes these brief instants seem to stretch toward infinity.

In the process, he conveys both the sensation of glimpsing something unremarkable and the effect of having that glimpse impressed on the mind as a memory. A vivid memory can play a mysterious role in the imagination out of proportion to its significance, like a smell or some notes of music or a breeze that triggers the recollection of a pleasant trip or a childhood game or a lost relative. It stays there, waiting. No wonder Proust loved Chardin so much. "You have already experienced it subconsciously," he wrote, "this pleasure one gets from the sight of everyday scenes and inanimate objects, otherwise it would not have risen in your heart when Chardin summoned it in his ringing commanding accents. But your consciousness was too sluggish to reach down to it. It had to wait for Chardin to come and lay hold of it and hoist it to the level of your conscious mind."

I'm not sure Chardin rings out with commanding accents, being moderate and soft-spoken, and I would add that be-

yond just pointing out what is already there, Chardin uncovered a deeper truth in simple nature, one that reveals itself slowly in his work, as it does in life. It has to do with the interplay of color and rhyming form, a harmony and geometry that suggest an underlying, fundamental order in the world, something immensely reassuring. In his still life *The Smoker's Case,* an open, rosewood box lined in satin shares a table with a copper goblet, a crystal flask, and a porcelain cup and pot. Propped against the box, a long-stemmed pipe smolders. Its diagonal line pleasingly breaks the rhythm of upright and horizontal forms. The colors are buttery white, blue, and brown. Chardin's father made billiard tables; it is possible that a friend of his, a *tabletier,* as the French call makers of inlaid boxes, made this one. Like everything Chardin painted, it has the look of something familiar and personal, giving the picture a restful, homey quality. Reflections in the silver cup, the crystal flask, and the copper goblet, all rhyming oval shapes, do a kind of call-and-response across the picture plane. It is a picture of perfect peace and equilibrium.

Art is in cups and saucers and in the streets, too, Chardin realized, centuries before Pop painters like James Rosenquist declared billboards to be modern murals. One of Chardin's first commissions was to paint a signboard for a surgeon. By then he had studied with a leading history painter in France, but grandiloquent, highbrow academic work of that sort didn't grab him. He became interested in the urban scene and in the here and now. He wanted to paint, he said, "with the greatest truthfulness." Painting evidently didn't come easily to him, another reason he may have painted spoons and onions at first: they were simpler to master than gods and battles. But soon he managed figure painting: pictures of do-

mestic interiors with servants and children, the tone never mocking or vulgar. Genre painters back then tended to make their fortunes laughing at the lower classes, but Chardin's work struck exactly the opposite tone: it was deliberate, gentle, and subtly elevating. He treated images of women cooking, or children playing, with a seriousness and a dignity reserved by other artists for supposedly loftier subjects. Moralizing messages, if there were any in Chardin, were at best oblique: scenes of children building houses of cards or playing with shuttlecocks may have metaphorically implied that life was precarious and fate could change with a gust of wind, but only if you chose to interpret them that way. Chardin didn't preach, although his work, in its grave modesty, has inspired modern art historians to assign various meanings to his tranquil scenes. They have been called proto-modern because the figures in them seem so completely absorbed in what they are doing, modernism exulting in the inward-looking autonomy that defines pure abstract painting. Chardin is sometimes credited with having quietly assimilated big ideas by Isaac Newton and John Locke, his contemporaries. His famous painting of a woman drinking tea, we have been told, is not just a picture of a woman drinking tea but a meditation on our perception of a woman drinking tea: the work can evoke the momentary sensation of a woman (she happens to be Chardin's first wife, just weeks before her death) whom we register as if at the periphery of our vision—it's a picture about seeing, in other words, not just about a pretty girl enjoying liquid refreshment. The eighteenth century in France was a time of scientific advancements in optics and perception as well as of rapidly changing attitudes toward children, education, and servants, and Chardin could not have been unaware of the social reverberations of his paint-

ings. The art historian Michael Baxandall has pointed out how, by causing viewers to linger over his various little objects, Chardin was subtly devising works that have multiple points of focus, and thereby expressing contemporaneous theories about how we do not take in complex space all at once but instead piece together the accumulated perception of different colors and shapes. His works therefore taught fresh views about seeing. But if so, Chardin declined to belabor these lessons, and we can approach him today simply as an artist whose profundity had to do with his straightforward honesty, or at least the appearance of it—what Denis Diderot said he loved best about Chardin. There was no cheekiness, no snobbery, and no sex in his pictures. A scal-

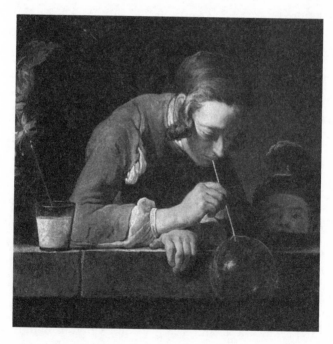

JEAN-BAPTISTE-SIMÉON CHARDIN, *Soap Bubbles*

lion was a scallion was a scallion. This was chaste and humble picture-making, emerging during one of the most erotic, opulent, and rhetorically extravagant eras in the history of European painting, exemplified by the perfumed virtuosity of Chardin's compatriot and nearly exact contemporary, François Boucher. The art of Chardin, by contrast with so much rococo art, was about love, not sex. The sheets stayed pressed in his pictures. If eroticism existed, we may sense it just as dense pigment pushed around lovingly: thick, painstakingly built-up paint, which can have a deeply sensual charge.

Call Chardin's style extravagant understatement. His great painting of a dead mallard hanging on a wall beside a Seville orange is so spare that the picture is almost a visual haiku. The duck, head down, with one wing extended, forms a kind of calligraphic sign against a plain backdrop. The trajectory from Chardin to Cézanne and Matisse, who both revered him, can be traced through such perfect mastery of pared-down abstract forms.

We are a society of families surrounded by the objects we have accumulated, which can become part of our family, too. We become more or less attached to these things, as to pets and people. All writers about Chardin point out that a small and specific pictorial family reappears again and again in his art, a family of cups and pans. We recognize them as we do friends after a while. Chardin's attendance on their condition, and by extension our attendance, because of the eloquence of his painting, can be so loving and complete that it approaches transference. Henri Cartier-Bresson, the photographer, who spent his last decades monkishly drawing copies of Chardin's and other artists' paintings in the Louvre, pointed out that in Chardin's famous picture of a dead ray

hanging gutted from a hook, the ray looked as if it were cruci-
fied. This dovetails with Proust's equally fantastic metaphor
for the ray as "the nave of a polychrome cathedral." Some-
how even Chardin's pictures of food prompt thoughts
of God.

I suspect it has to do with the particular quality of his si-
lence. His are pictures of an extraordinary hushed reverence
for the dignity of modest things, for paint's ability to simu-
late those things, and for a viewer's elevation through ex-
tended looking at those things. With Chardin, one loses
track of time staring, say, at a bunch of cherries, wondering
at their translucence, then counting the cherries—there are
five—and noticing that five matches the sum of two peaches,
a green apple, and two sections of a split apricot to create
perfect symmetry in the picture. A tiny observation, but like
many simple facts of life, strangely marvelous when it turns
out to be a key to some greater truth in life. Chardin's work
is a compilation of these little facts that together make as
true a record of the value of seeing the world in all its details
as exists in the history of art.

Then again, if opening our eyes to the little things in
the world simply delivered pleasure, it would be wonderful,
but it would also be only half true to real life. We left my son
in the supermarket, entranced by the Spider-Man balloons
and gum-ball machines. Like all small children, he occupies
a state of grace in which everything is potentially fascinat-
ing because everything is new. Children dawdle to look at
what adults hurry past. They take time because they have
time. They see the world through fresh eyes. Maybe this is
why artists who push us to look more carefully at simple
things may also strike a slightly melancholic note. They re-
mind us of a childlike condition of wonderment that we
abandoned once we became adults and that we need art to

highlight occasionally, if only to recall for us what we have given up.

What Chardin's views of brown crockery and dead rabbits did for the eighteenth century, Thiebaud's gum-ball machines, pumpkin pies, meat and cheese deli counters, lipsticks,

WAYNE THIEBAUD, *Three Machines*

and hot dogs may do for us today. They have the aura of loves lost and too fondly recalled. Objects suspended in weightless isolation, they glow with a brilliance so peculiar and unreal that it looks as if it must be from either the light of heaven or the glare of an operating theater. After a while Thiebaud's pictures prompt something more complicated than plain joy—as with Chardin, closer to the nature of memory, which is always a tricky affair. This reaction slowly registers in our minds as the gap between what actually was—between those cloying Boston cream pies that we really ate and the gum-ball machines that ate our pennies—and the world as we wished it to be. Thiebaud gives us not real cheese but

Platonic cheese, as the writer Adam Gopnik once put it. And this gap between reality and desire ushers in, in Thiebaud's art, even more than in Chardin's, a sadness after the first leaping rush of pleasure. Thiebaud's work is not about a perfect world. It is about the fact that the world never was and still isn't perfect, except perhaps the little imaginary part of it to which we can briefly retreat in these paintings and thereby glimpse the way all things ought to be.

In this regard, Thiebaud owes long-standing, explicit debts not just to Chardin but also to Giorgio Morandi and the turn-of-the-last-century Spanish virtuoso Joaquín Sorolla. His art, following their examples, is a throwback in its craftsmanship, which has its own nostalgic effect on us. Joy yielding to melancholy yields to the less jolting but more durable satisfaction of being in the presence of pictures lovingly and expertly made. A dedication to craft is not exclusively an American trait, of course, but part of Thiebaud's Americanness also has to do with his version of this quality, just as part of it has to do with the objects of Americana that he depicts. Call it his can-do spirit.

Thiebaud also displays an American brand of wit. Melancholy and wit not being mutually exclusive, these pictures belong, as some writers have pointed out, to the tradition of Charles Chaplin and Buster Keaton. Whether it is with a row of cakes in a store window or cartoonish visions of San Francisco wherein the streets shoot straight up like raised drawbridges, Thiebaud demonstrates the fine art of telling a dry joke: "This sandwich, and then this sandwich again, and then the same damn sandwich again," as Gopnik has pointed out. We smile at the hot dogs and lipsticks solemnly arranged like so many receding headstones at a cemetery not just because of their solemnity but also because

of the repetition. Despite all that food and all that land, Thiebaud's pictures, which also include big empty spaces and isolated shapes—those roadside spots where the car inconveniently dies—connote not just the joy of abundance but faint dread: they approximate that device in the movies when a guy leaves his house and drives around only to end up where he started, so then he tries another route and ends up in the same place, and so on. The camera dotes on the deadpan sight, again and again and again, of the house, just as Thiebaud does on his pies and cakes.

Simultaneously, we can't fail to note that there are variations, subtle differences between one slice of pie and the next, which betray an expressive, improvisatory hand. Thiebaud invites us to bring a careful discrimination to our appreciation of the world around us. These are the same pies, but not painted quite the same way. The quality of paint handling is, again, the key measure of subtle change: if it's sometimes hard to pinpoint precisely whether the psychological tone is ironic or affectionate or detached, it is obvious that the works are the opposite of mechanical.

This applies even to the human figures that Thiebaud began to paint in the early 1960s, when, like Philip Pearlstein, Alfred Leslie, and Alex Katz, he settled upon an unsentimental way of depicting people. The effect, Thiebaud once explained, is meant to be akin to "seeing a stranger in some place like an air terminal for the first time: you look at him, you notice his shoes, his suit, the pin in his lapel, but you don't have any particular feelings about him." It is typical of an artist like Thiebaud to make the best of this mundane situation—waiting in an airport—and to see art in what might appear to be a waste of time. These figures look bored stiff, literally: they're blank-faced zombies, rather endearing, like

the pies, and presented as if they were soldiers at attention. The usual comparison is to Edward Hopper, but psychologically speaking Thiebaud's figures are much less like Hopper's lonely souls than like those women in Vermeer or like the subjects of some early Northern Renaissance portraits, which is to say, they are minutely described but affectless. We can read what we want into them, as we can into the faces of the strangers we pass on the street or see behind the checkout counter or at the airport terminal ready to board our flight. Here is Thiebaud's Willy Loman, in an ill-fitting business suit, hunched over a paperback in some waiting room. There is Twiggy's look-alike in yellow dress and groovy white boots, her slim face framed by a severely cropped bob and giving nothing away, the formal payoff of the painting being the jog of her skinny elbow outlined in blue, which breaks the vertical plane of back and chair, a painterly flourish. And then there are the twin majorettes, beaming in the sunlight, batons held high, an image with the sentimental whiff of a faded snapshot. These characters may conjure up people we once knew or feelings we had, leaps of association, sometimes wild, the way the gum-ball machines can bring to mind, say, a row of gunslingers—the Earps ready for a showdown in the slanting light of the late afternoon—if that's how we choose to see them. They are free-floating signs, wide open to our dreams.

I should mention that Thiebaud had youthful stints as a Disney animator, a movie poster illustrator, and a comic-strip writer. But he also spent time as a boy on his grandfather's farm in southern California, then on a big family ranch in southern Utah, milking cows, shooting deer for meat, plowing wheatfields, and planting alfalfa. For a while he even thought about becoming a farmer. Those landscapes

he paints are views of farms and valleys turned into complex, almost abstract grids of antic patterns, seen from a bird's-eye perspective. The art-historical sources here include Chinese painting, Claude Monet, and cubism—dizzy jigsaw-puzzle designs in which flattened fields under hazy skies turn from deep blue to pink, and a solitary poplar, a slender cone, may cast a blue-green shadow against a patch of mustard. The affection and eccentricity of these landscapes, which are partly inspired by real views of the deltas in the Sacramento Valley, speak clearly of firsthand experience. Thiebaud (his maternal grandmother was one of the Mormon pioneers who settled in Utah in the mid-1800s) is as much an artist of the American West—of Western light, Western space, Western silences, Western attitudes—as he is an heir to Krazy Kat or Mickey Mouse. It is possible to recognize in his paintings not just a landscape or a gum-ball machine but a particular place and thing whose specificity enhances its aura of familiarity.

To art aficionados, I might add, Thiebaud's work also offers gentle in-jokes whereby a drawer of neckties becomes a mock Morris Louis, a bathtub brings to mind Donald Judd, and scattered crayons suggest Richard Serra. Humor deflates pretense, which Thiebaud, it so happens, entirely lacks in life, as in art. His pictures, like Chardin's, provoke happiness if for no other reason than that they are content to be what they are, which is plenty. That is also the message they convey, by extension, about the modest objects and people they depict. See his paintings of cakes on their spindle-legged platforms. Notice how the vertical stripes of the frosted cake in the back balance the horizontal layers of cream inside the chocolate cake in the front, while the hollow circle made by the empty center of the angel-food cake to the side comple-

ments the yellow circle of the lemon custard pie near the center, and how the number of cakes adds up to seven, three on either end of the one with the heart drawn in red icing on top.

Delicious.

WAYNE THIEBAUD, *Man Sitting—Back View*

ACKNOWLEDGMENTS

ONE DAY, John Darnton suggested that I write a book about the consolations of art. That got me started. My plan was to frame history and philosophy, almost as if on the sly, in the context of a book whose deepest ambition is simply to be a good read for anyone who happens to pick it up.

I have been very lucky. At the Penguin Press, I am thankful almost beyond words for Ann Godoff's faith, generosity, judgment, and friendship. She is what every writer dreams about in a publisher. Liza Darnton has endured endless importunings and other daily annoyances from me with patience, unshakable calm, and good sense. Kate Griggs, Miranda Ottewell, Valerie von Volz, Claire Vaccaro, Amanda

Dewey, and Darren Haggar dealt with my critic's fussy temperament and produced more than one excellent version of the book. Sarah Hutson has taken the idea and run with it.

Jonathan Karp prodded and encouraged me early on. I owe him an enduring debt. Ariel Kaminer read and edited the manuscript not once but twice, with grace, precision, and humor. She frequently saved me from myself. I thank her. My friends Alan Riding, Michael Leja, Diane Simon, Sheila Glaser, Elisabeth Sifton, Marilyn Minden, and Lisa Hendricksson also read drafts of the book, improving it in countless ways, big and small.

Others confirmed facts, fixed errors, offered ideas, talked me through particular chapters or alternate book titles, and generally tried to set me straight, among them Jodi Kantor, Sarah Whitfield, Mason Klein, Desirée Alvarez, Jon Hendricks, Michael Govan, Mia Fineman, William S. Wilson, Nancy Holt, Carrie Albert, and Margaret Jones. Frances Beatty and the staff at Richard L. Feigen & Co. were helpful with permissions for photographs and information especially related to Ray Johnson. Thomas Walther, the collector, whose assortment of amateur snapshots inspired a show at the Metropolitan Museum, graciously allowed some of those photographs to be reproduced here. Elyse Topalian of the Met aided with permissions and other practical matters.

At *The New York Times*, during the gestation of this book, I have been edited, shepherded along, and endlessly indulged by many friends and colleagues: Myra Forsberg, Wendy Sclight, Annette Grant, Nancy Kenney, Jon Landman, Sam Sifton, Jim Schachter, John Storm, John Rockwell, Holland Cotter, Roberta Smith, Steve Erlanger, Marty Gottlieb, Don Caswell, John Russell, Joe Lelyveld, Bill Keller, Jill Abramson, Chip McGrath, Katherine Bouton, Gerry Marzorati, Adam Moss, and Al Siegal.

I have learned much from listening to artists. Philip Pearlstein, Michael Heizer, and Matthew Barney gave me their time and opened up their studios to me. They were very generous.

During the latter stages of the book, Daniel Belasco did more than just oversee the absurdly complicated task of pulling together illustrations. He tracked down information, corrected errors, sought out experts, and provided sage editorial advice that I have tried to follow. His help and intelligence were invaluable.

After all these years, Suzanne Gluck and I still can't seem to shake each other. She saw me through the process. Now I don't know what I would do if she weren't my friend and agent.

As for Maria Simson, who has made the book, like everything in my life, so much better, and whose editing was, as always, pitch-perfect, she is simply the most remarkable person I know. I am in awe.

SELECTED BIBLIOGRAPHY

Alexander, Caroline. *The Endurance: Shackleton's Legendary Antarctic Expedition.* New York: Knopf, 1999.

Antarctica: The Extraordinary History of Man's Conquest of the Frozen Continent. New York: Reader's Digest, 1990.

Bailey, Colin, ed. *The Age of Watteau, Chardin, and Fragonard: Masterpieces of French Genre Painting.* New Haven: Yale University Press, 2003.

Barney, Matthew. *The Cremaster Cycle.* New York: Guggenheim Museum Publications, 2003.

Barrette, Bill. *Eva Hesse: Sculpture.* New York: Timken Publishers, 1989.

Barthes, Roland. *Camera Lucida.* New York: Farrar, Straus and Giroux, 1981.

Baxandall, Michael. *Patterns of Intention: On the Historical Explanation of Pictures*. New Haven: Yale University Press, 1985.

———. *Shadows and Enlightenment*. New Haven: Yale University Press, 1995.

Benjamin, Walter. *Illuminations: Essays and Reflections*. New York: Schocken Books, 1969.

Berger, John. *Selected Essays of John Berger*. New York: Knopf, 2003.

Blom, Philipp. *To Have and to Hold: An Intimate History of Collectors and Collecting*. Woodstock, NY: Overlook Press, 2003.

Bonnard/Matisse: Letters between Friends. New York: Harry N. Abrams, 1992.

Brown, Julia, ed. *Michael Heizer: Sculpture in Reverse*. Los Angeles: Museum of Contemporary Art, 1984.

Celant, Germano. *Michael Heizer*. Milan: Fondazione Prada, 1997.

Cézanne. New York: Harry N. Abrams, 1996.

Chardin. New York: Metropolitan Museum of Art, 2000.

Clark, Kenneth. *The Nude: A Study in Ideal Form*. Garden City, NY: Doubleday, 1956.

Cooke, Charles. *Playing the Piano for Pleasure*. New York: Simon & Schuster, 1941.

Coombs, David, with Minnie S. Churchill. *Sir Winston Churchill: His Life and His Paintings*. London: Running Press Book Publishers, 2004.

Cooper, Helen A., ed. *Eva Hesse: A Retrospective*. New Haven: Yale University Press, 1992.

Danto, Arthur. "Beauty for Ashes." In *Regarding Beauty: A View of the Late Twentieth Century*. Washington, DC: Hirshhorn Museum and Sculpture Garden, 1999.

———. *The Madonna of the Future: Essays in a Pluralistic Art World*. New York: Farrar, Straus and Giroux, 2000.

de Botton, Alain, *How Proust Can Change Your Life; Not a Novel*. New York: Pantheon Books, 1997.

de Custine, Astolphe. *Letters from Russia*. New York: New York Review of Books, 2002.

Felstiner, Mary Lowenthal. *To Paint Her Life: Charlotte Salomon in the Nazi Era*. New York: HarperCollins, 1994.

Freedberg, David. *The Power of Images: Studies in the History and Theory of Response*. Chicago: University of Chicago Press, 1989.

Fried, Michael. "Art and Objecthood." *Artforum* (June 1967).

Garrels, Gary, ed. *Sol LeWitt: A Retrospective*. San Francisco: San Francisco Museum of Modern Art, 2000.

Green, Jane, and Leah Levy, eds. *Jay DeFeo and the Rose*. Berkeley: University of California Press, 2003.

Greenberg, Clement. *Clement Greenberg: The Collected Essays*. Chicago: University of Chicago Press, 1986.

———. *Homemade Esthetics: Observations on Art and Taste*. New York: Oxford University Press, 2000.

How to Draw a Bunny. Documentary film. Directed by John Walter, 2002.

Hyman, Timothy. *Bonnard*. New York: Thames and Hudson, 1998.

Kenseth, Joy, ed. *The Age of the Marvelous*. Hanover, NH: Hood Museum of Art, Dartmouth College, 1991.

Kernan, Nathan. "The Presence of Absence." In *Joan Mitchell: Selected Paintings 1956–1992: The Presence of Absence*. New York: Cheim & Read, 2002.

Kimmelman, Michael. *Portraits: Talking with Artists at the Met, the Modern, the Louvre, and Elsewhere*. New York: Random House, 1998.

Lansing, Alfred. *Endurance: Shackleton's Incredible Voyage*. New York: McGraw-Hill, 1959.

Machotka, Pavel. *Cézanne: Landscape into Art*. New Haven: Yale University Press, 1996.

Marling, Karal Ann. *As Seen on TV: The Visual Culture of Everyday Life in the 1950s*. Cambridge, MA: Harvard University Press, 1994.

Muensterberger, Werner. *Collecting: An Unruly Passion: Psychological Perspectives.* Princeton, NJ: Princeton University Press, 1994.

Munroe, Alexandra, with Jon Hendricks. *Yes Yoko Ono.* New York: Harry N. Abrams, 2000.

Nabokov, Vladimir. *Speak, Memory.* New York: Putnam, 1966.

Nash, Steven A., with Adam Gopnik. *Wayne Thiebaud: A Paintings Retrospective.* San Francisco: Fine Arts Museums of San Francisco, 2000.

Nickel, Douglas R. *Dreaming in Pictures: The Photography of Lewis Carroll.* San Francisco: San Francisco Museum of Modern Art, 2002.

Nicolson, Marjorie Hope. *Mountain Gloom and Mountain Glory: The Development of the Aesthetics of the Infinite.* New York: W. W. Norton, 1959.

Noever, Peter, ed. *Donald Judd: Architecture.* Ostfildern-Ruit, Germany: Hatje Cantz, 2003.

Other Pictures: Anonymous Photographs from the Thomas Walthers Collection. Essay by Mia Fineman. Santa Fe: Twin Palms Publishers, 2000.

Pearlstein, Philip. *Philip Pearlstein.* Athens, GA: Georgia Museum of Art, 1970.

Perl, Jed. *Gallery Going: Four Seasons in the Art World.* New York: Harcourt, 1991.

Proust, Marcel. *Marcel Proust on Art and Literature, 1896–1919.* New York: Carroll & Graf, 1984.

The Quilts of Gee's Bend. Houston: Museum of Fine Arts, 2002.

Rewald, John. *Cézanne: A Biography.* New York: Harry N. Abrams, 1986.

Rosen, Charles. *The Romantic Generation.* Cambridge, MA: Harvard University Press, 1995.

Rosenberg, Pierre. *Chardin, 1699–1779.* Paris: Réunion des Musées Nationaux, 1979.

Saint-Exupéry, Antoine de. *Airman's Odyssey*. New York: Harcourt, Brace & Co., 1984.

Salomon, Charlotte. *Life? or Theatre?* Zwolle, Netherlands: Waanders, 1998.

Schama, Simon. *Landscape and Memory*. New York: Knopf, 1995.

Sebald, W. G. *Austerlitz*. New York: Random House, 2001.

Serota, Nicholas, ed. *Donald Judd*. New York: Distributed Art Publishers, 2004.

Smith, Alison, ed. *Exposed: The Victorian Nude*. London: Tate Publishing, 2001.

Sontag, Susan. *On Photography*. New York: Dell, 1977.

South with Endurance: Shackleton's Antarctic Expedition, 1914–1917. New York: Simon & Schuster, 2001.

Stein, Judith, ed. *I Tell My Heart: The Art of Horace Pippin*. Philadelphia: Pennsylvania Academy of Fine Arts, 1993.

Storr, Robert. *Philip Pearlstein: Since 1983*. New York: Harry N. Abrams, 2002.

Studio 360. "Can Art Be Taught?" National Public Radio, January 10, 2004.

Sylvester, David. *About Modern Art*. New Haven: Yale University Press, 2001.

Terasse, Michel. *Bonnard at Le Cannet*. London: Thames and Hudson, 1988.

Tharp, Twyla, with Mark Reiter. *The Creative Habit: Learn It and Use It for Life: A Practical Guide*. New York: Simon & Schuster, 2003.

Ullmann, Alex. *Afghanistan*. New York: Ticknor & Fields, 1991.

Varnedoe, Kirk. *A Fine Disregard: What Makes Modern Art Modern*. New York: Harry N. Abrams, 1990.

Warren, Elizabeth V., and Roger Angell. *The Perfect Game: America Looks at Baseball*. New York: Harry N. Abrams, 2003.

Weschler, Lawrence. *Mr. Wilson's Cabinet of Wonder.* New York: Pantheon Books, 1995.

Whitfield, Sarah, and John Elderfield. *Bonnard.* New York: Harry N. Abrams, 1998.

Wilson, William S. *Ray Johnson.* Black Mountain, NC: Black Mountain College Museum and Arts Center, 1997.

Worden, Gretchen. *Mütter Museum of the College of Physicians of Philadelphia.* New York: Blast Books, 2002.

Zagajewski, Adam. *A Defense of Ardor.* New York: Farrar, Straus and Giroux, 2004.

INDEX

Page numbers in *italics* indicate photographs.

INDEX

Heine, Heinrich, 57, 146
Heizer, Michael, 194–205
Heizer, Ott F., 198
Heizer, Robert F., 198
Hendricks, Jon, 74
Hermitage museum, 29
Hesse, Eva, 116–19, 125
Hicks, Hugh Francis, 3–4, 5, 7, 93–95,
 96, 101, 104, 108–9
Hillary, Sir Edmund, 56
Himmler, Heinrich, 94
Hindemith, Paul, 122
Hirschfeld, Al, 151–53
Hirst, Damien, 107
Hitler, Adolf, 125
Hobbes, Thomas, 55
Hoffman, Lorenz, 101–2
Holt, Nancy, 180, 181, 205
Hopper, Edward, 224
Horovitz, Len, 6
Howard, Elston, 135
Hume, David, 63, 190
Hurley, Frank, 132–33, 135–36, 137–39,
 140–43, 144–47
Hussein, Saddam, 81
Hyman, Timothy, 1, 18

Indica Gallery, 90
Industrial Revolution, 82
Ingres, Jean-Auguste-Dominique, 7,
 161–62
installation art, 178–79; see also spe-
 cific installation artists
Into Thin Air (Krakauer), 67
Invisible Man (Ellison), 108
Iris Clert Gallery, 83
Irwin, Robert, 83
Isenheim altarpiece (Grünewald),
 177–78
Island of the Dead, The (Böcklin), 138
Isnard, Antoinette, 26

Jackson, Chevalier, 106–7, 107
Janklow, Mort, 76
Jeanne-Claude, 63
Jenkins, Olaf P., 198
Jesus Christ, 81
Jetty, see Spiral Jetty (Smithson)
Johns, Jasper, 114
Johnson, Ray, 71, 72–80, 88, 90
Joy of Painting, The (TV series), 33

Judd, Donald, 96, 118, 188–90, 191–94,
 225
Jungle Woman, The (film), 145

Kabakov, Ilya, 190
Kandinsky, Wassily, 214
Kant, Immanuel, 53–54, 66, 67, 190
Kaprow, Allan, 83
Katz, Alex, 153, 223
Keaton, Buster, 222
Kelly, Ellsworth, 143, 213–14
Kernan, Nathan, 21
Kertész, André, 46
Kimmelman, Michael, 30
Klee, Paul, 134
Klein, Yves, 83
Klemperer, Otto, 122
Komar, Vitaly, 55
Kowalski, Walt, 35
Krakauer, Jon, 67
Kubek, Tony, 135
Kulturbund Deutscher Juden, 123
Kunst- und Wunderkammern, 7,
 101–4, 105

Lachman, Harry, 17
Lannan Foundation, 203
Lenin, Vladimir Ilich, 81
Lennon, John, 89, 90
Leonardo da Vinci, 161
Leslie, Alfred, 153, 223
Levitated Mass (Heizer), 202
LeWitt, Sol, 72, 83, 86–88, 119, 125
Lichtenstein, Roy, 154
Life? or Theater? A Play with Music
 (Salomon), 121, 122, 123, 124,
 124, 125, 126–27, 128, 129
Lightning Field, The (De Maria),
 179–80, 180, 181, 187, 203, 204
Lin, Maya, 200
Lippold, Richard, 73
Locke, John, 217
Lolita (Nabokov), 169
Loman, Willy, 224
Long, Richard, 200
Louis, Morris, 225
Luther, Martin, 56

Maciunas, George, 88, 89
Mackiewicz, Jennifer, 197
Malevich, Kazimir, 96

ILLUSTRATION CREDITS

Page 16: © 2005 Artists Rights Society (ARS), New York / (ARS), New York / ADAGP, Paris. Reunion des Musées Nationaux / Art Resource, NY.

21: Copyright © The Estate of Joan Mitchell. Courtesy Cheim & Read, New York.

27: © 2005 Artists Rights Society (ARS), New York / ADAGP, Paris.

44, 47, 49: © Thomas Walther Collection.

61: Bildarchiv Preussischer Kulturbesitz / Art Resource, NY.

80: © Estate of Ray Johnson, Richard L. Feigen & Co. Collection of William S. Wilson.

103: Courtesy of the Pennsylvania Academy of the Fine Arts, Philadelphia. Gift of Mrs. Sarah Harrison (The Joseph Harrison, Jr. Collection).

107: Courtesy Mutter Museum, College of Physicians of Philadelphia.

113: © 2005 Estate of Jay DeFeo / Artists Rights Society (ARS), New York.

117: © The Estate of Eva Hesse. Hauser & Wirth, Zurich and London.

120: Photo: Jewish Historical Museum, Amsterdam, Collection Marian Lackler, USA.

ILLUSTRATION CREDITS

124: Collection Jewish Historical Museum, Amsterdam. Copyright Charlotte Salomon Foundation.

142, 147: Royal Geographical Society, London.

168: A. P. Watt Ltd on behalf of the Trustees of the C. L. Dodgson Estate.

173: © Philip Pearlstein. Courtesy Betty Cuningham Gallery, New York.

180: Walter De Maria, The Lightning Field, 1977, Quemado, New Mexico. Photo: John Cliett. © Dia Art Foundation.

181: (two images) Art © Nancy Holt / Licensed by VAGA, New York, NY.

193: Art © Judd Foundation / Licensed by VAGA, New York, NY.

196: © Triple Aught Foundation.

206: © 1999 Matthew Barney. Photo: Chelsea Romersa. Courtesy Gladstone Gallery, New York.

218: Courtesy The Metropolitan Museum of Art.

221: Art © Wayne Thiebaud / Licensed by VAGA, New York, NY. "Three Machines," 1963, oil on canvas, Fine Arts Museums of San Francisco.

226: Art © Wayne Thiebaud / Licensed by VAGA, New York, NY.

ABOUT THE AUTHOR

Michael Kimmelman is the chief art critic of *The New York Times* and a contributor to *The New York Review of Books*. His book *Portraits: Talking with Artists at the Met, the Modern, the Louvre and Elsewhere* was named as a notable book of the year by *The New York Times* and *The Washington Post*. He lives in Manhattan with his wife and son.